Spirit of America

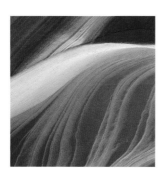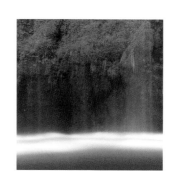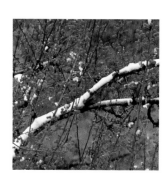

Spirit of America

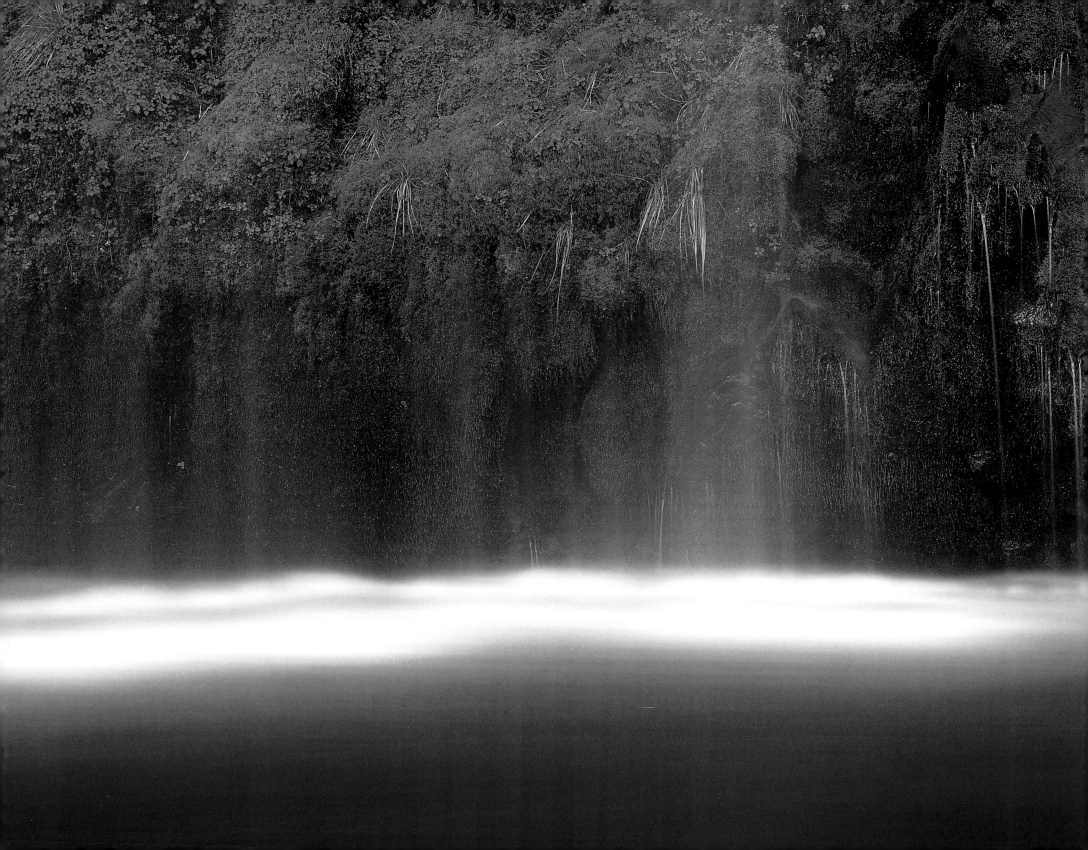

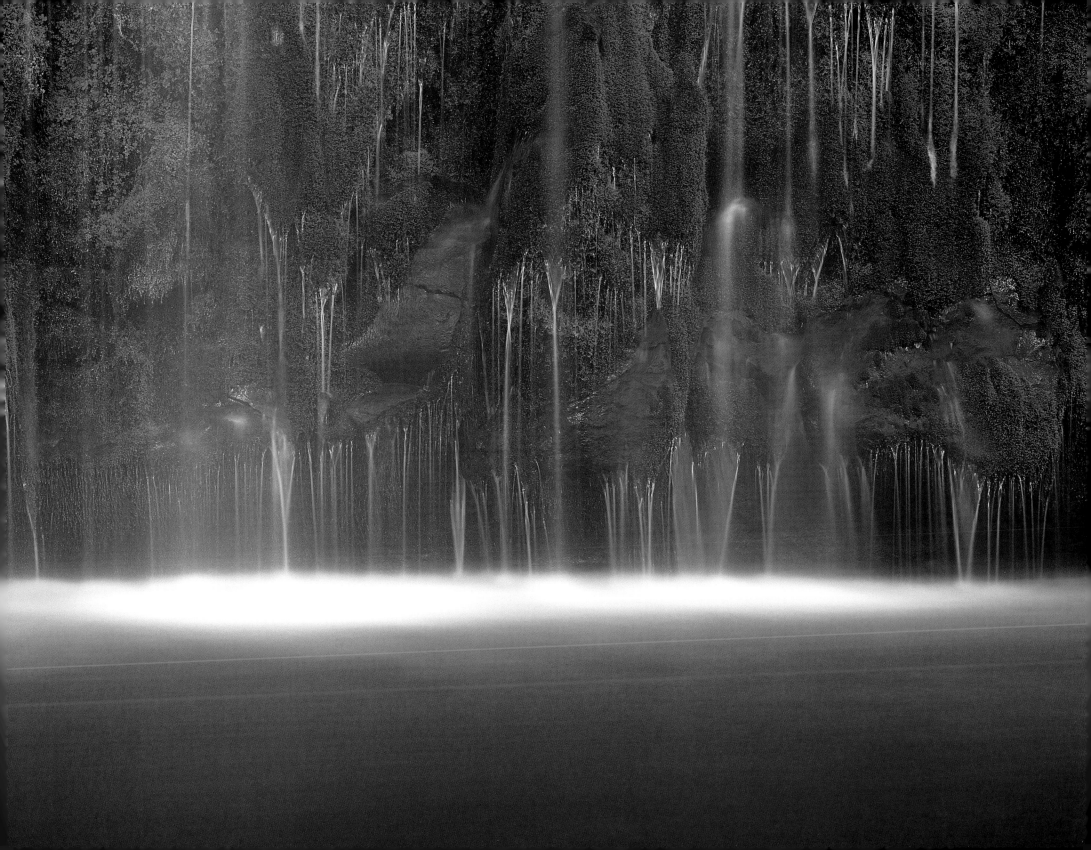

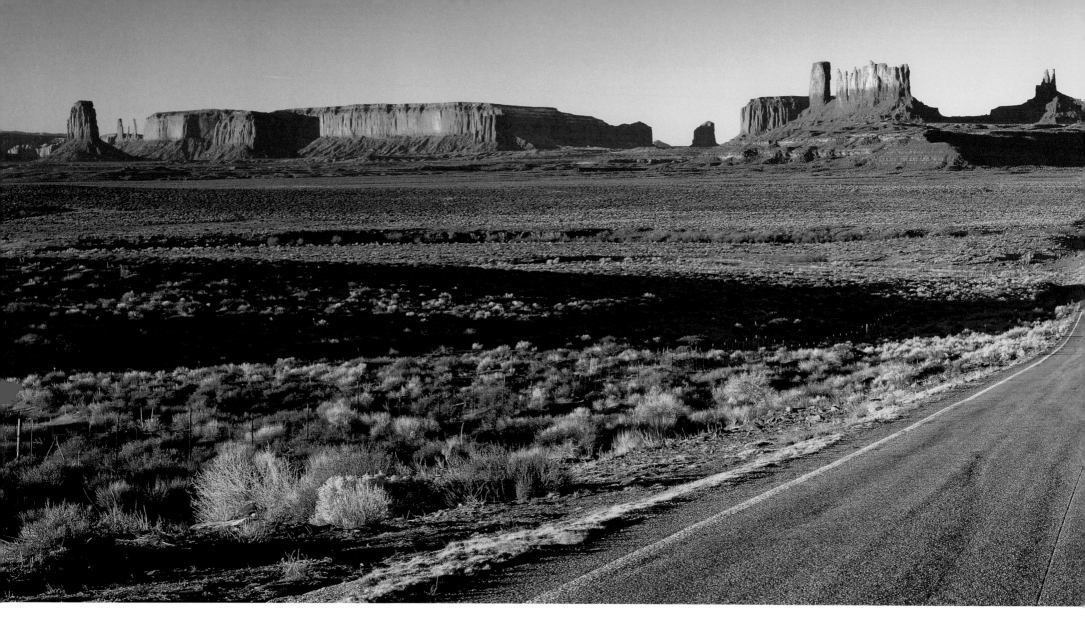

previous page: Tranquillity - sierra cascades, CALIFORNIA.

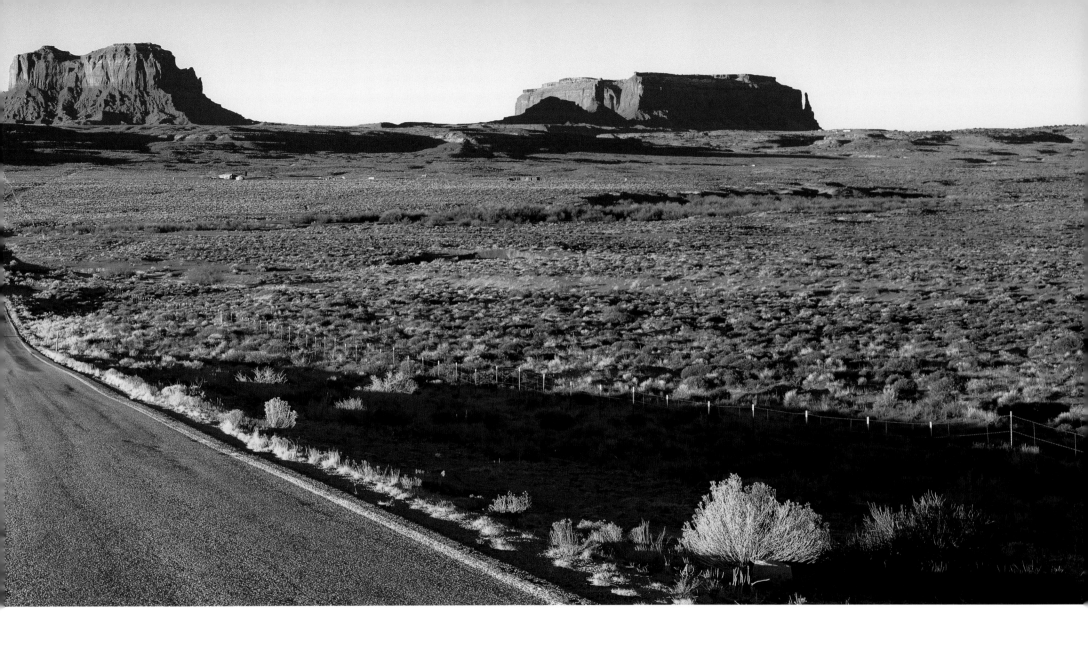

Highway 163, leading to Monument Valley Navajo Tribal Park.

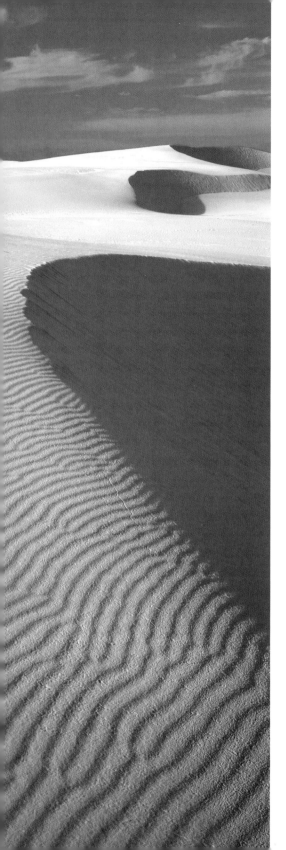

DISCOVERING AMERICA'S HEART

In 2003 I completed the biggest challenge of my life - to shoot a 192-page book on the American landscape. In order to capture the true essence of this vast country, I needed to visit every state and every landmark, through every season. Fifty thousand miles, a thousand rolls of film and five years of my life later I achieved my goal. It was the journey of a lifetime - the most ambitious project I've ever undertaken, and I doubt I'll ever match my incredible experience.

Setting out to cross America was the ultimate road trip, and for a guy from Australia, a very steep learning curve. So much was alien to me - navigating treacherous winter roads, dealing with the effects of extreme weather conditions (on both me and my equipment) finding out it sure is hard driving on the wrong side of the road, and to my mind the craziest discovery of all – McLobster burgers in Maine!

With sometimes up to three months between shooting a film and getting to process it, I was a nervous wreck. I'd walk into a lab and drop a bag with 200 rolls on the counter and have absolutely no idea what I was going to get. There were so many variables – did I get the exposures right, did I get the best shot of the area, had I been in the right place, were my cameras even working properly? I took a lot of risks because often I was working with completely new photographic techniques - like shooting the spectrum of the fall colours, or blown out exposures blanketed in snow. I had no experience with how the film would react and I definitely got a few surprises. Lab day was always the best and worst of times.

The thing that struck me about America was the incredible diversity of the landscape. Here it seemed like only days between sitting at the top of the world over the lunar-like volcanic rim of Haleakala in Hawaii, to balancing with my tripod on the edge of the frozen shores of Lake Superior in bitter sub-zero temperatures.

My real challenge lay in finding those one or two 'perfect' images that really depicted each state. Sometimes that was incredibly hard, travelling through mile after mile of unfamiliar

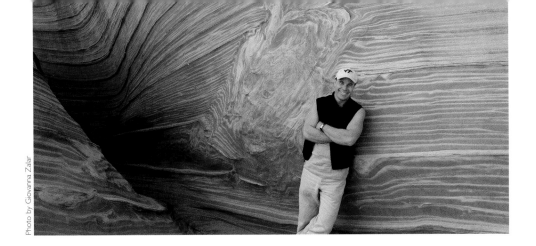

Photo by Giovanna Zalar

terrain, and I was constantly searching for compositions. I knew if I lost concentration for one moment I might miss the killer shot - sometimes the icon or monument a state is most famous for isn't the one thing that really embodies its true spirit. For a project like this though, I felt I couldn't ignore the recognisable landscape. Some places like Yosemite for instance have been shot a million times, but I always tried to capture a different perspective. I spent countless hours researching each state, reading, and talking to the locals - my heavy Australian accent sometimes requiring an interpreter. Consequently I spent a lot of time chasing dud leads. But while searching unsuccessfully for a magic 'tip off' I often stumbled across the 'real' shot by mistake. Arkansas was one of those places. I spent hours looking for a particular location I had been told about, but to no avail. I dejectedly hiked back to the van and stopped to watch the sunset. A gnarled old tree clinging to the edge of a cliff really intrigued me and

without being too hopeful, I shot off a couple of rolls of film. I didn't know it at the time but it turned out to be one of the hero shots of the trip.

With every mile I travelled and every frame I shot, I was piecing together a huge jigsaw which would eventually form this book. America has such an incredible natural beauty, and at times I was truly awed by the scale of the landscape. I experienced just how intimidating it could be when hiking through Paria Canyon - one of the most extreme wilderness areas I have ever visited. I became completely engrossed in shooting the sunset forgetting it was a five-mile hike back to the truck. I had no choice but to try and negotiate my way out by moonlight. I ended up totally disoriented wandering the silent canyon. I eventually made it out after a tense couple of hours, but it was a harsh reminder that we should always respect the power of the land.

" The real voyage of discovery is not in discovering new lands, but in seeing with new eyes " (Marcel Proust) - and I truly believe that my lack of preconceptions of America was my greatest asset. There was always something new for me to discover, and I could never get lost because I wanted to see it all! So many times I was in a weird location or some crazy position taking a shot, and a puzzled local would come over to find out what I could possibly find interesting to shoot! But for me it was breaking new ground. I found myself in situations I had never faced before and it forced me to work with new elements and really push my creative limits.

These images are the threads that weave together my network of memories. There are a million moments of my trip I'll never forget, and probably a million more I don't even know I missed. This book is one of the great achievements of my life, but I'm no different from the next person. I'm just an ordinary guy with a big camera chasing my dreams - and somewhere out on the road in between Highway 163 in Arizona and a twenty-four hour twilight in Alaska, I reckon I really did discover the spirit of America.

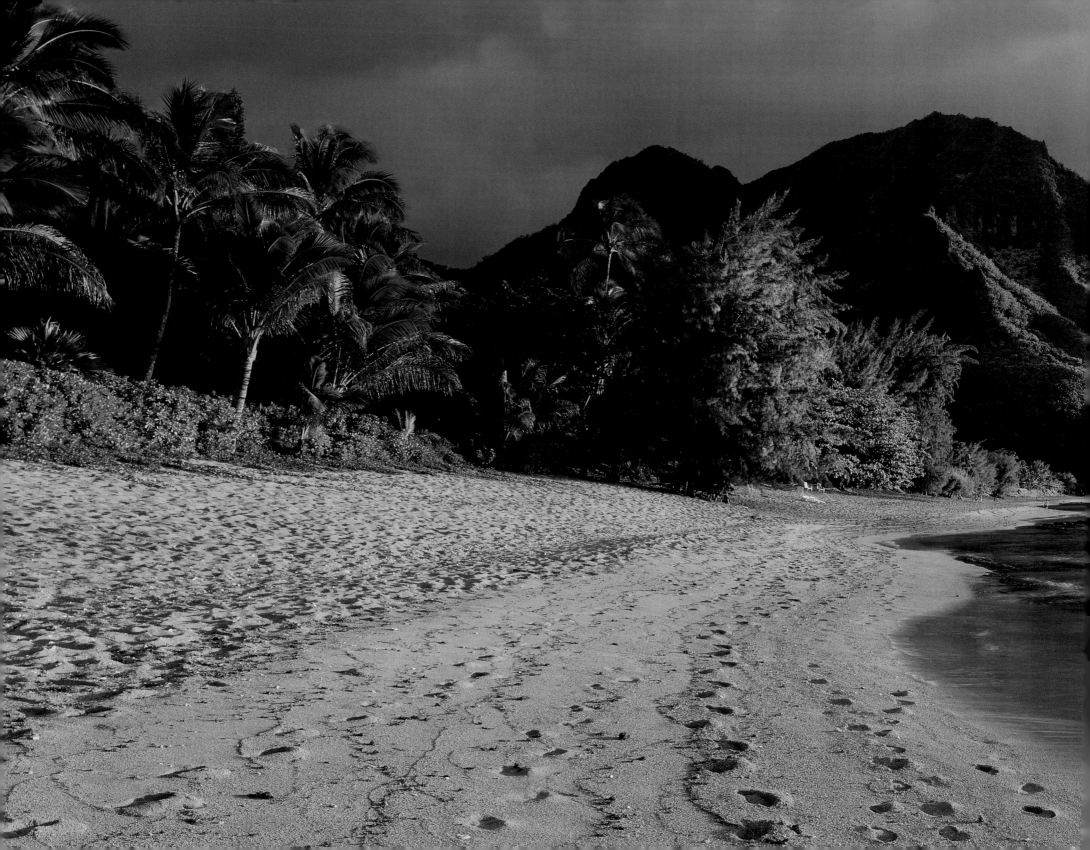

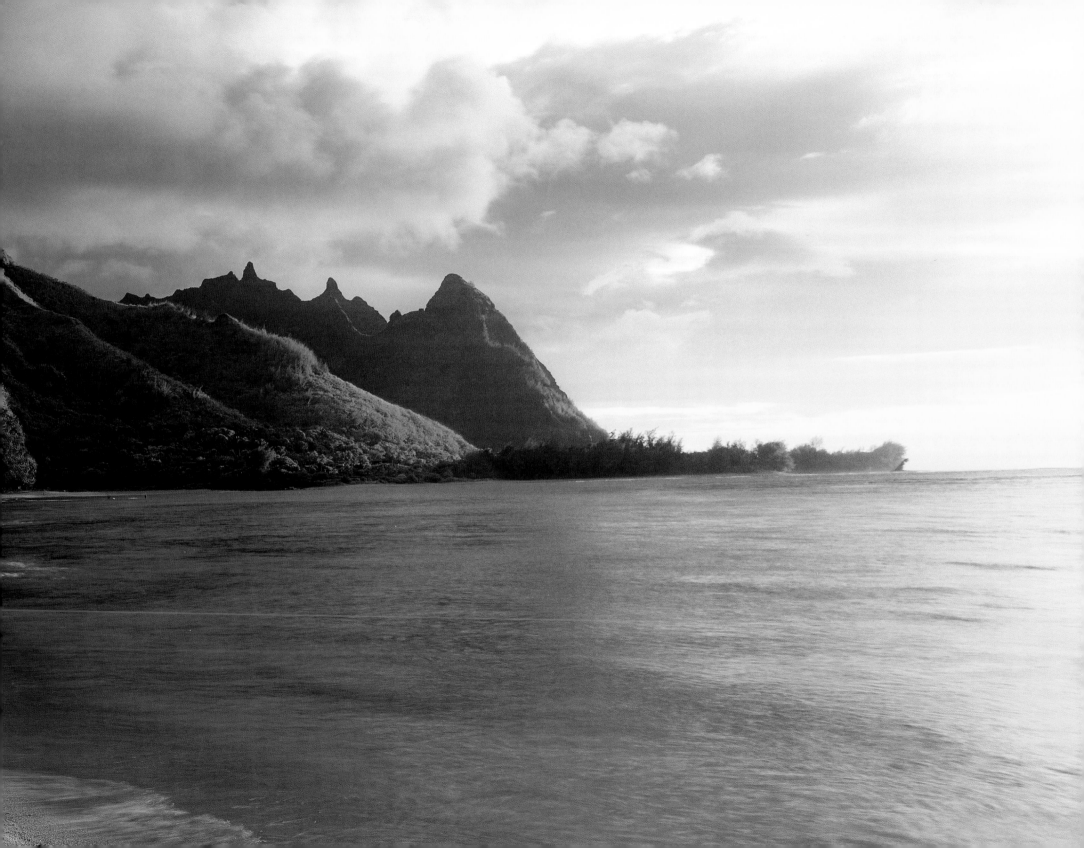

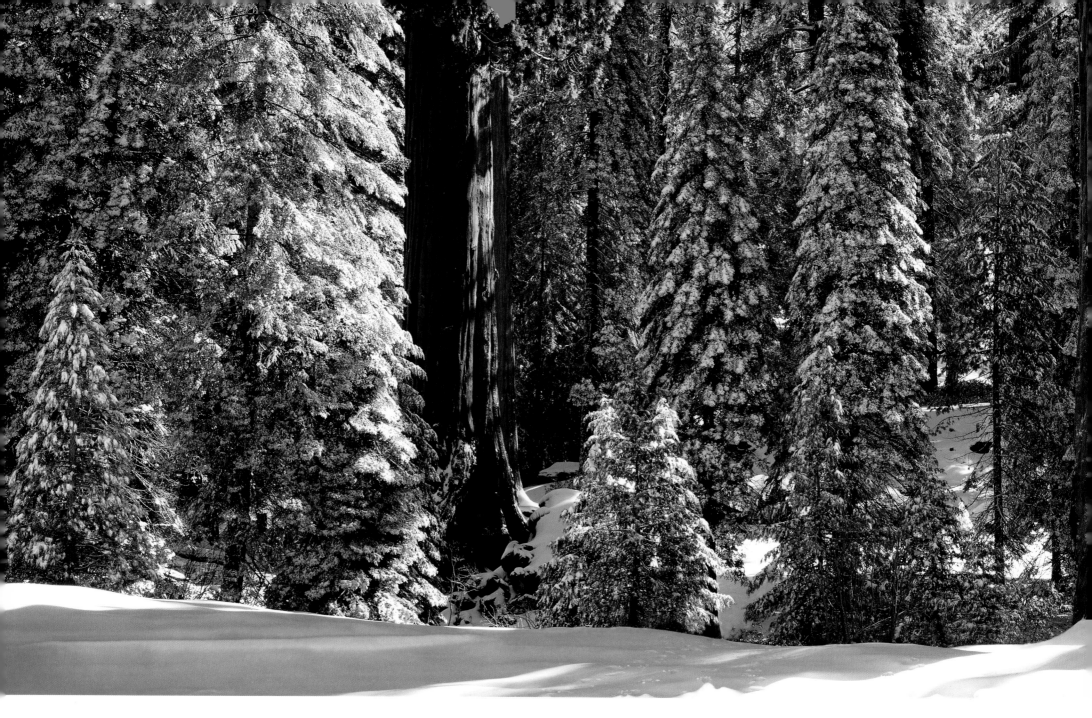

previous page: Painted light, Na Pali Coastline, Kauai, **HAWAII.**

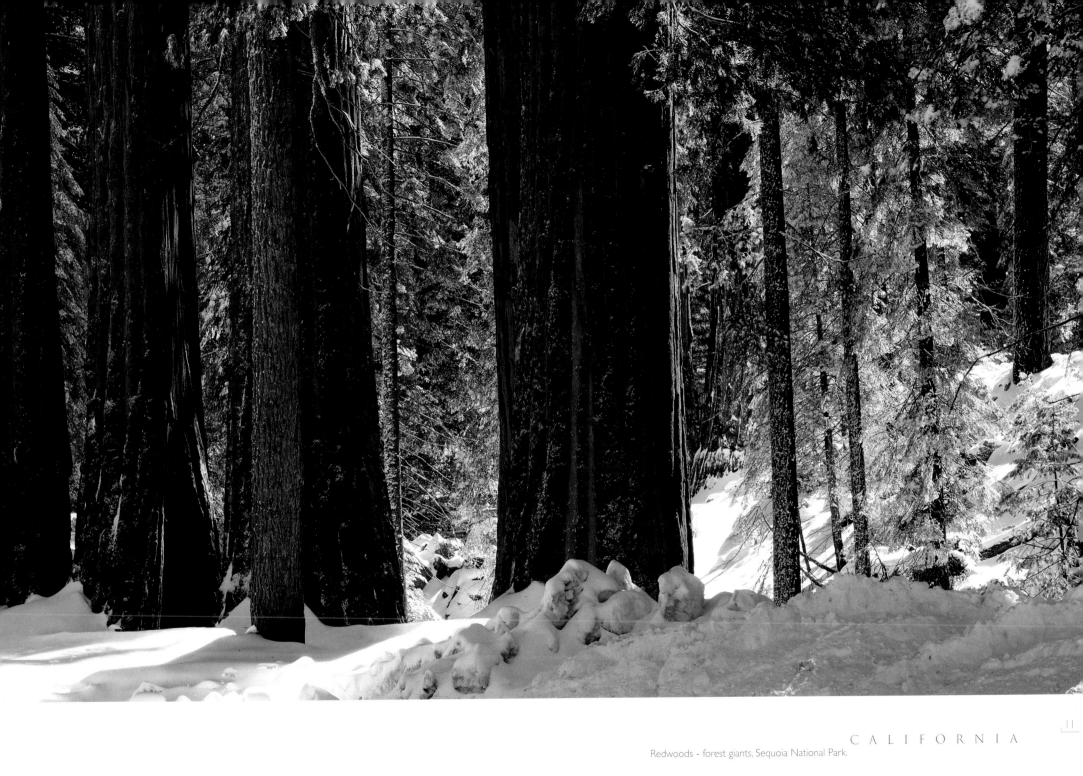

Redwoods - forest giants, Sequoia National Park.

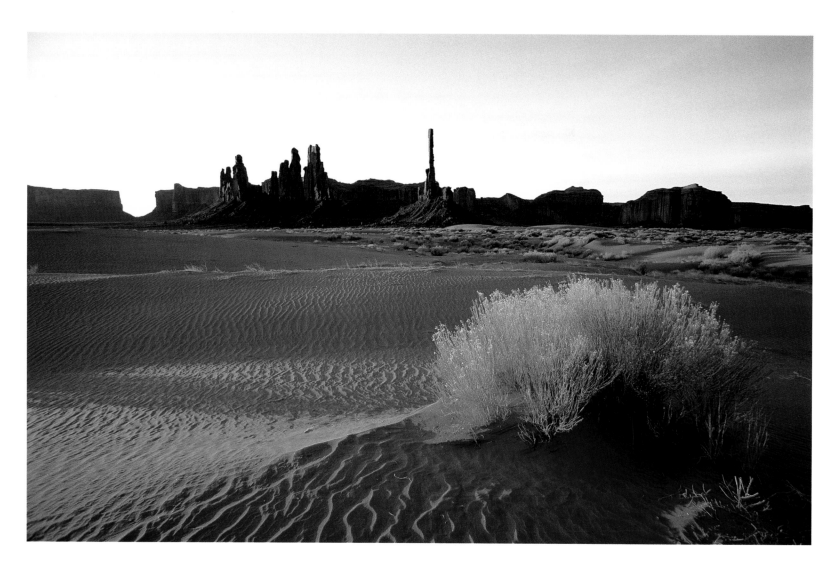

ARIZONA

Monument Valley Navajo Tribal Park.

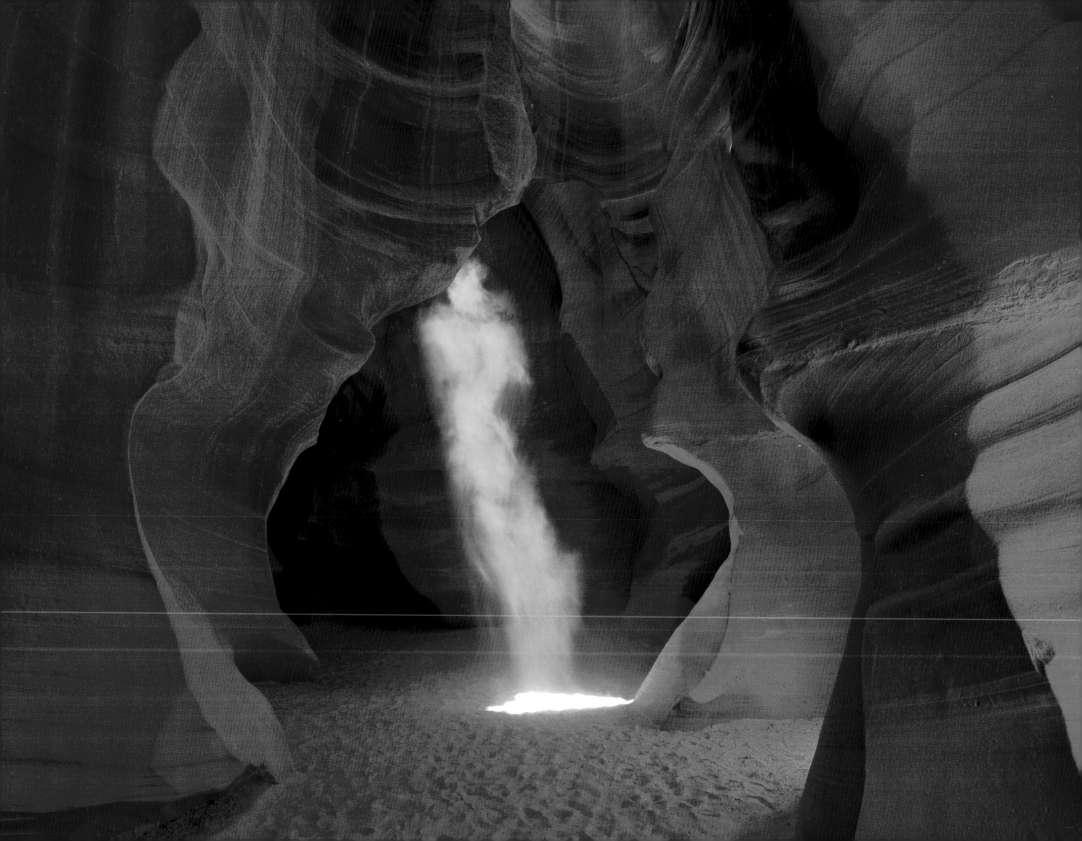

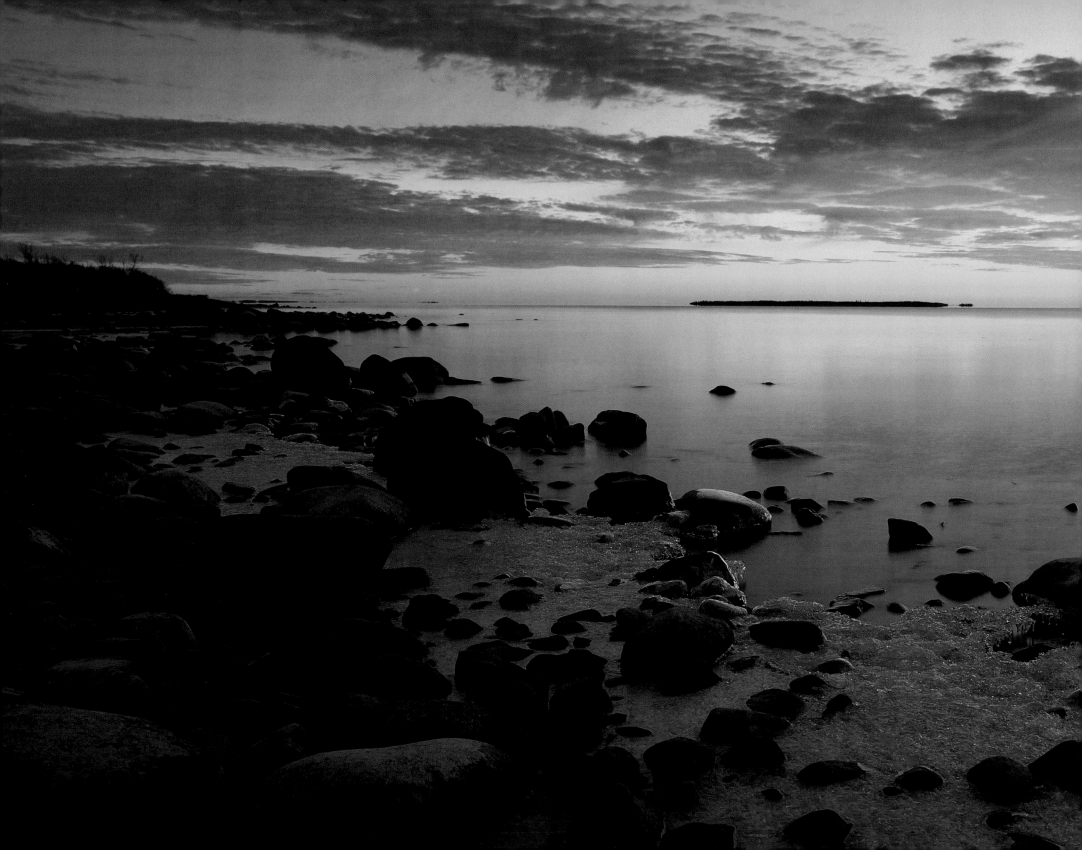

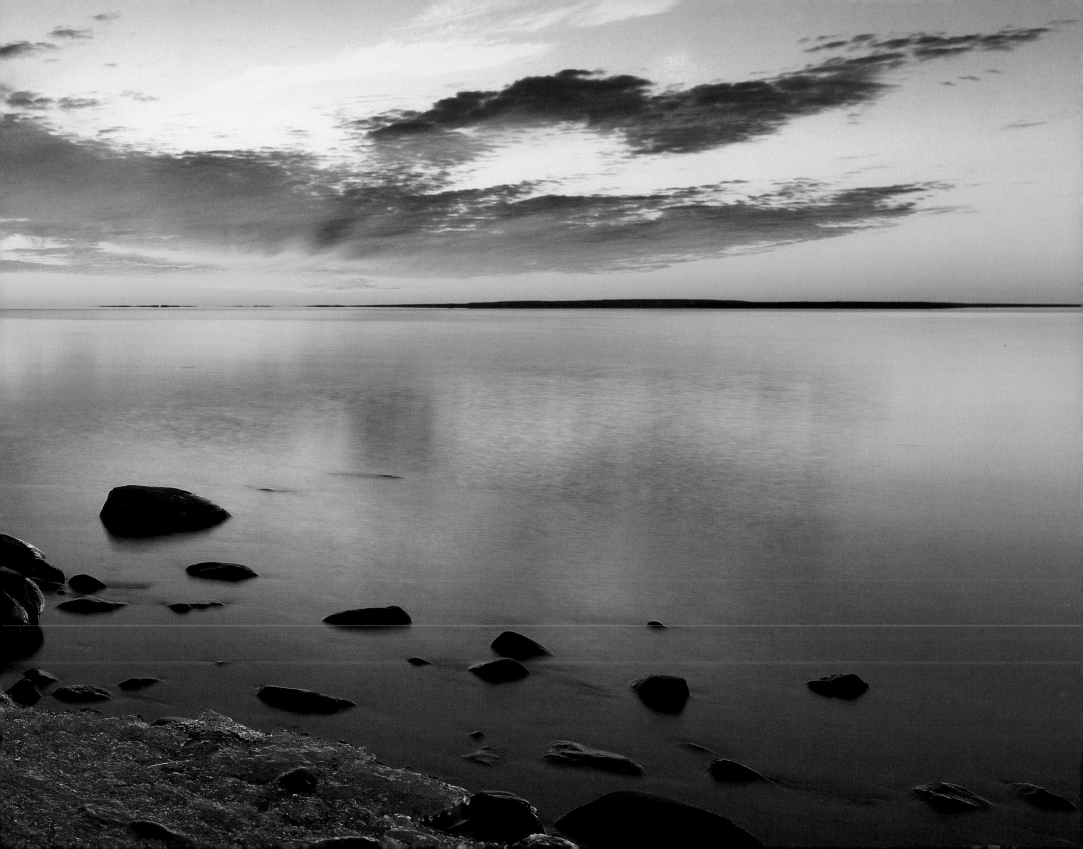

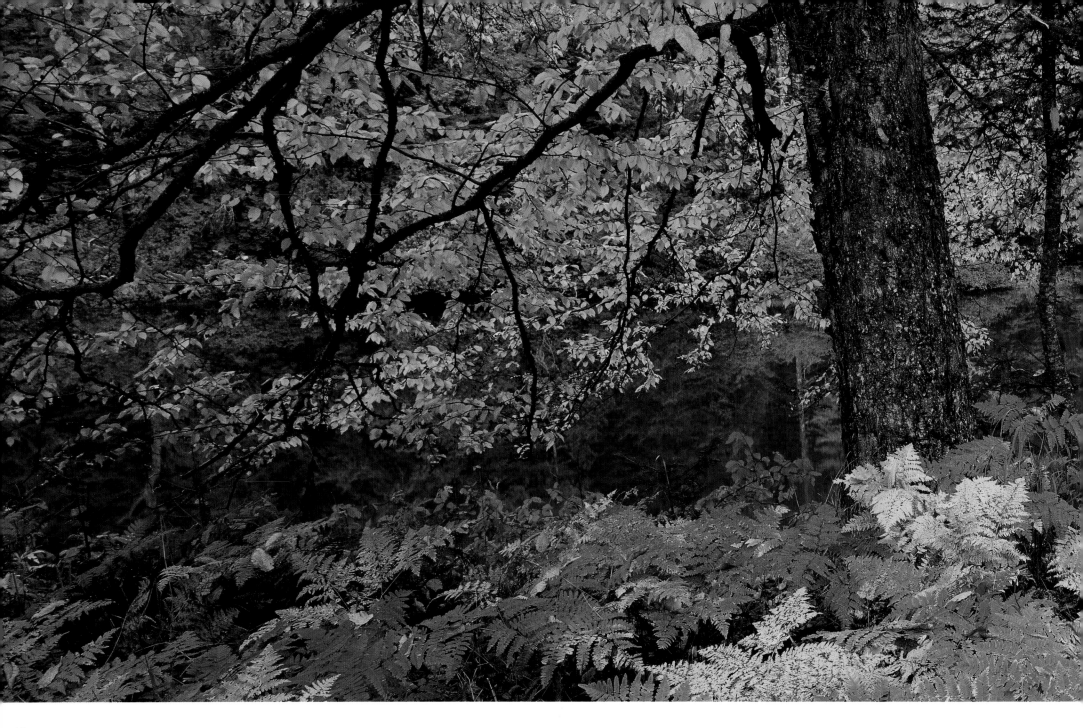

previous page: Lake Superior, **MICHIGAN.**

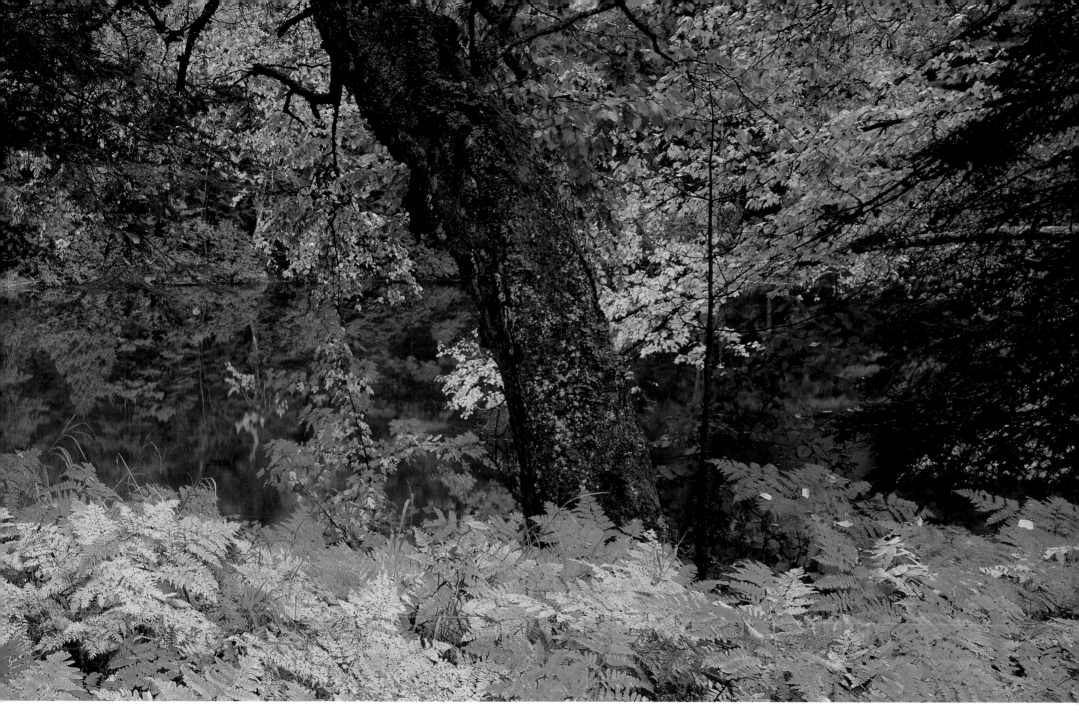

NEW HAMPSHIRE

Tranquil reflections, Androscoggin River, Errol.

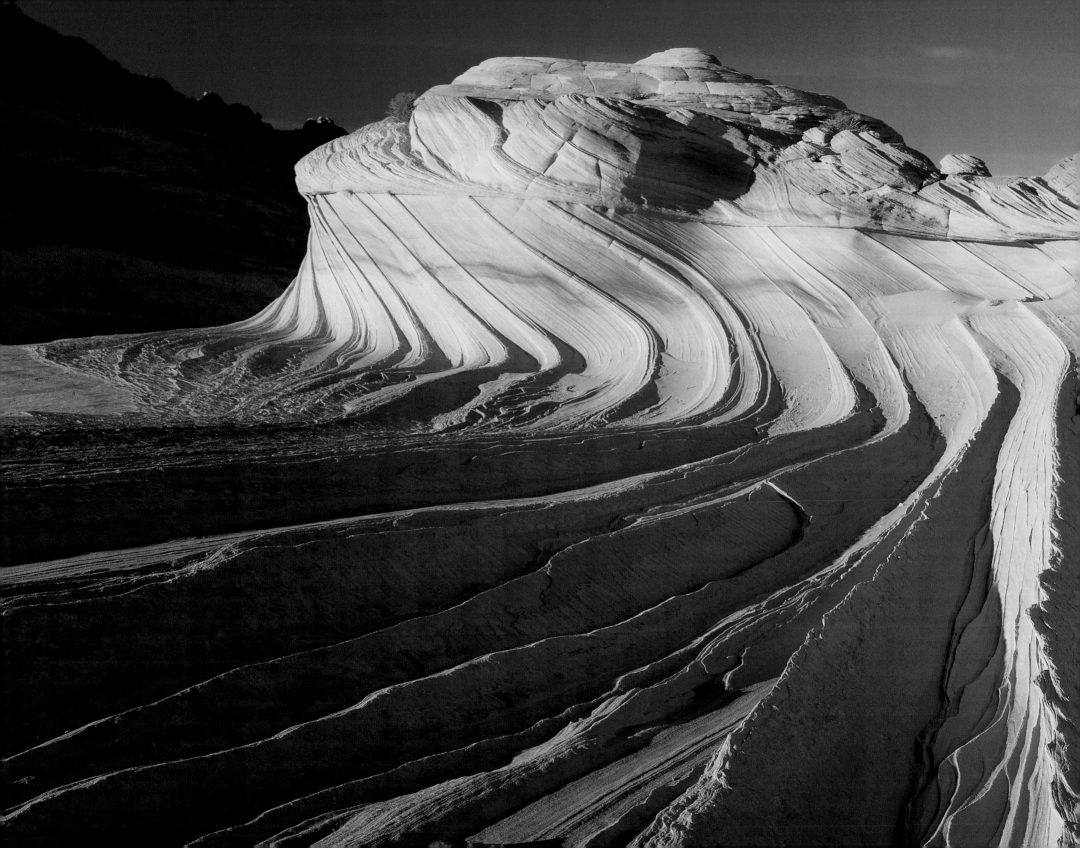

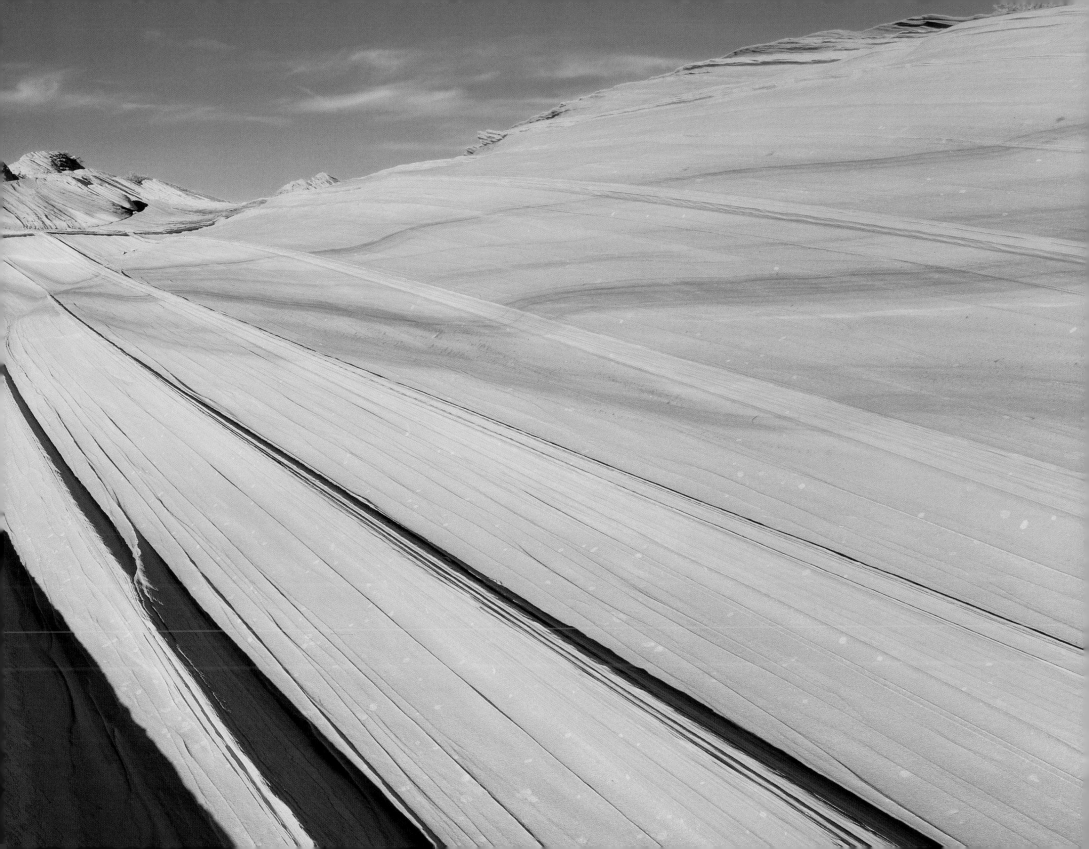

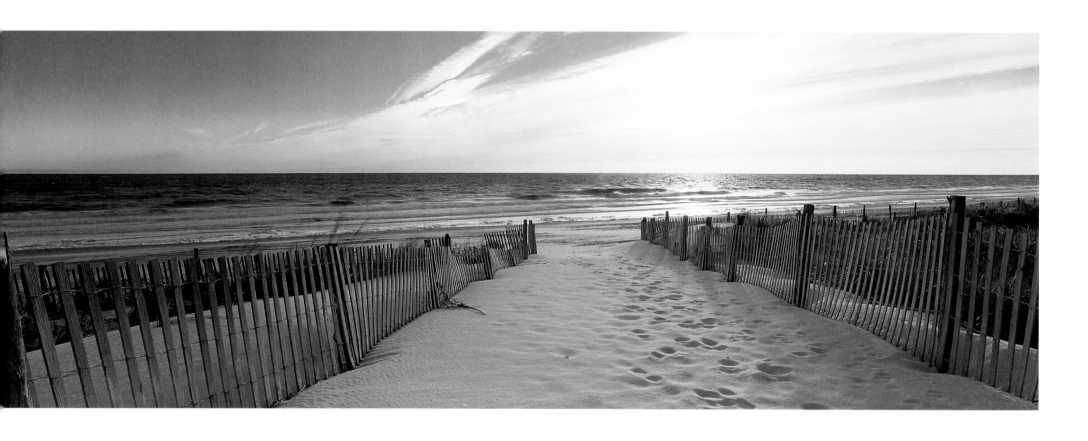

RHODE ISLAND
Newport.

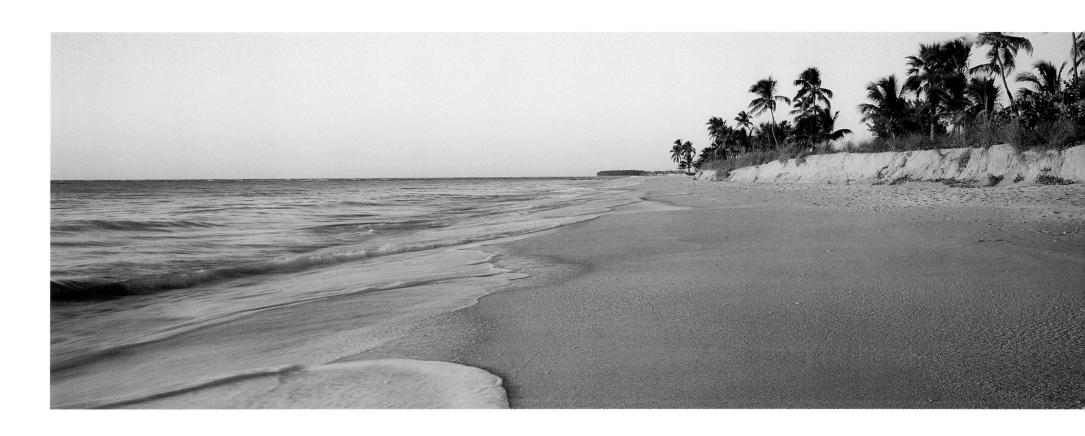

FLORIDA
Captiva Island, Gulf of Mexico.

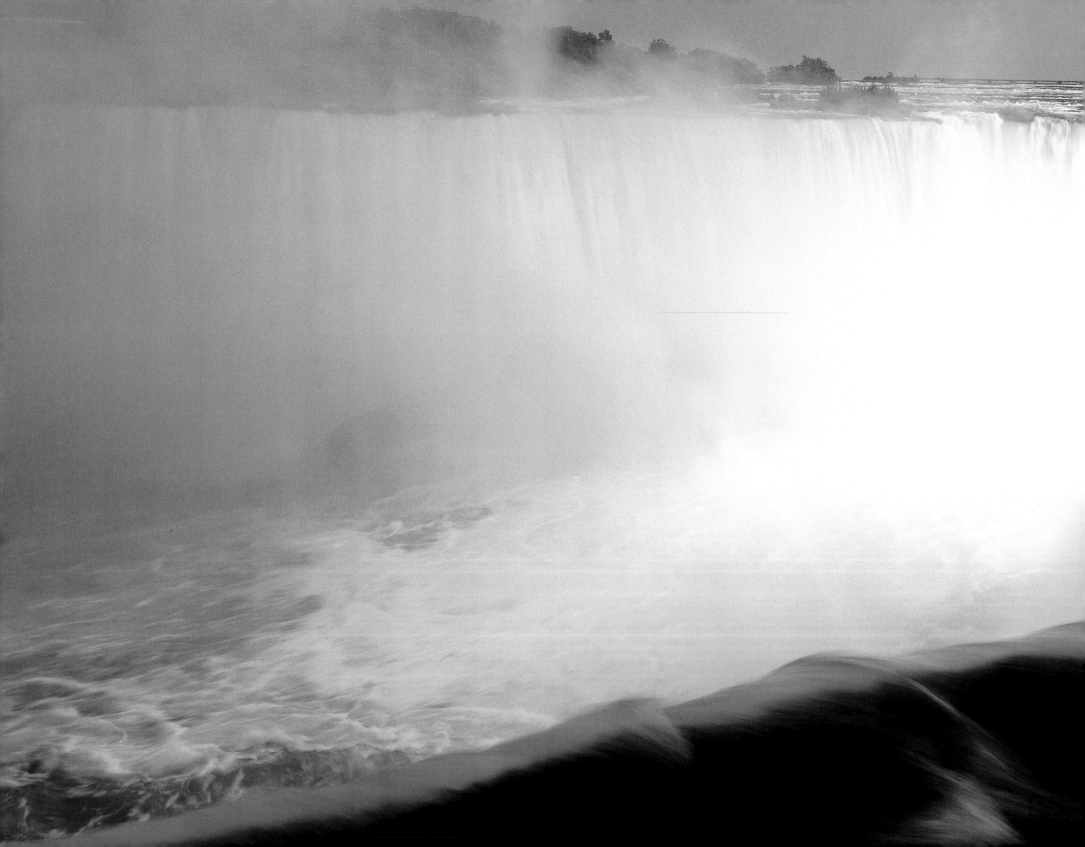

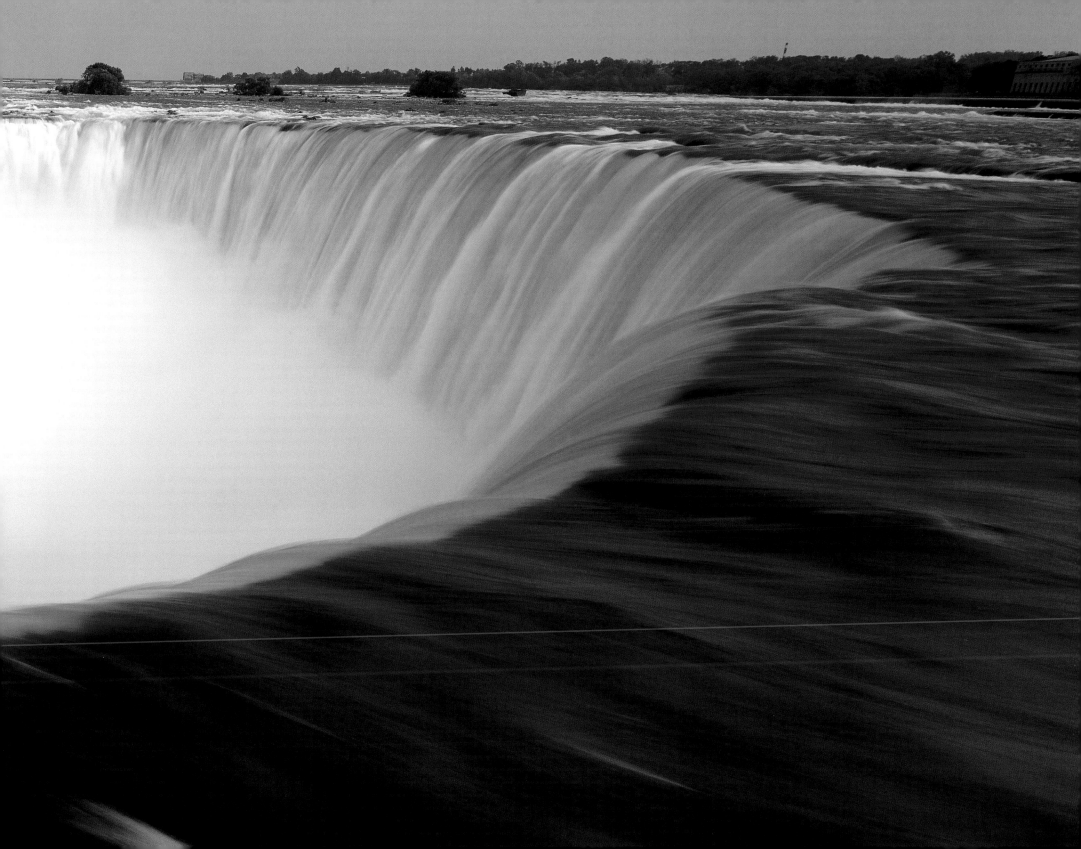

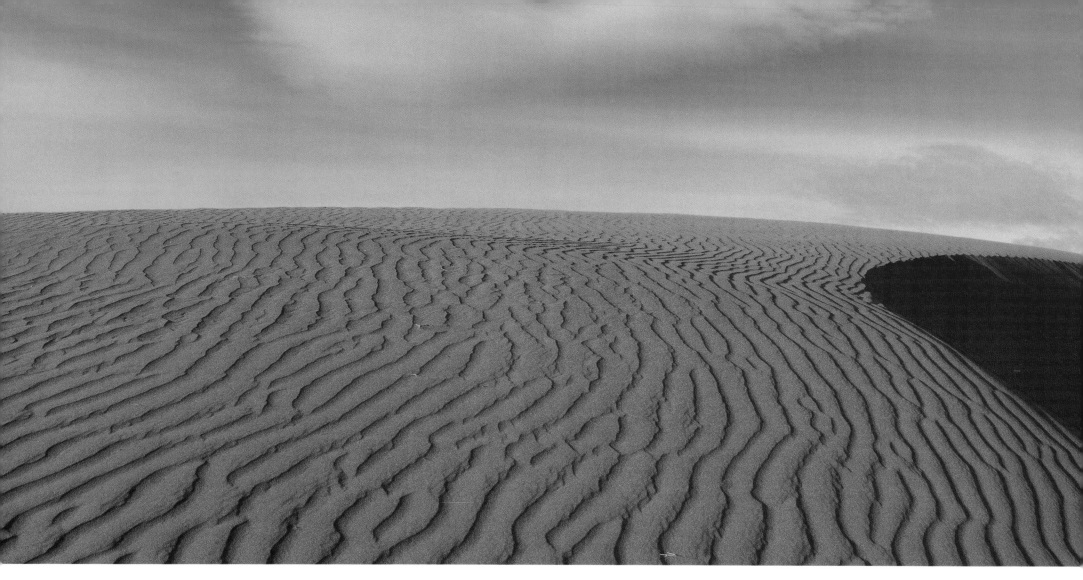

previous page: Niagara Falls State Park, **NEW YORK**.

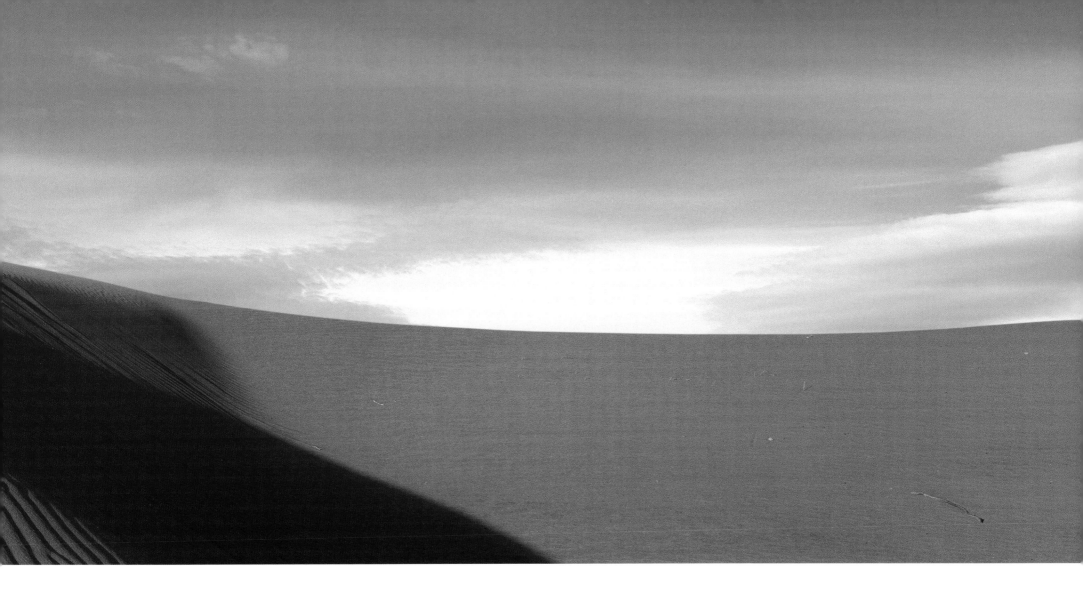

ARIZONA

Sculptured sands, Monument Valley Navajo Tribal Park.

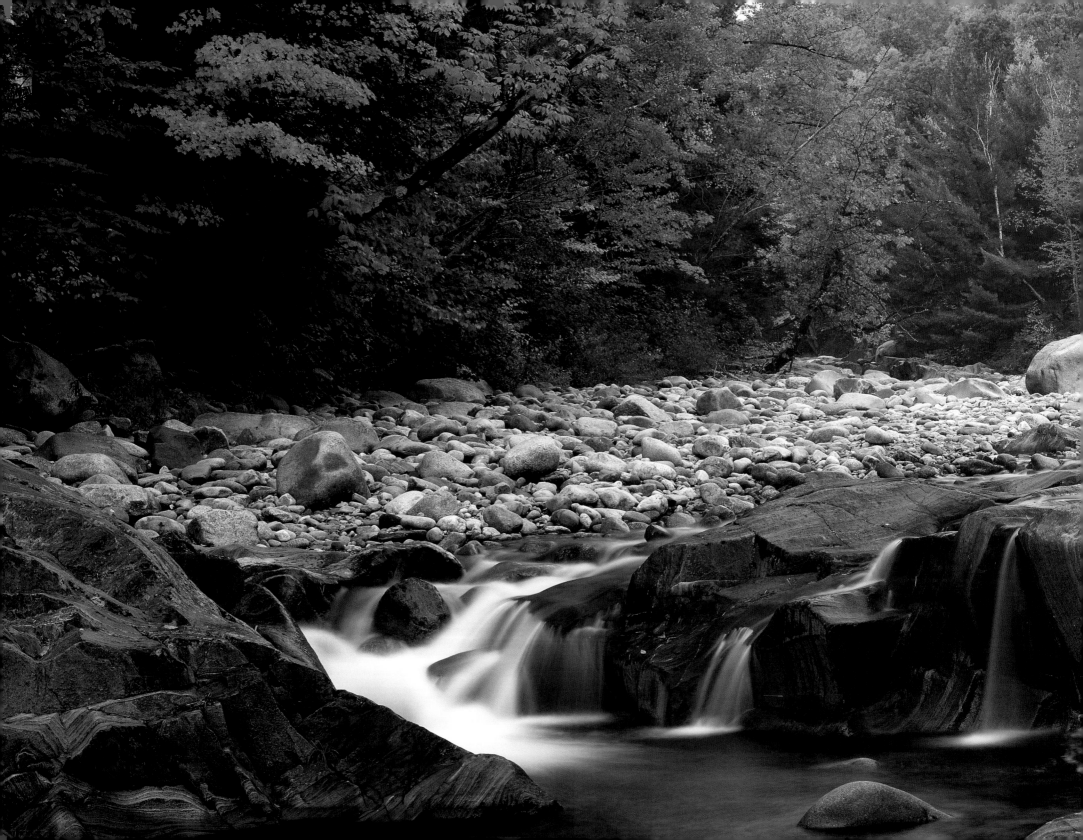

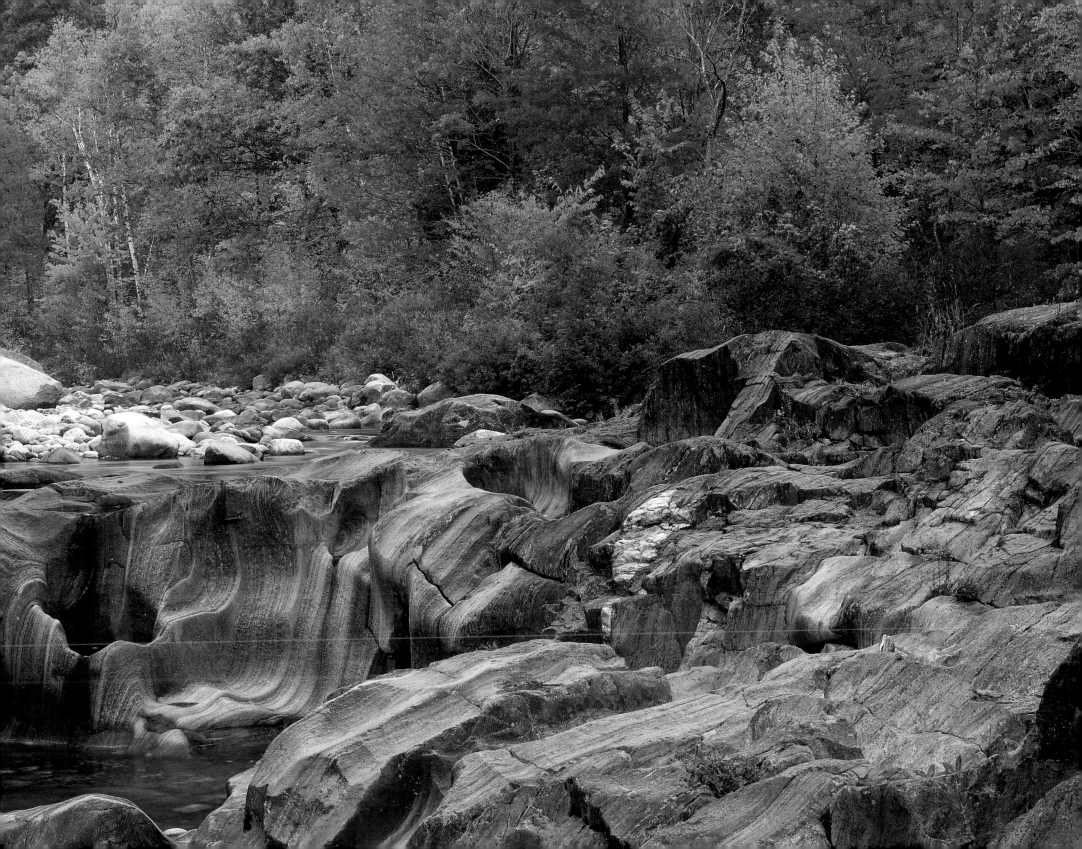

A S T A T E O F M I N D

No words can describe the silence of a sleeping desert – it's a stillness unlike any other. Out in the burnt sienna heart of America, I felt that even breathing might disturb the ancient spirits of the land. There is a real sense of separation from the outside world and at times in the immense wilderness it was easy to believe I was the last man on earth. Wide-open spaces absent of identifying landmarks, insane expanses of sculptured dunes and billowing waves of solid sandstone - it's a land of extremes. Depending on the season, shifting sands can erase the comforting sight of your footprints in minutes or they can remain etched and frozen for months. Shadows lengthen and move throughout the day, and the harsh desert sun highlights every contour and texture of the landscape.

In the rich ochre environment of the canyonlands, shooting became not so much about the colour but the composition. Over thousands of years rushing water has carved the sandstone slot canyons into an

architectural maze of confusing angles and blind corners. I returned over and over to Antelope Canyon, watching how the unpredictable light could alter the scene. It was fascinating - shards of sunlight spilt through the cracks from the surface above and reflected onto the sculptural planes. I shot hundreds of frames capturing every mood of this secret, spiritual place.

For all its strength and imposing façade, the raw and primitive landscape of the interior can be an incredibly fragile environment. In some parts of the Paria Plateau, the time-worn sandstone is so delicate and brittle it crumbles to the touch. These regions are administered as National Parks and Monuments and with care they can be preserved and their spirit protected. They are the places I love to shoot alone - it's an incredibly intimate process. I go into a zone of pure concentration and really listen to the land as it speaks to me. With every angle and every composition I discover a new secret – I feel the wilderness and shoot from my heart.

previous page: Swift River, Roxbury, **MAINE**.

overleaf: Portland Head Lighthouse, **MAINE**.

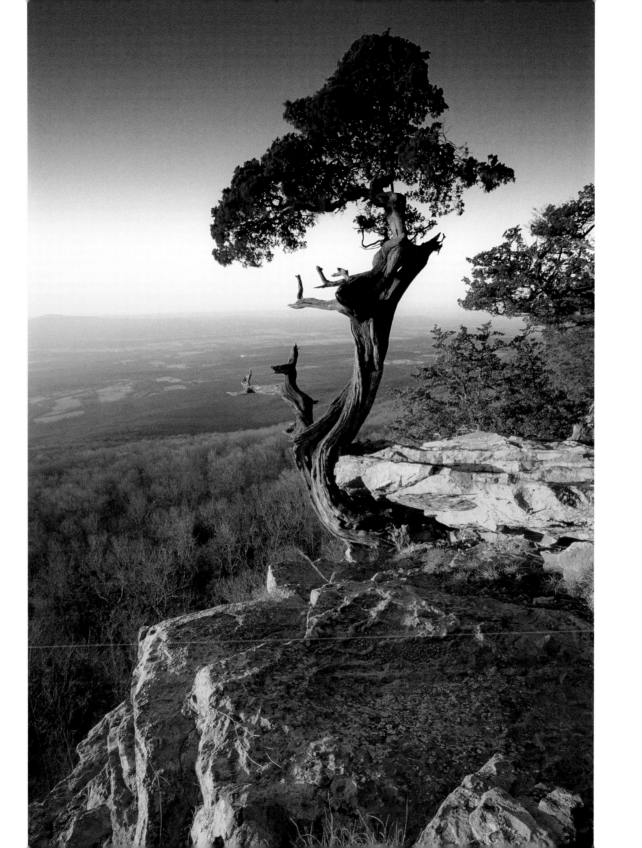

ARKANSAS

Mount Magazine.

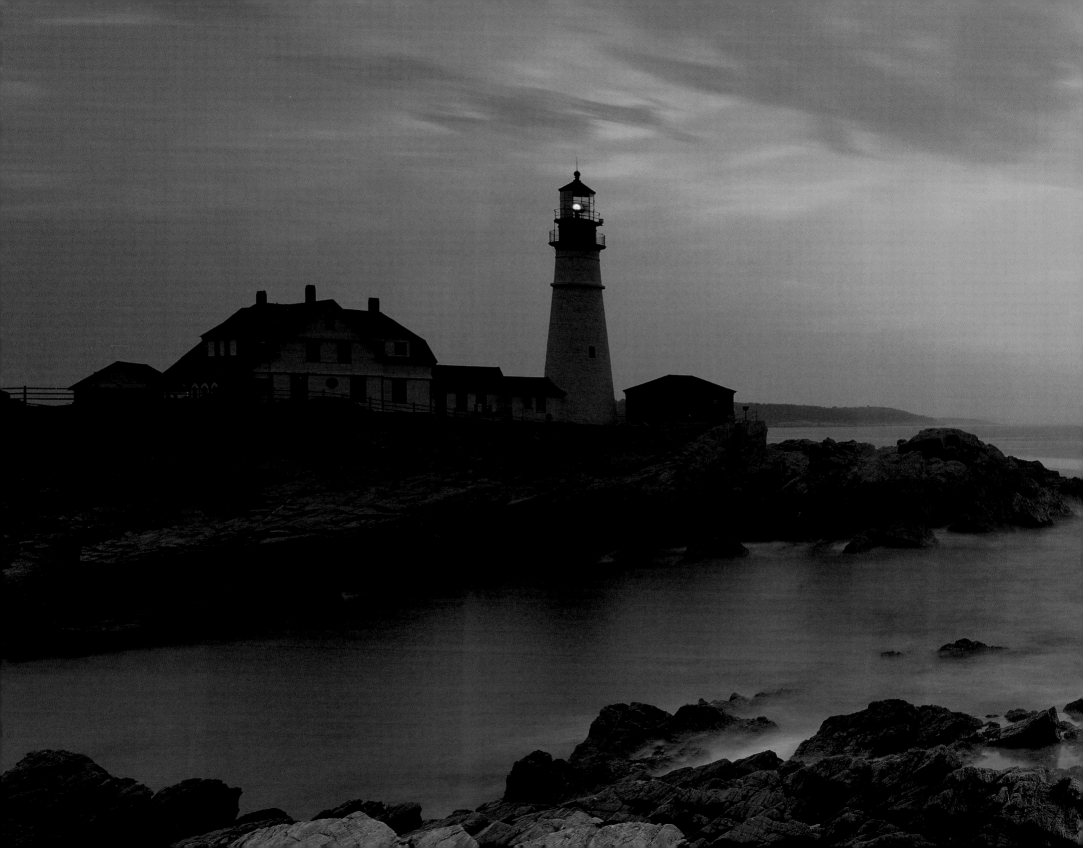

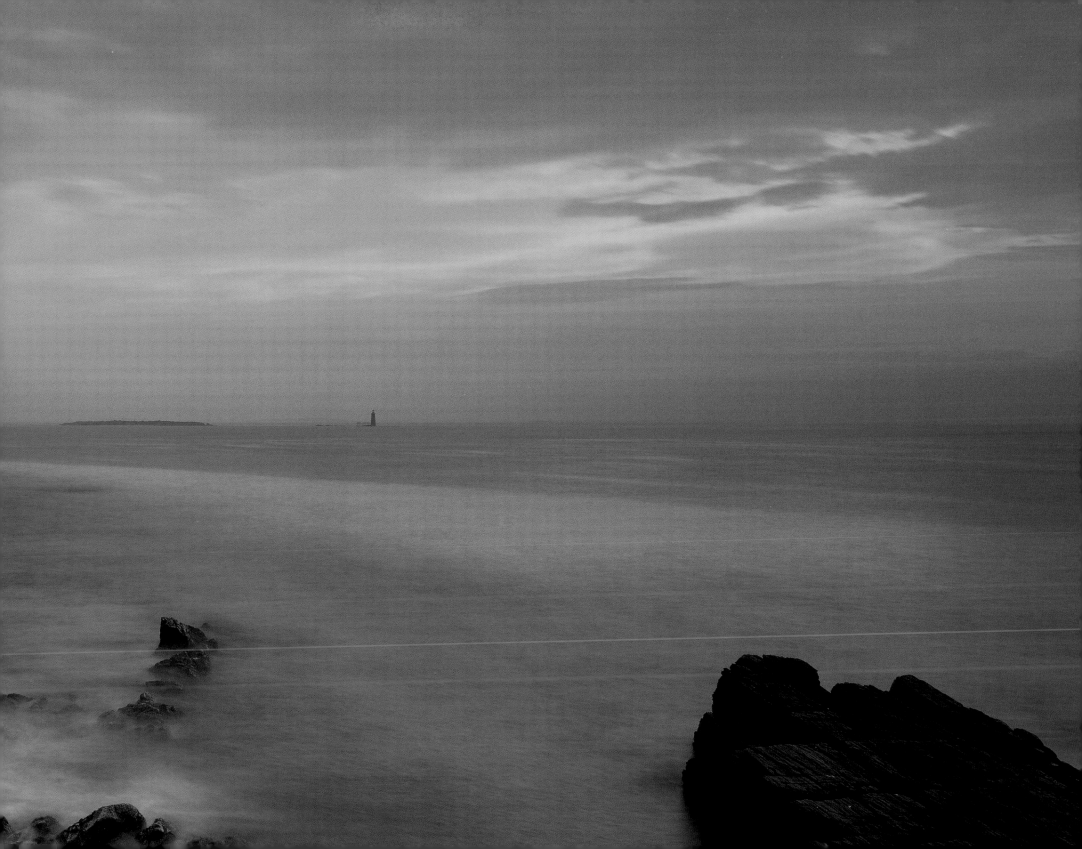

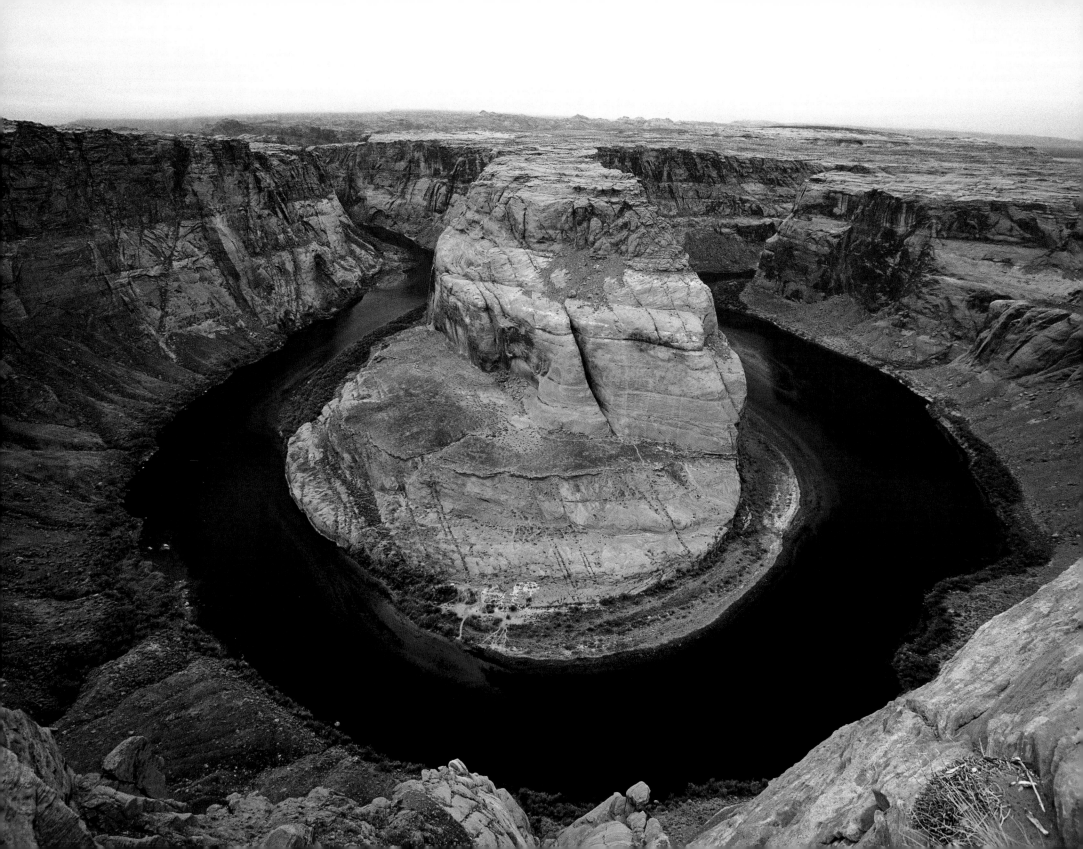

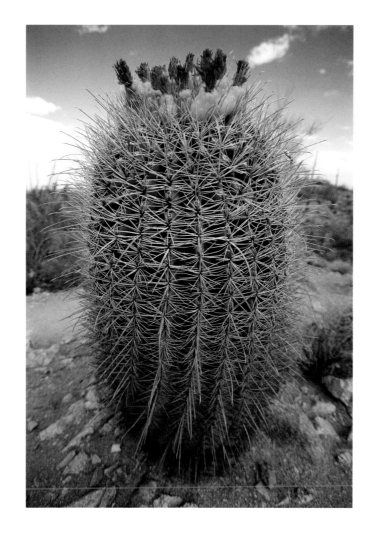

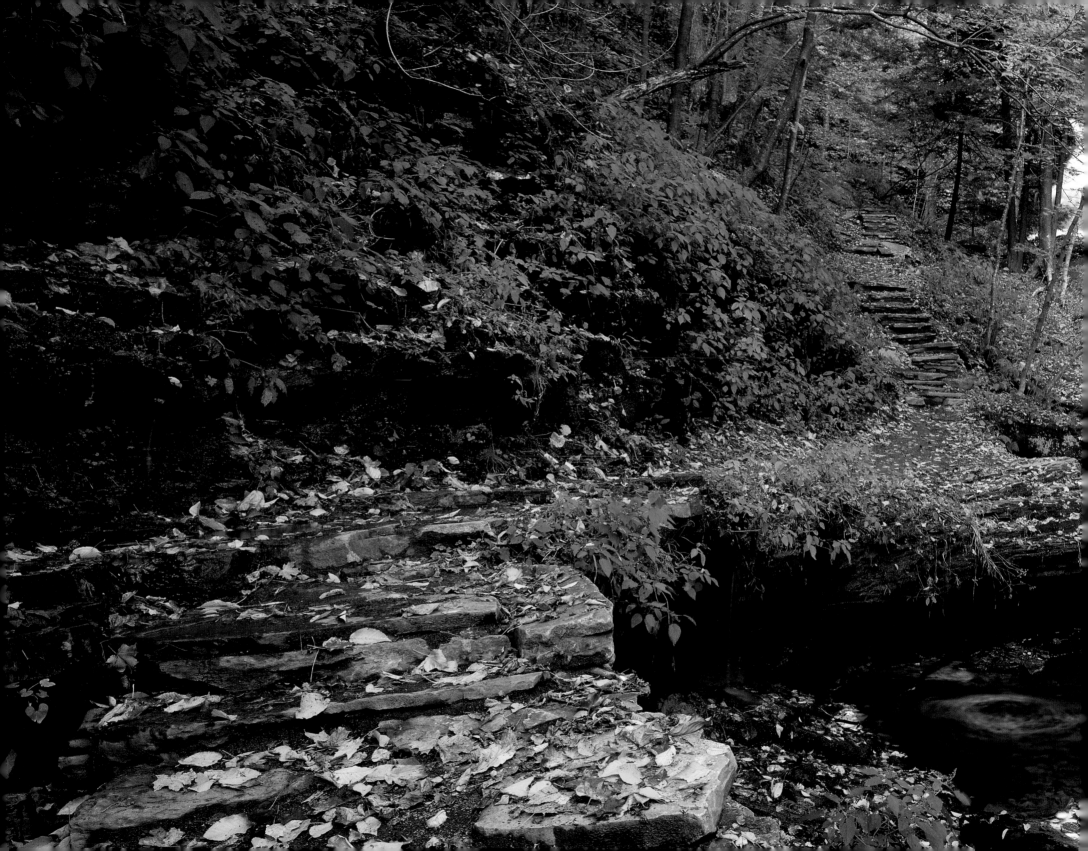

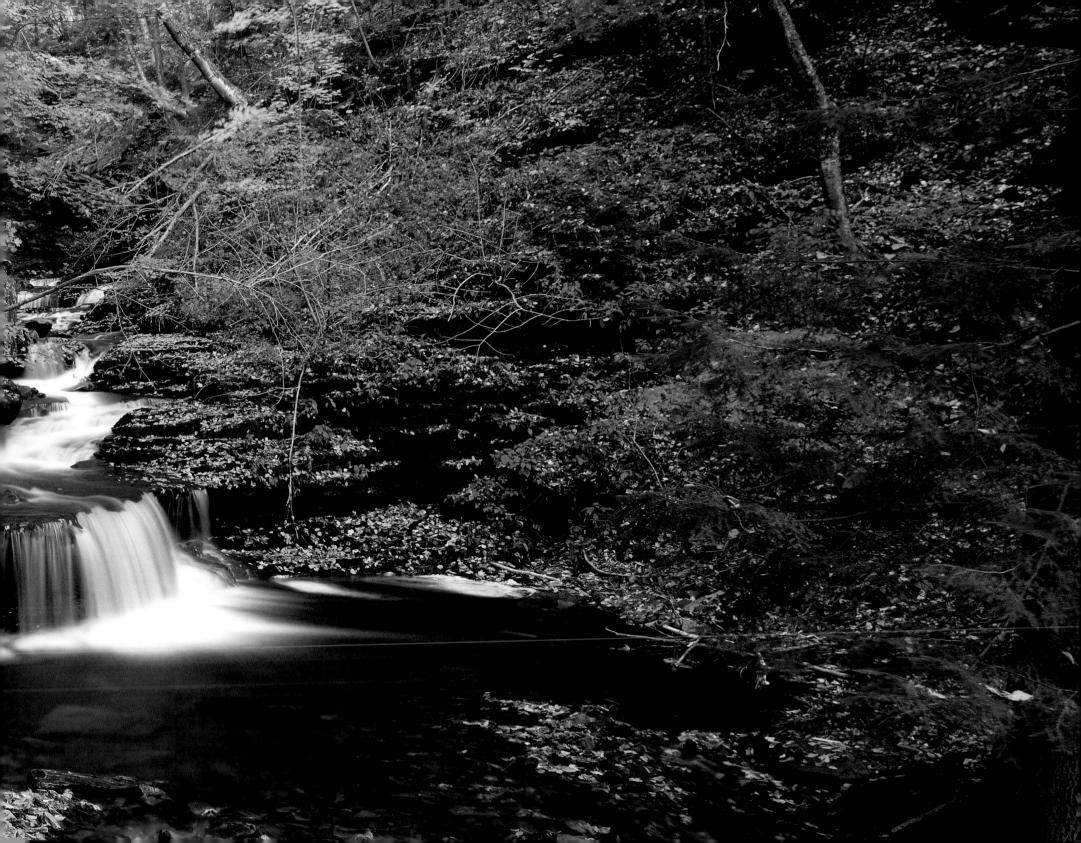

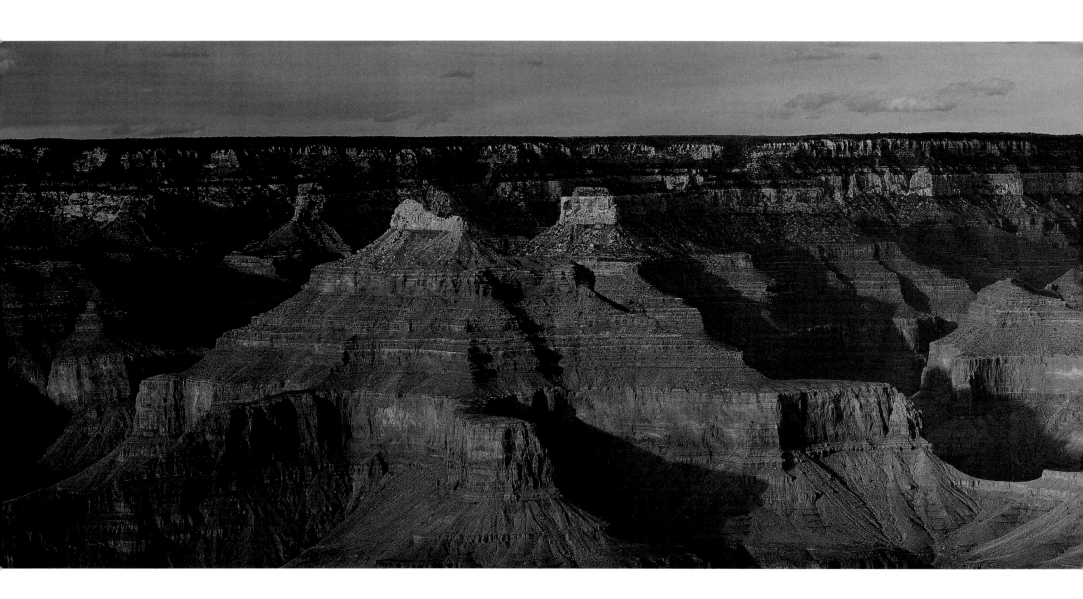

previous page: Kitchen Creek, Rickett's Glen State Park, **PENNSYLVANIA**.

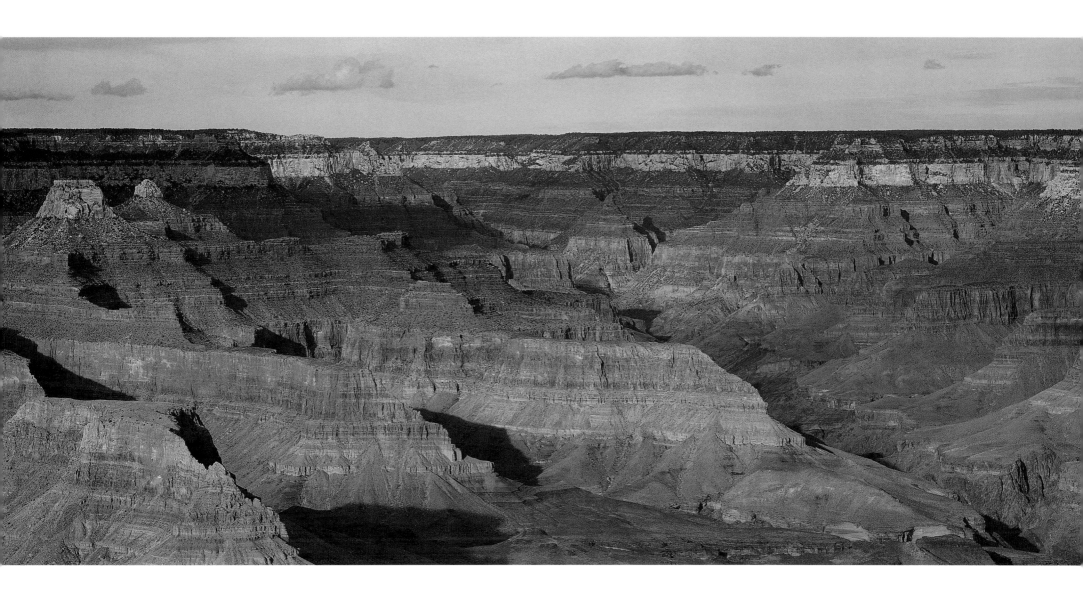

ARIZONA

Evening shadows, Hopi Point, Grand Canyon.

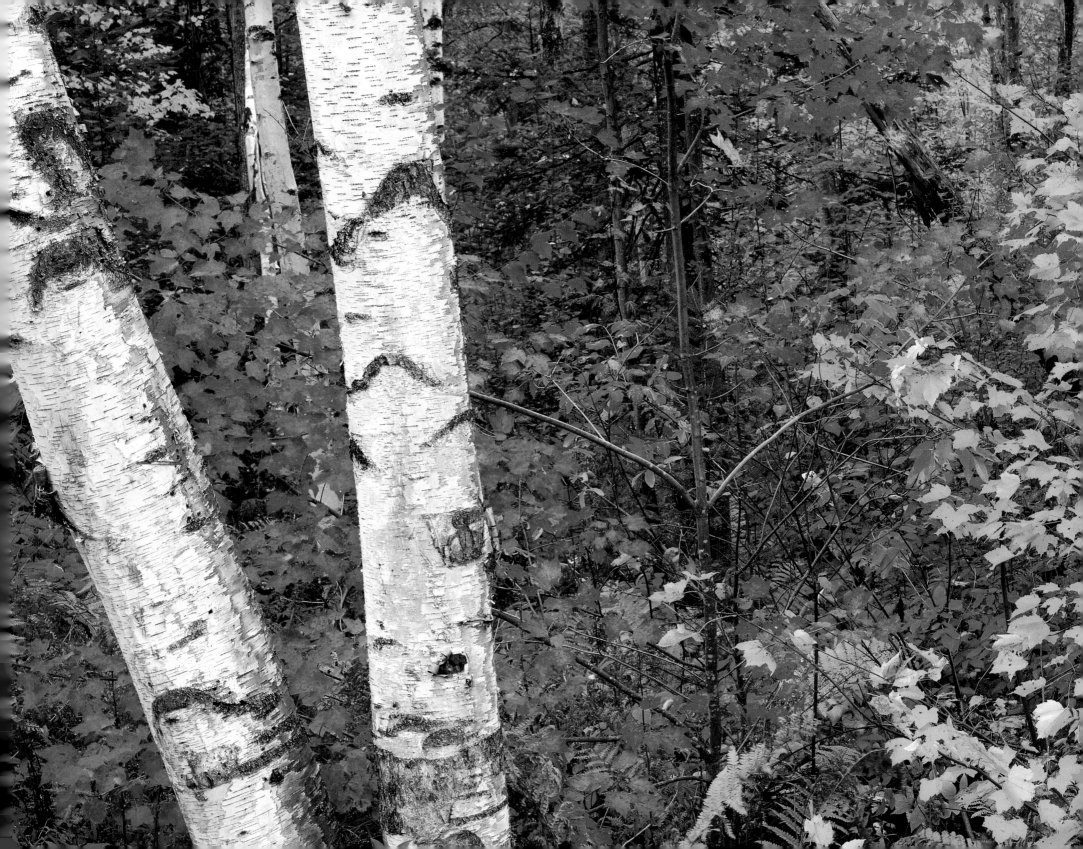

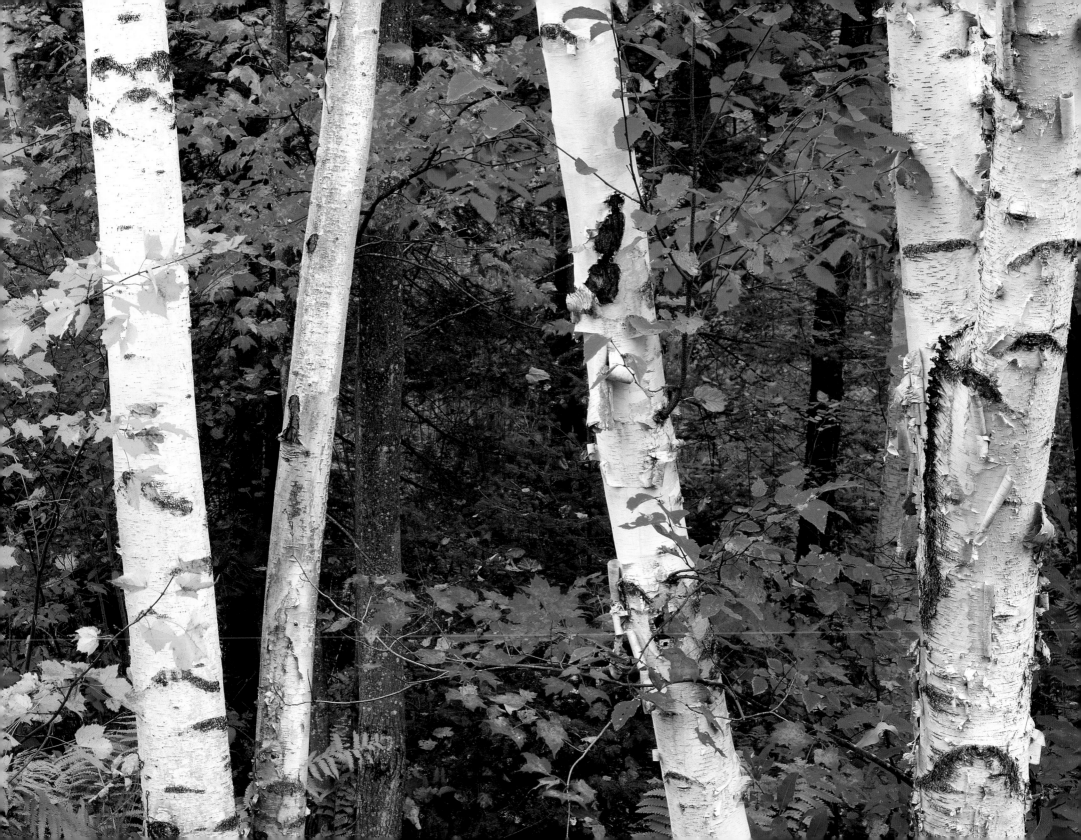

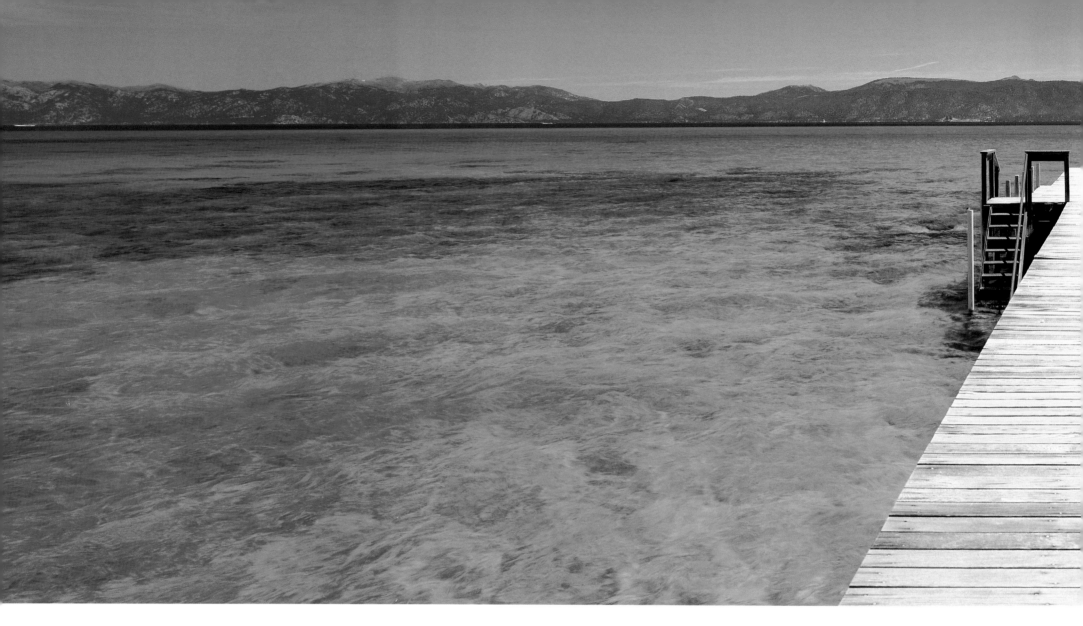

previous page: Autumn palette, **VERMONT**.

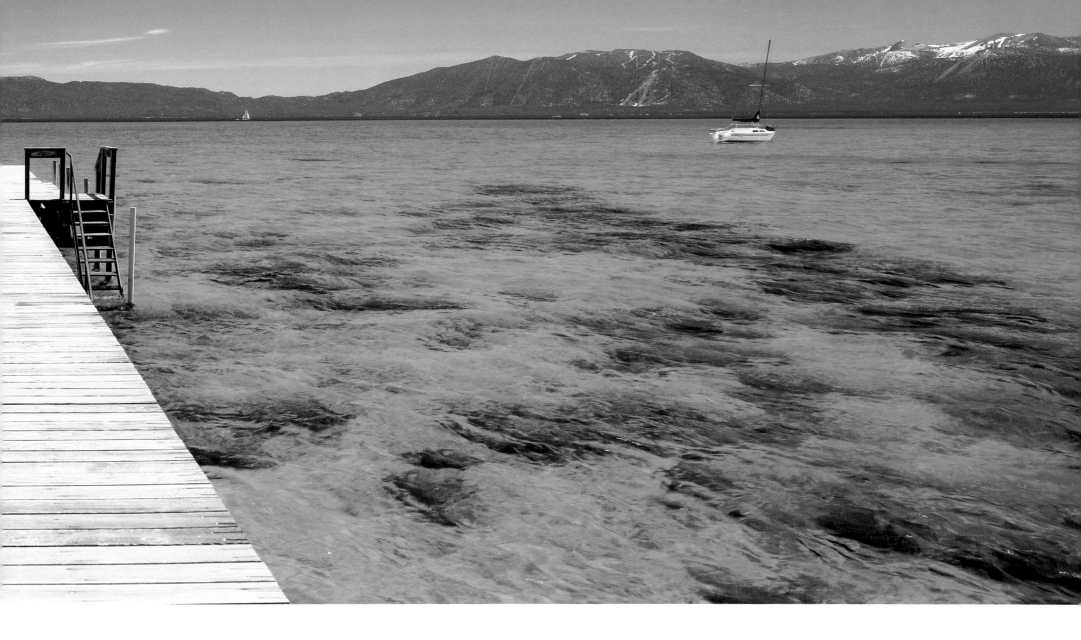

South Shore, Lake Tahoe.

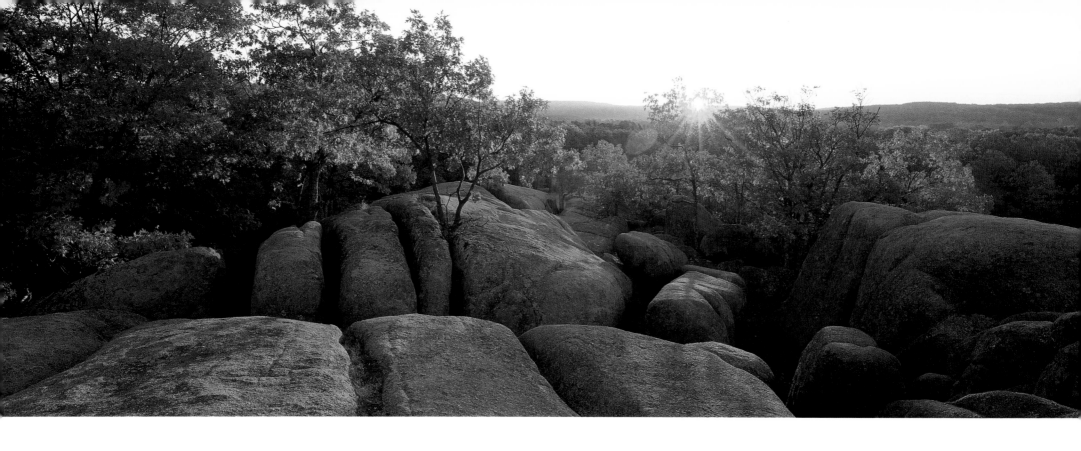

Sculptured forms etch the contours
of an enduring land - shaped by time and
preserved by nature.
I isolate a single element - a simple
silhouette or a strong shape - and nature
completes the perfect composition.
I search for the unseen and discover the
hidden strength.

42

MISSOURI Elephant Rocks.

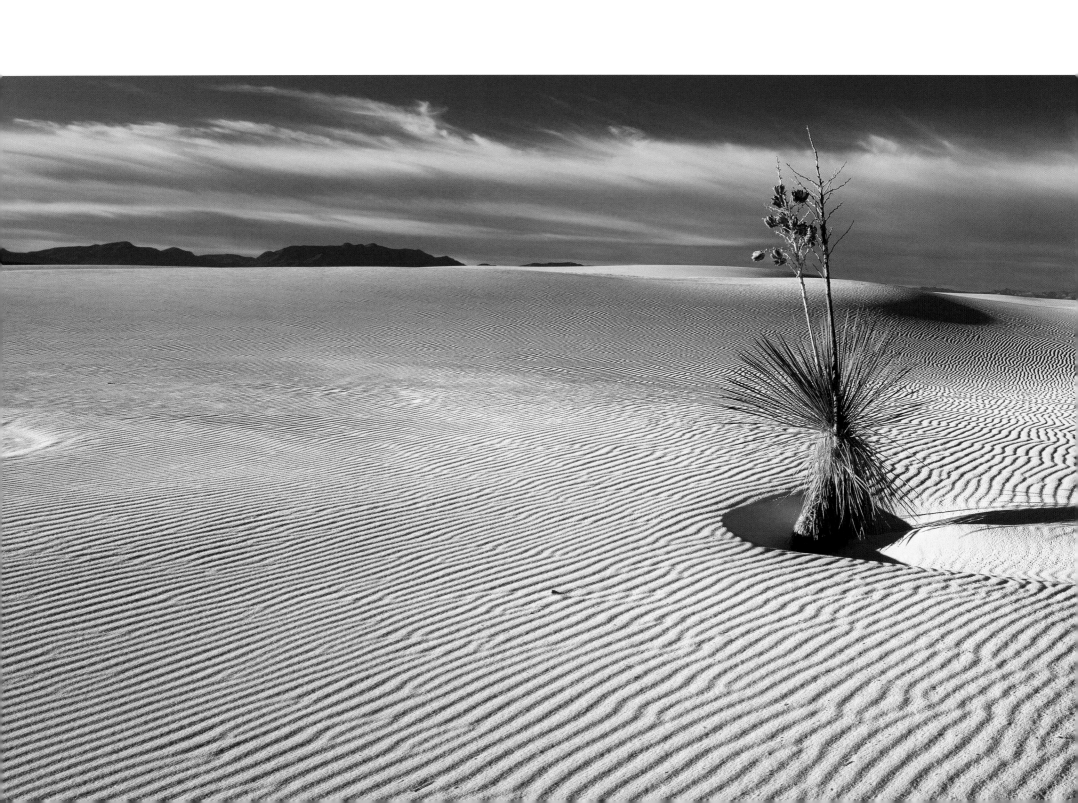

White Sands National Monument.

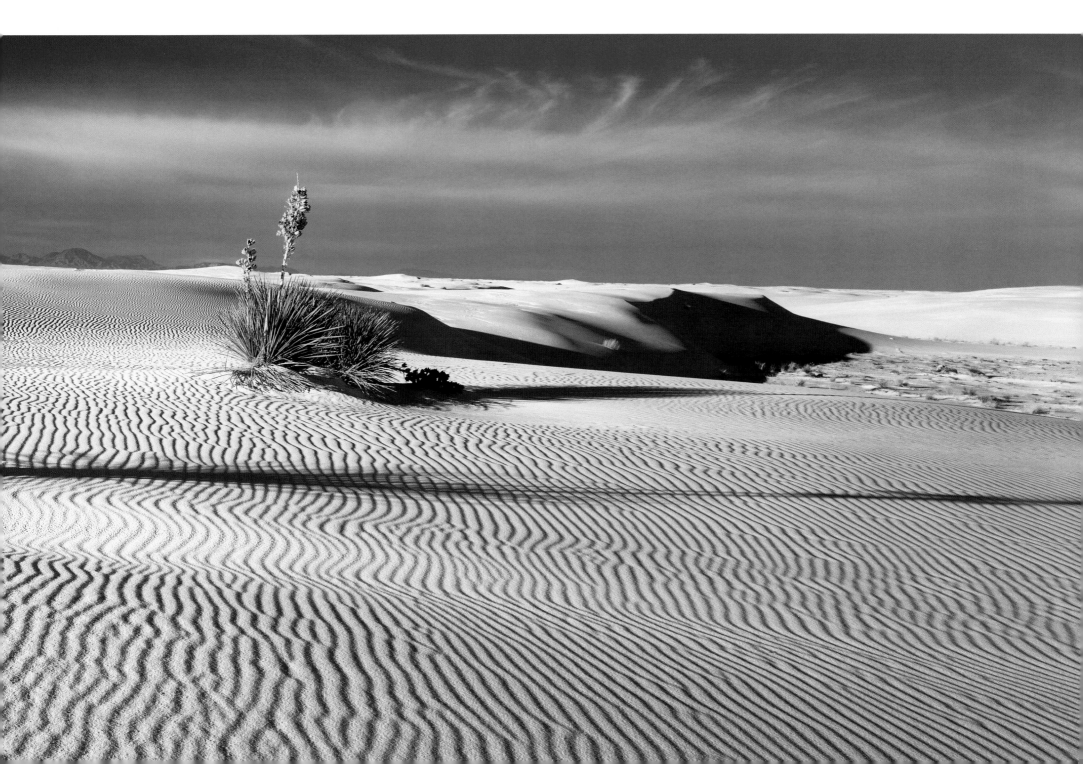

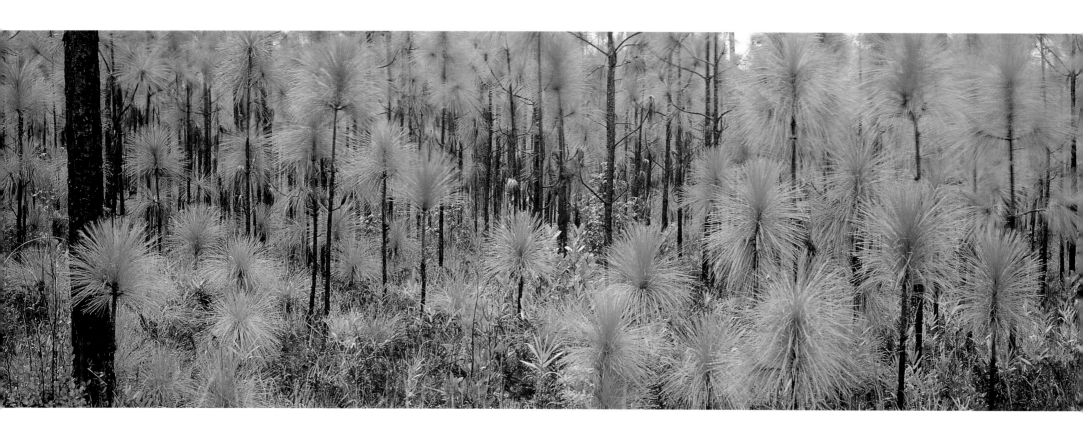

SOUTH CAROLINA
Francis Marion National Forest

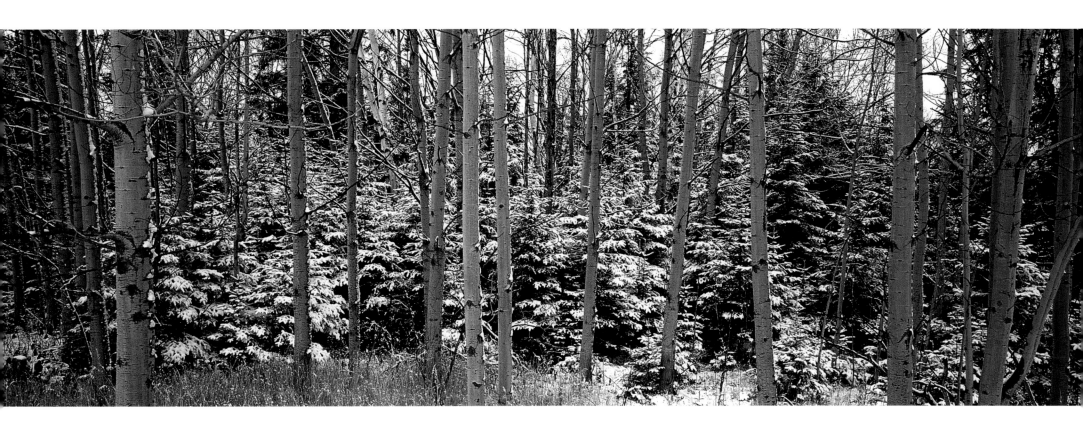

NORTH DAKOTA

Sheyenne River.

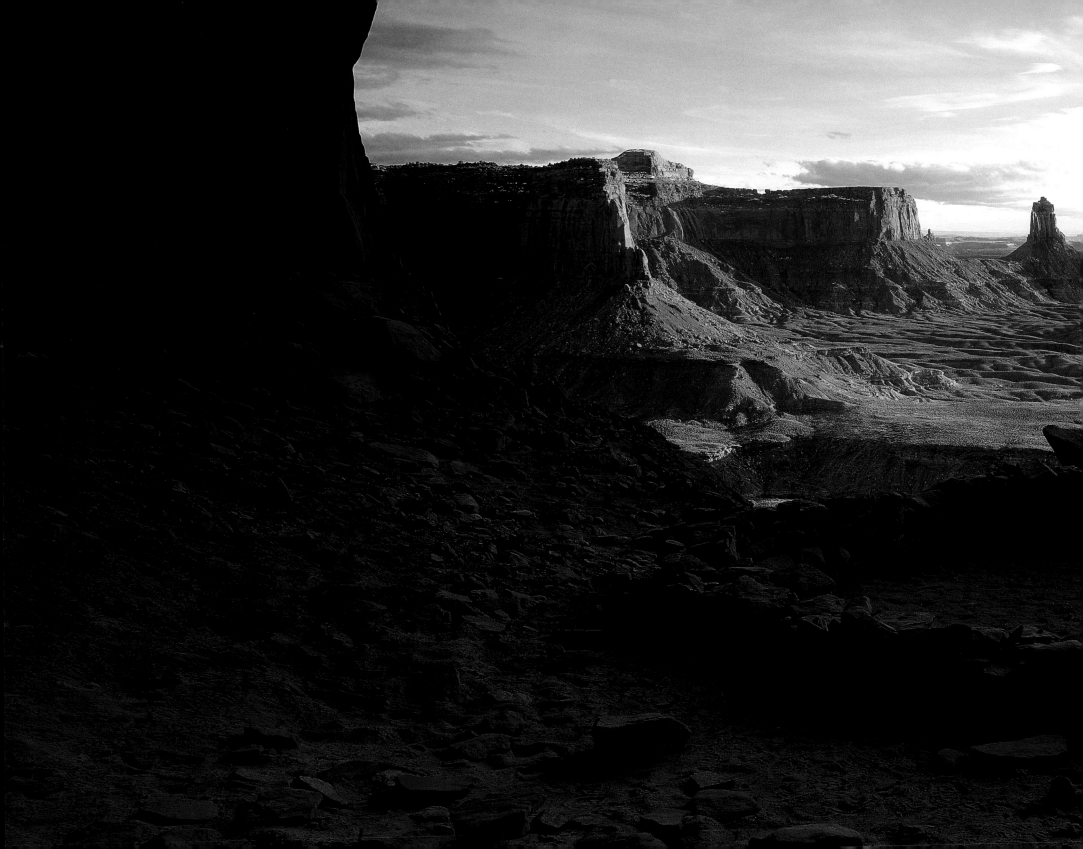

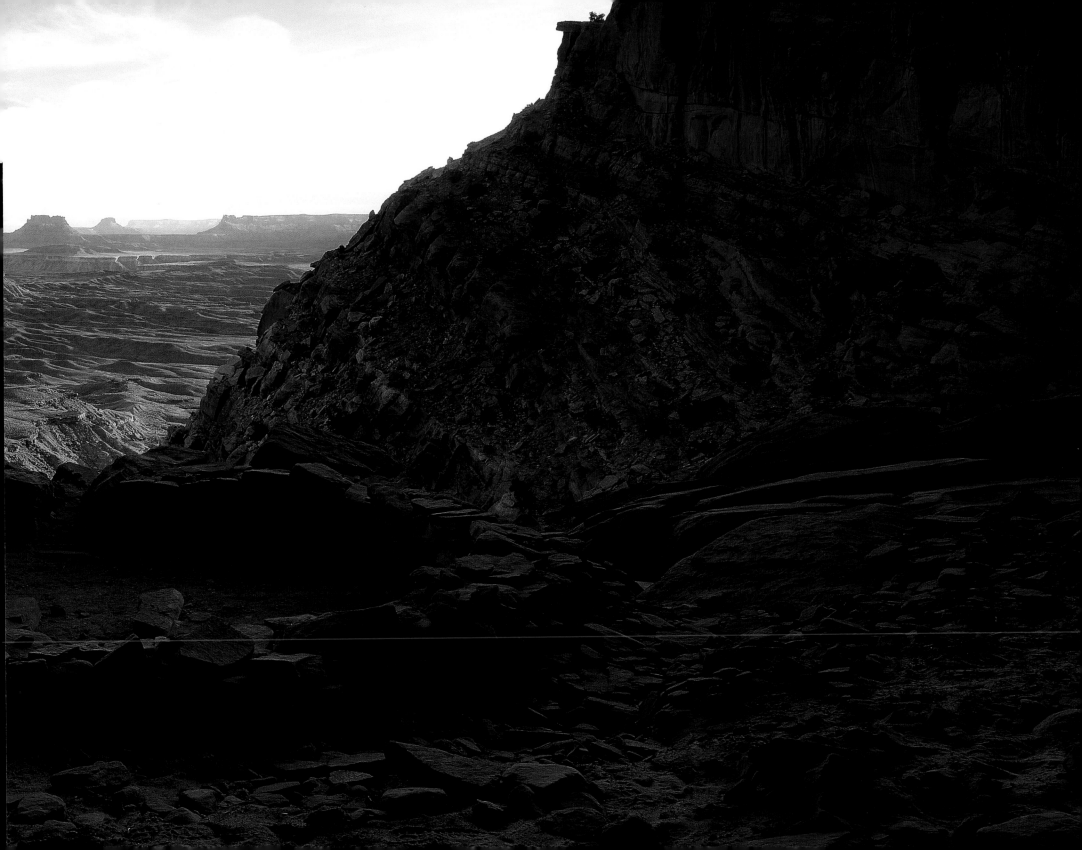

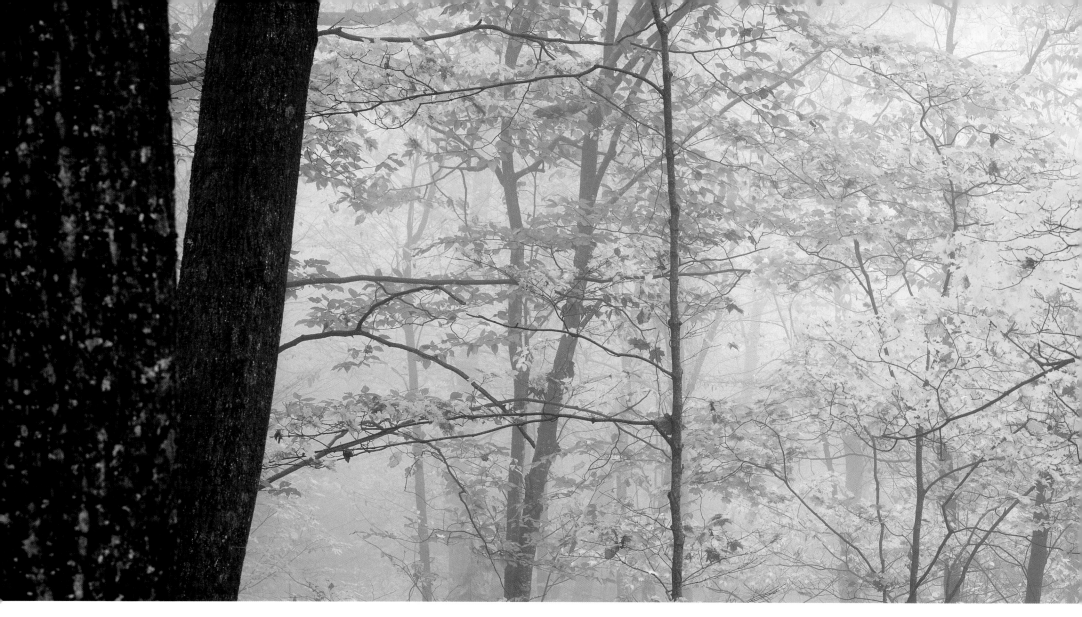

previous page: Ancient Pueblo Indian site, Canyonlands National Park, **UTAH**.

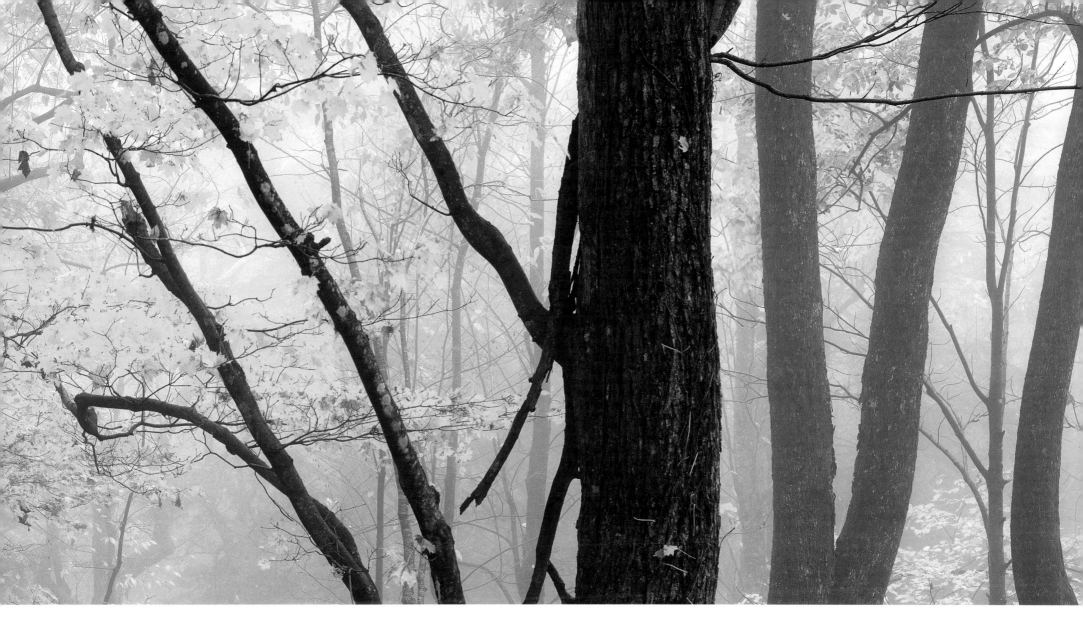

KENTUCKY

Mammoth Cave National Park.

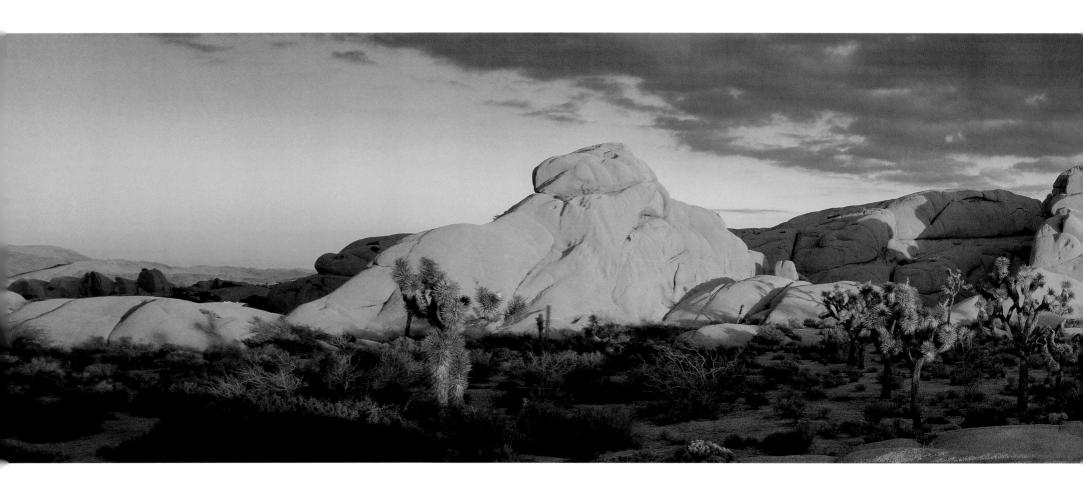

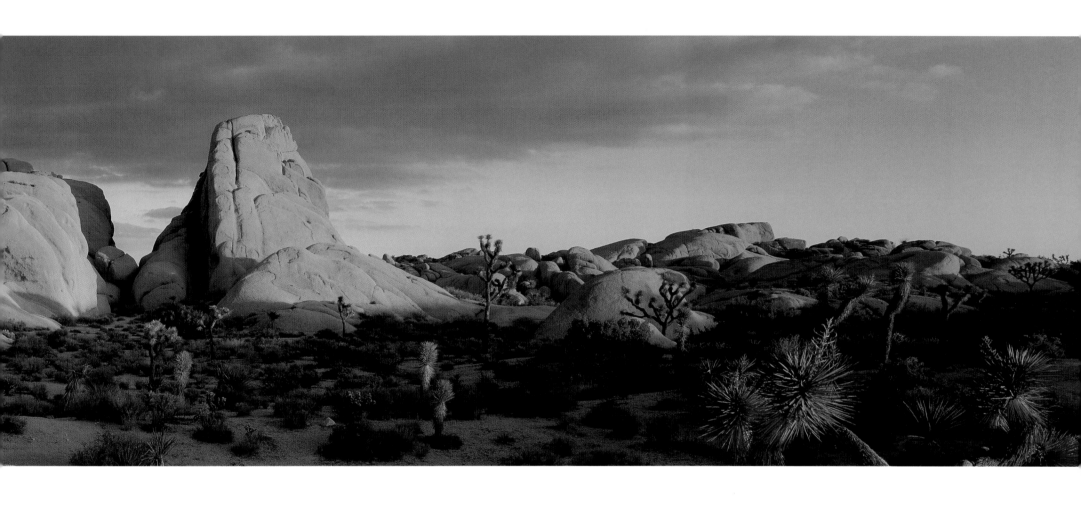

Joshua Tree National Park.

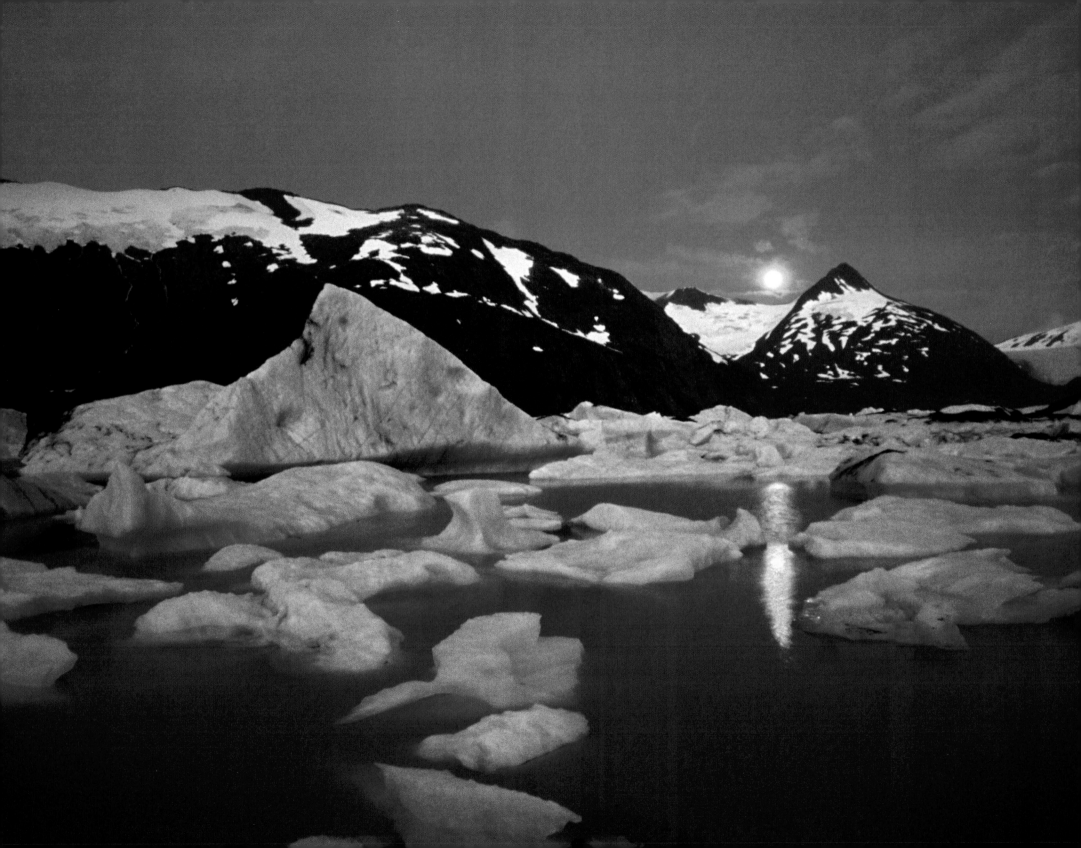

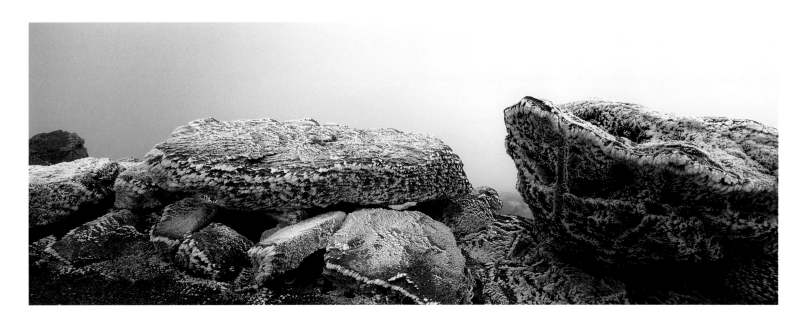

NEW HAMPSHIRE
Mount Washington State Park.

overleaf: Litchfield Hills, **CONNECTICUT**.

ALASKA
Portage Glacier under moonlight.

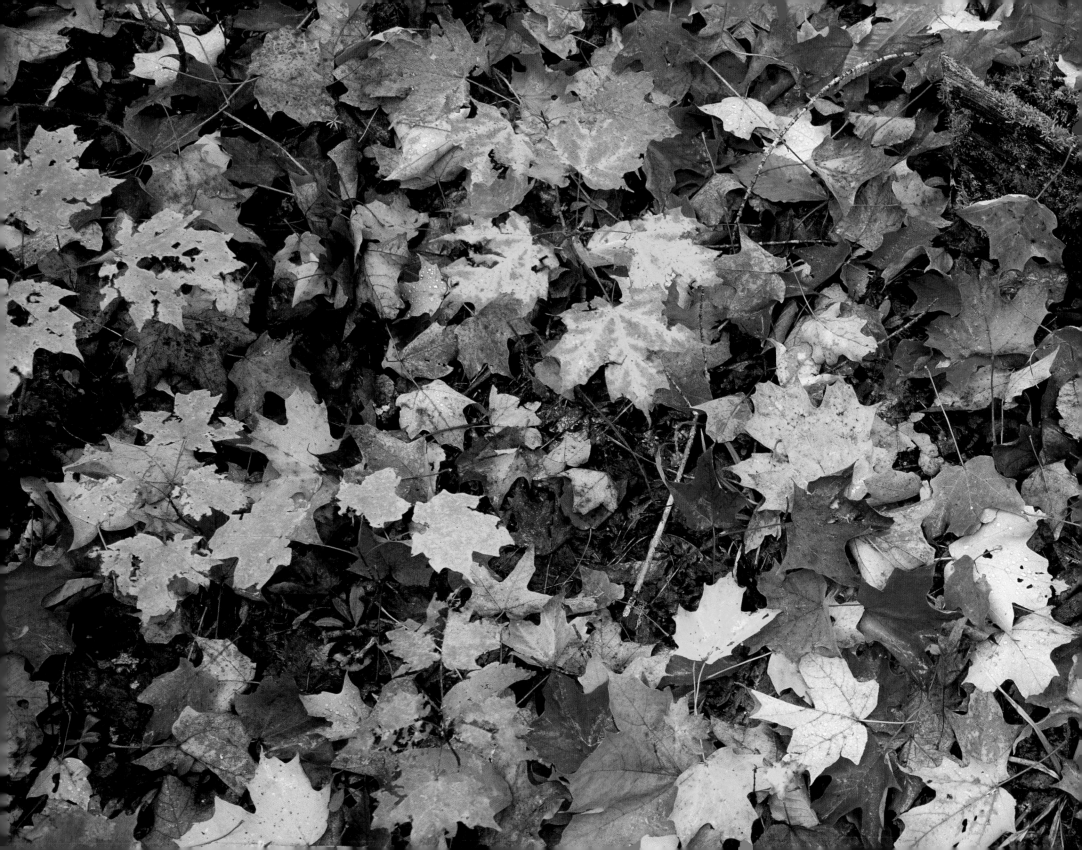

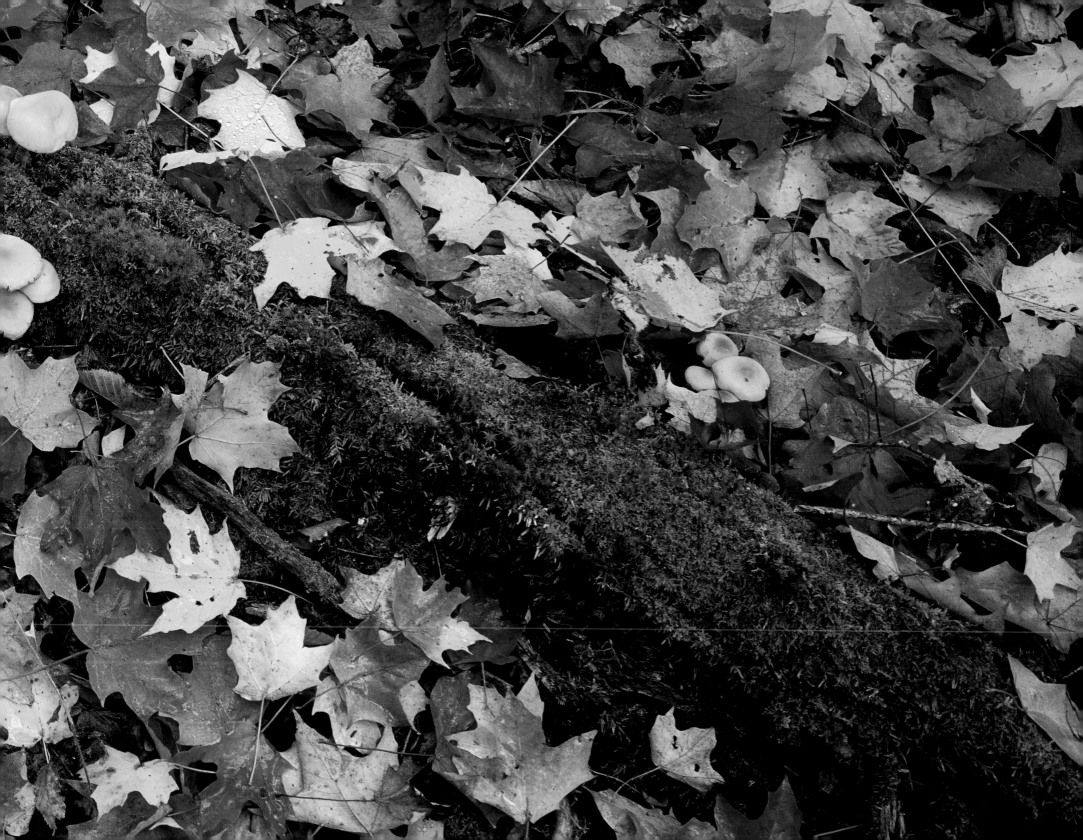

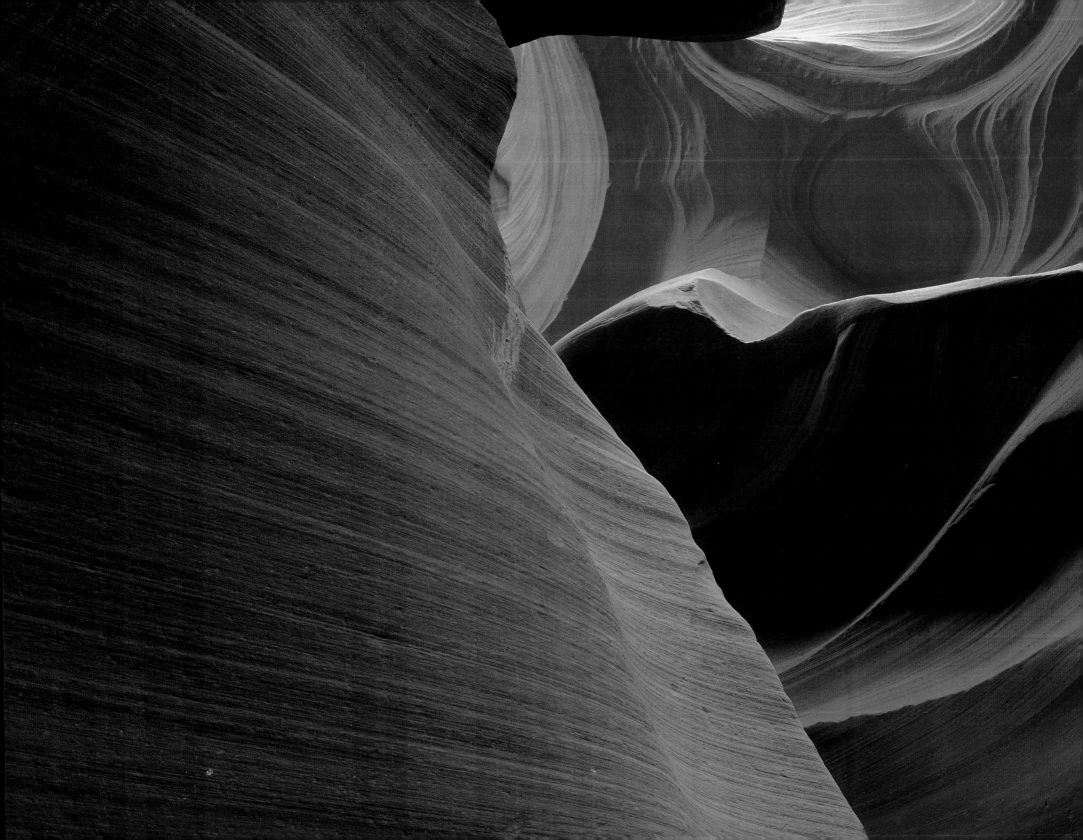

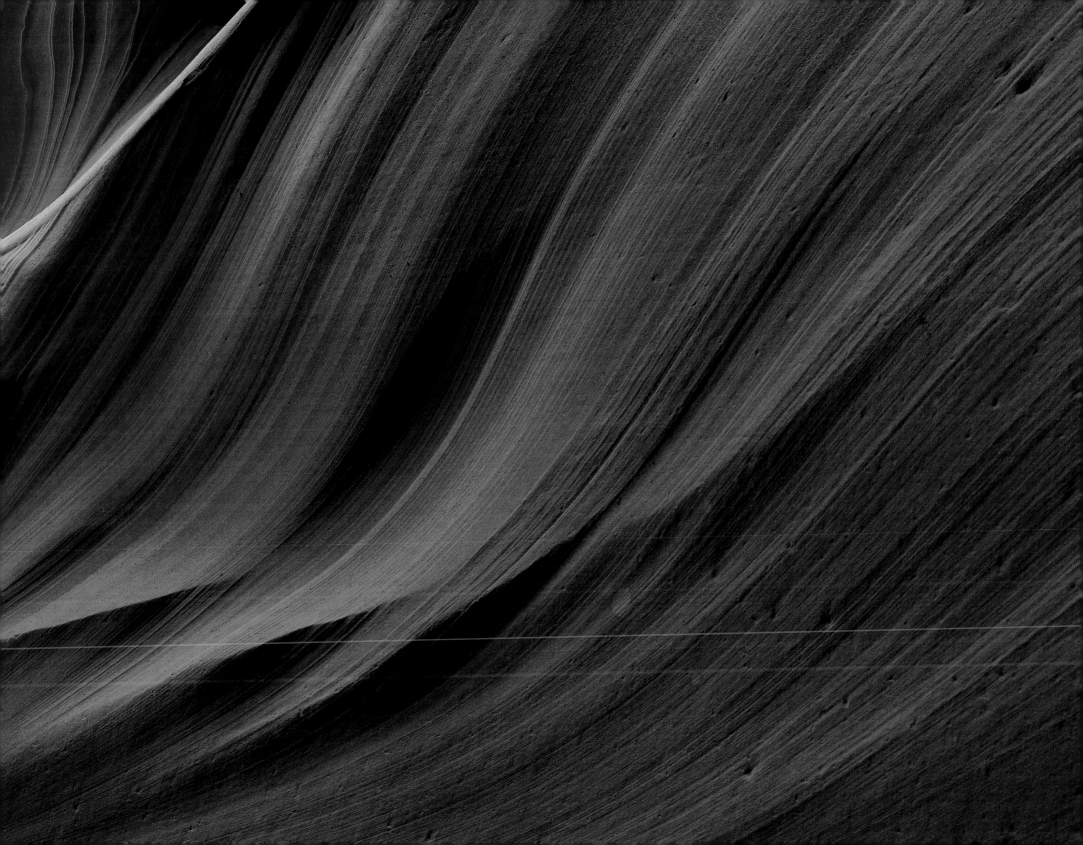

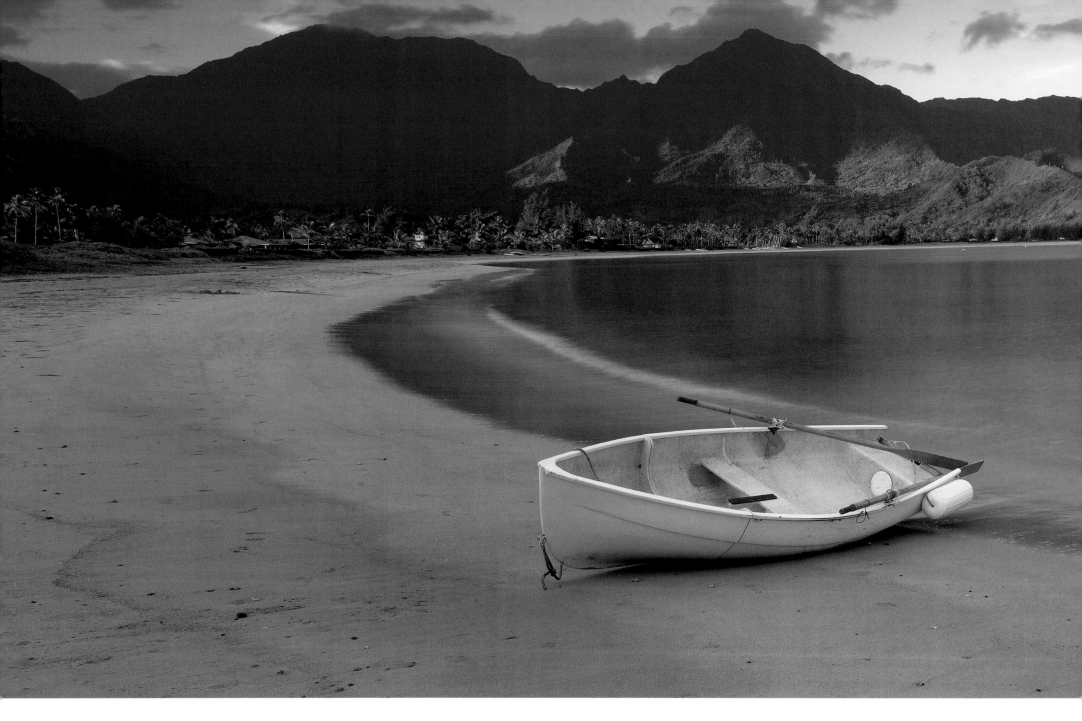

previous page: Lower Antelope Canyon, **ARIZONA**.

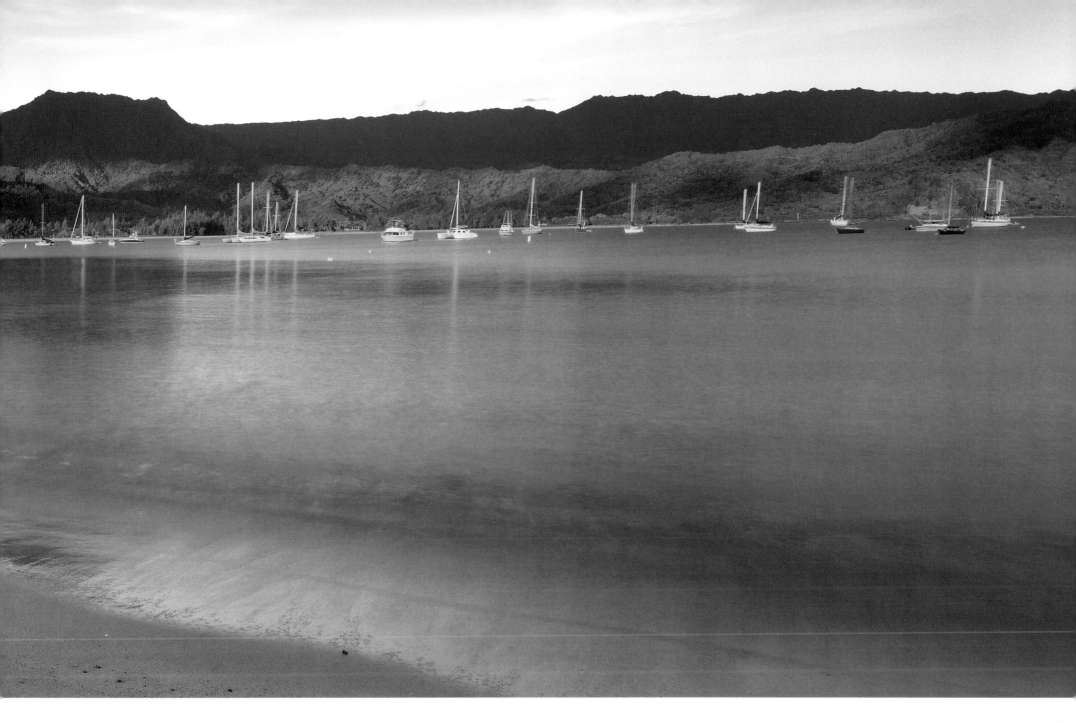

HAWAII

Hanalei Bay, North Shore, Kauai.

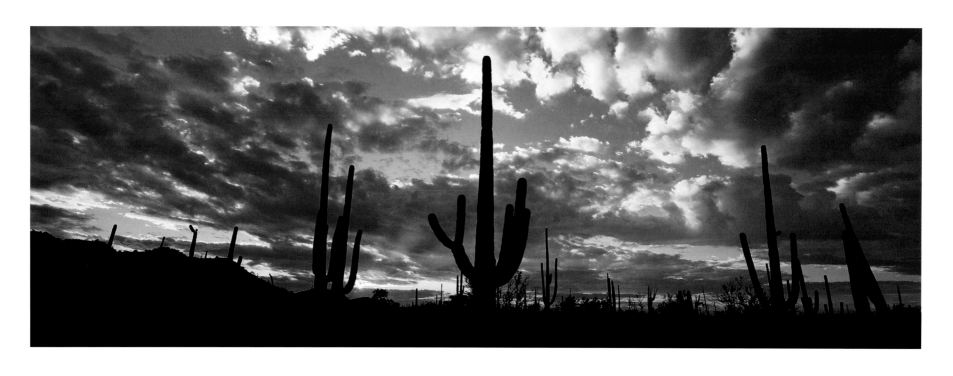

A R I Z O N A
Cactus silhouette, Saguaro National Park

T E X A S
Chisos Mountains, Big Bend National Park

overleaf: Crater Lake National Park, **OREGON**.

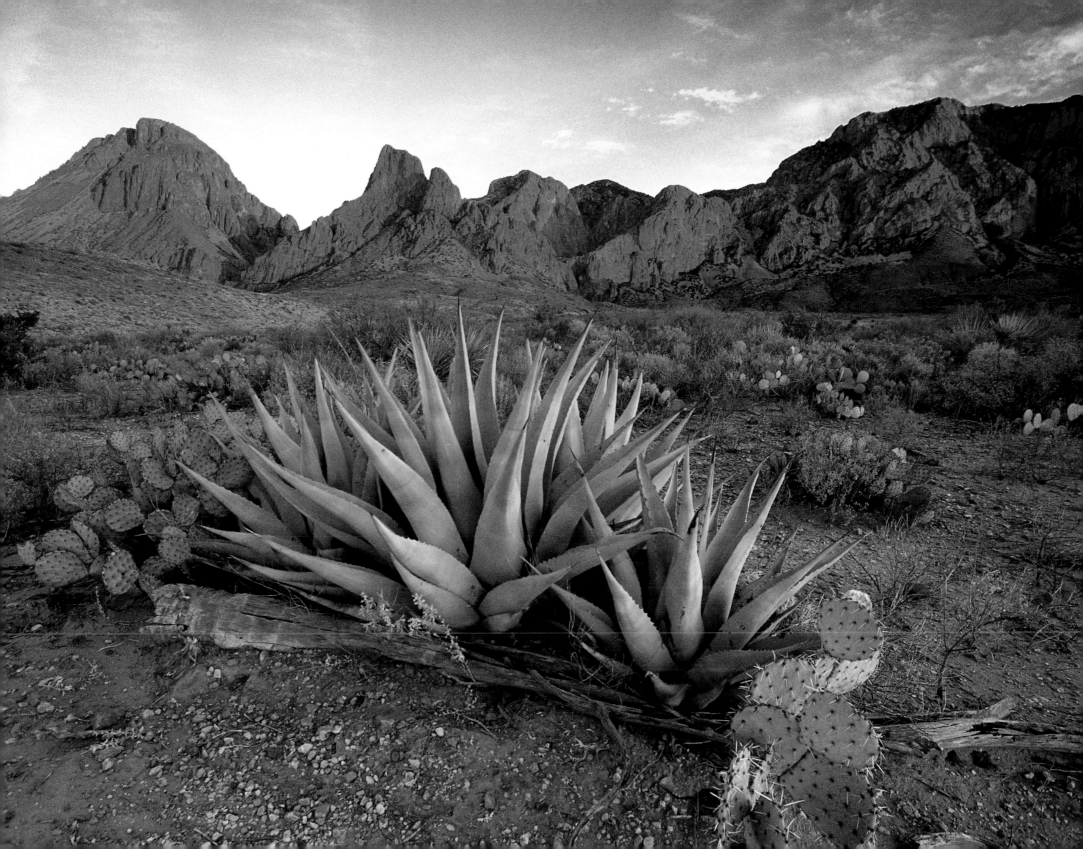

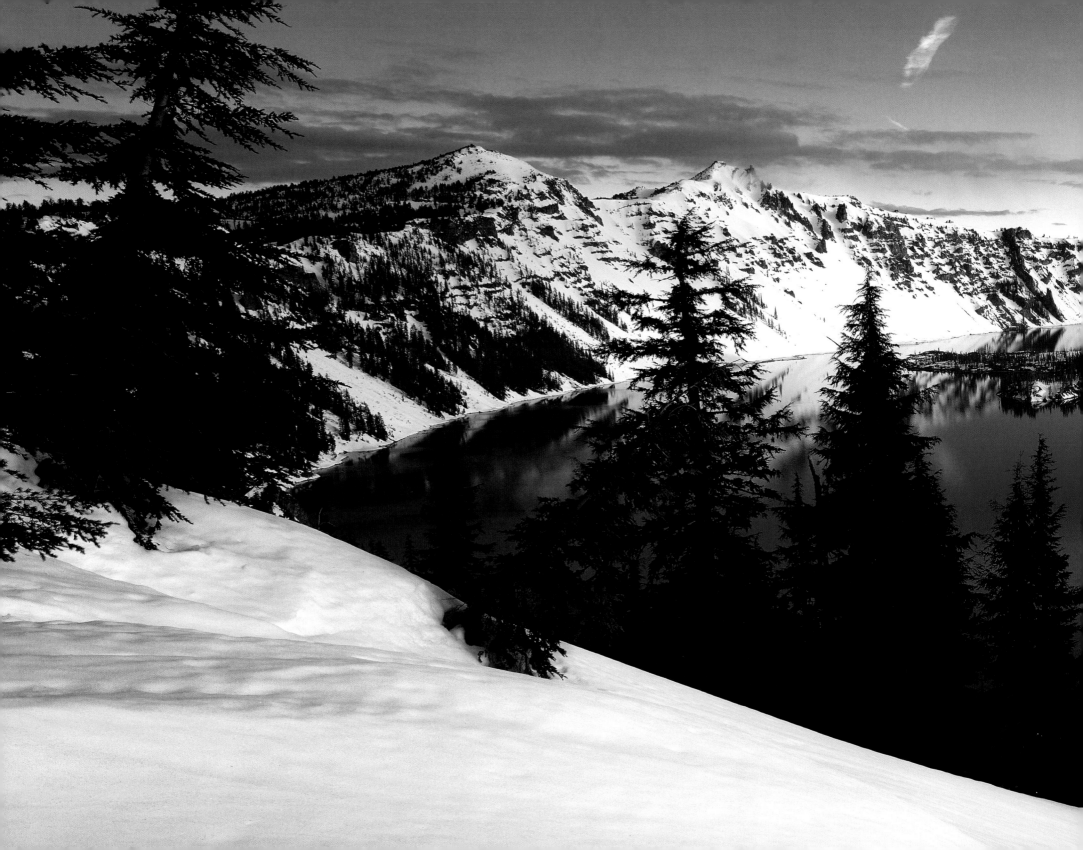

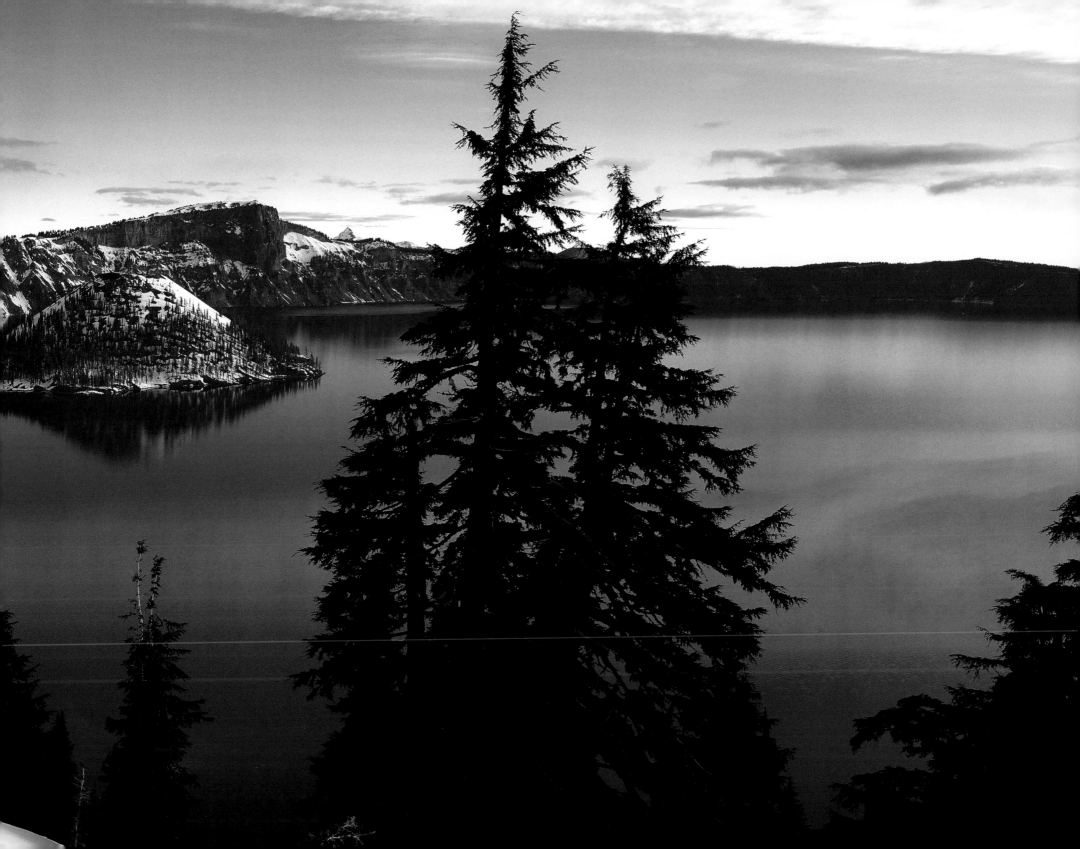

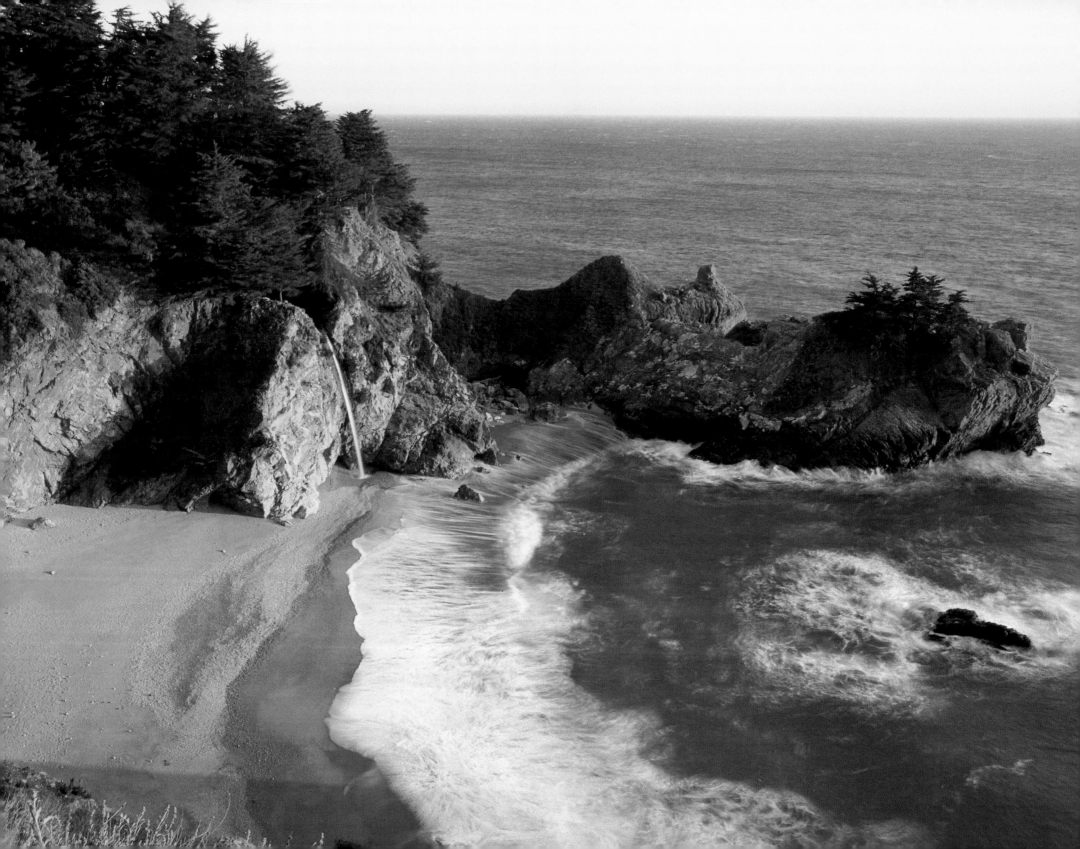

Man is naturally drawn to the sea and it evokes powerful emotions, but it's more than that. It is the ultimate symbol of strength - the intersection of the two most powerful forces of nature, the ocean and the land. The peaceful infinity of waves tumbling and receding on an empty beach is one of the most calming sounds in the world, and it's an awesome feeling to stand on the very edge of the earth with everything behind and nothing ahead but the distant horizon.

We all look at the same landscape, but it's what we see in it that makes the difference. When shooting coastlines, the essence of the image is movement. Even in the most serene sunrise, the illusion of motion can transform an ordinary shot into something very special. I use long exposures to capture the effect of the tide as it retreats and advances, and choose my moment depending on the mood of the composition. Nature is never static; she is constantly changing and evolving. I take the same approach to photography and strive to retain the element of motion that brings the shot to life.

I explored the edge of America as the seasons overlapped, and my images of the diverse coastline changed daily as the journey progressed. In the East I weaved in and out of jutting fingers of land that make up the coast, capturing the character of sleepy fishing villages built on the lifeblood of the sea, and statuesque lighthouses presiding over sheer granite cliffs. On the other side of the country on the wild West Coast, in a gentle handshake of nature, ancient Redwood groves come down to meet the rocky shores, and fresh mountain waterfalls cascade directly into the ocean. Along the windswept Big Sur coastline and beyond, Highway One twists and turns in its struggle to follow the contour of the land. In complete contrast, far removed from the wilderness, the pristine white sands and turquoise waters of Florida and the Gulf of Mexico presented me the perfect images of a sub-tropical paradise. Across the Pacific on the rugged shores of the Na Pali Coast in Hawaii, ragged cliffs dramatically silhouetted against a foreground of perfect beaches and lush forest vegetation, reminded me of my own piece of paradise in Australia.

As the canyonlands are the heart of America, the coastline is the winding backbone that encircles and protects the land. I followed the trail that set the course of my great adventure, and it always led me to the shot.

CALIFORNIA
Julia Pfeiffer Burns State Park, Big Sur.

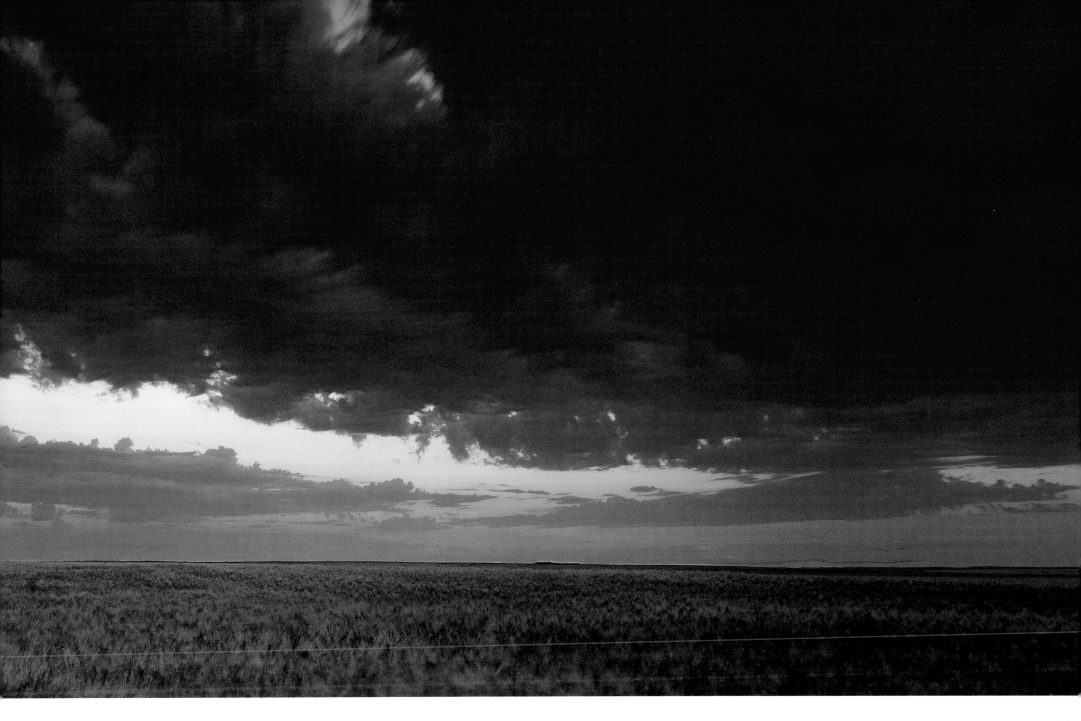

NORTH DAKOTA
Stormy skies, Prairielands.

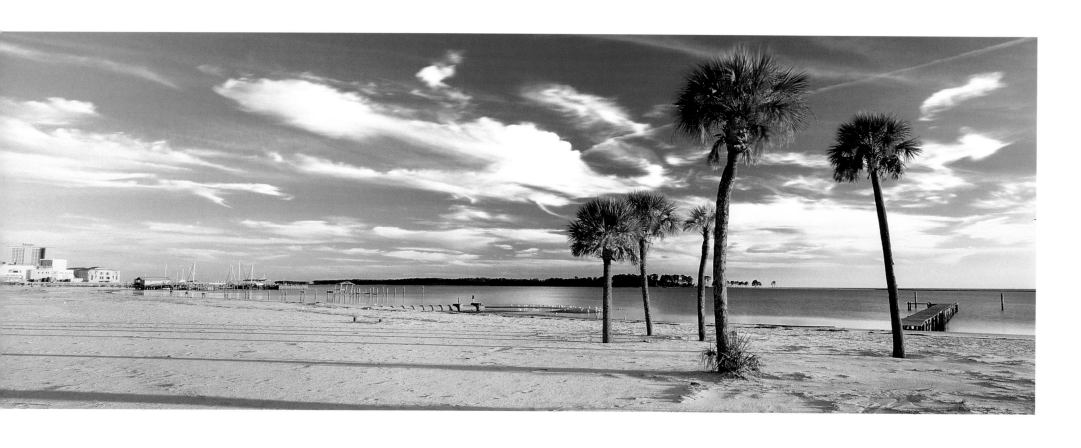

Evening shadows, Biloxi.

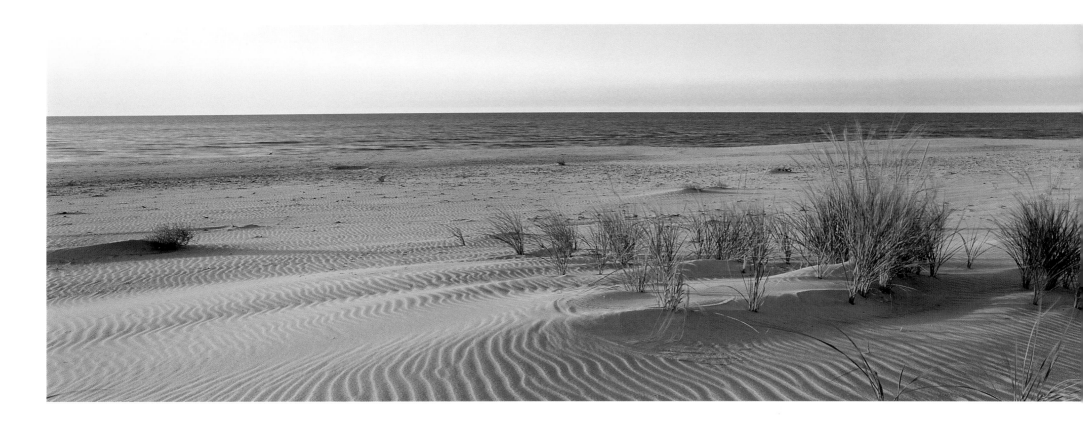

INDIANA
Indiana Dunes National Lakeshore, Lake Michigan.

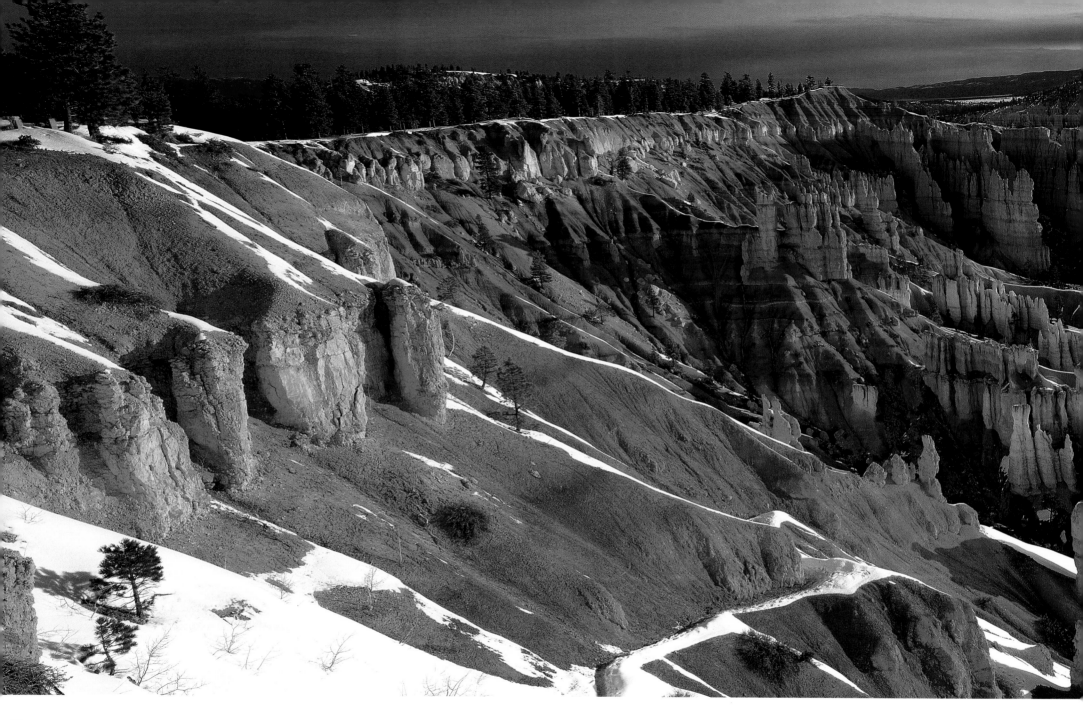

72

U T A H
Main Amphitheater, Bryce Canyon National Park.

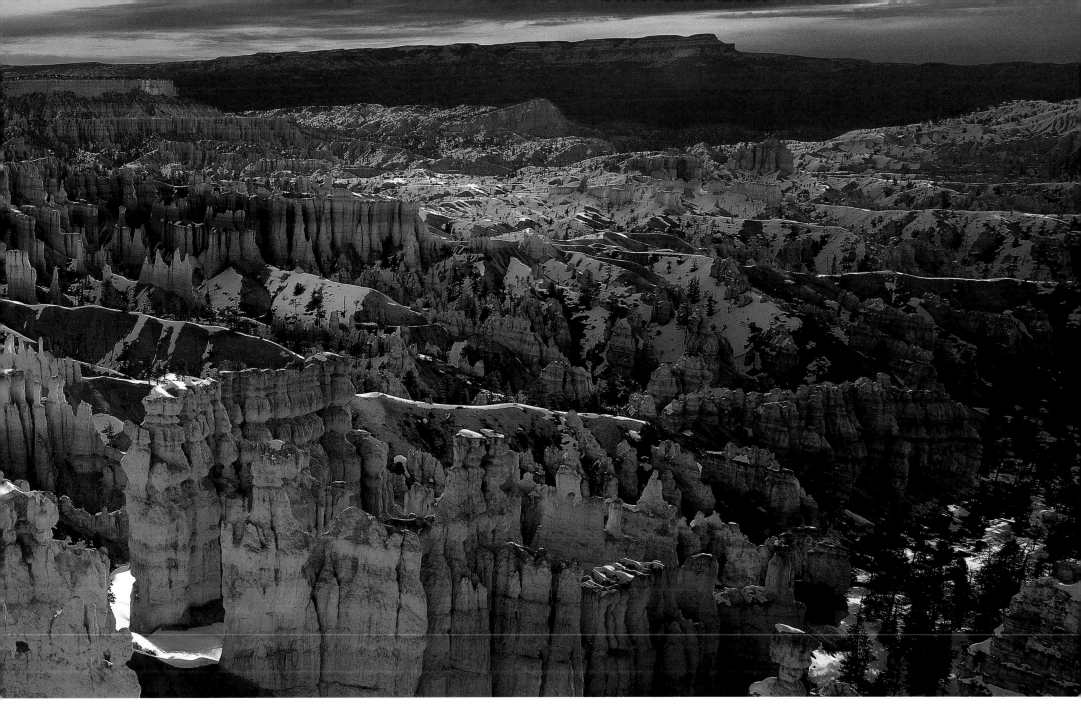

overleaf: Fontainebleau State Park, **LOUISIANA**.

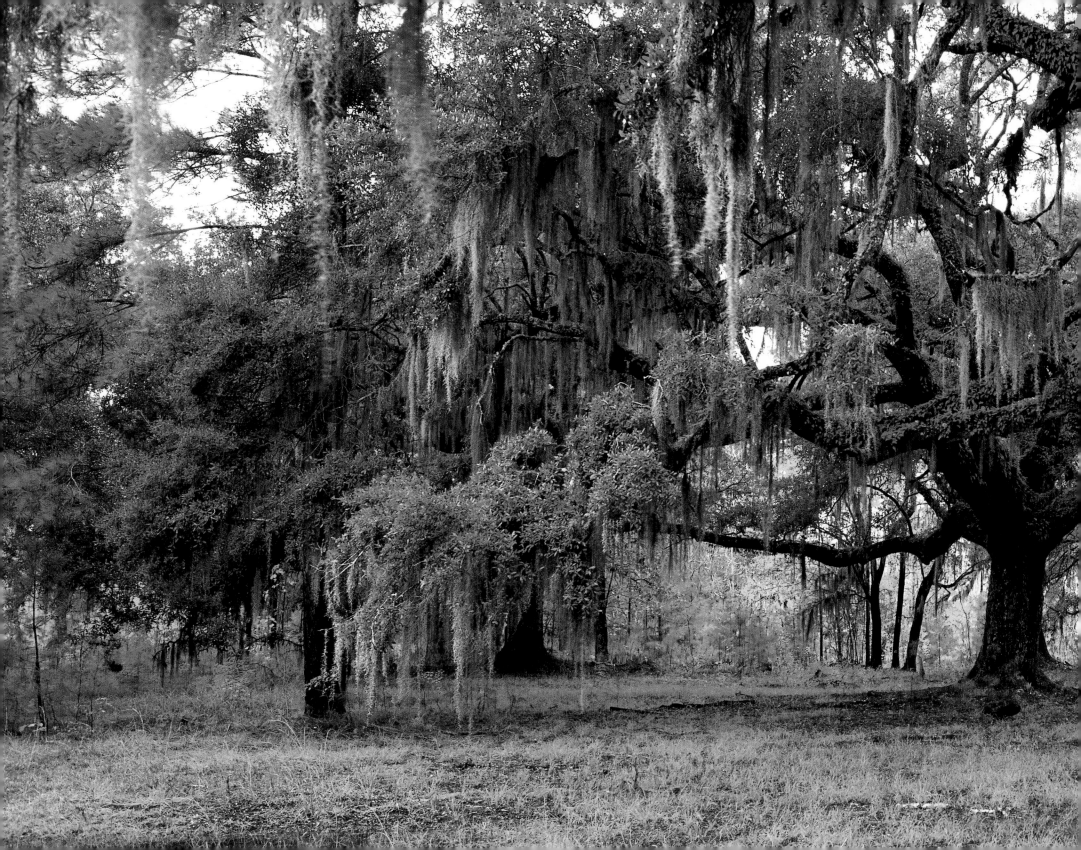

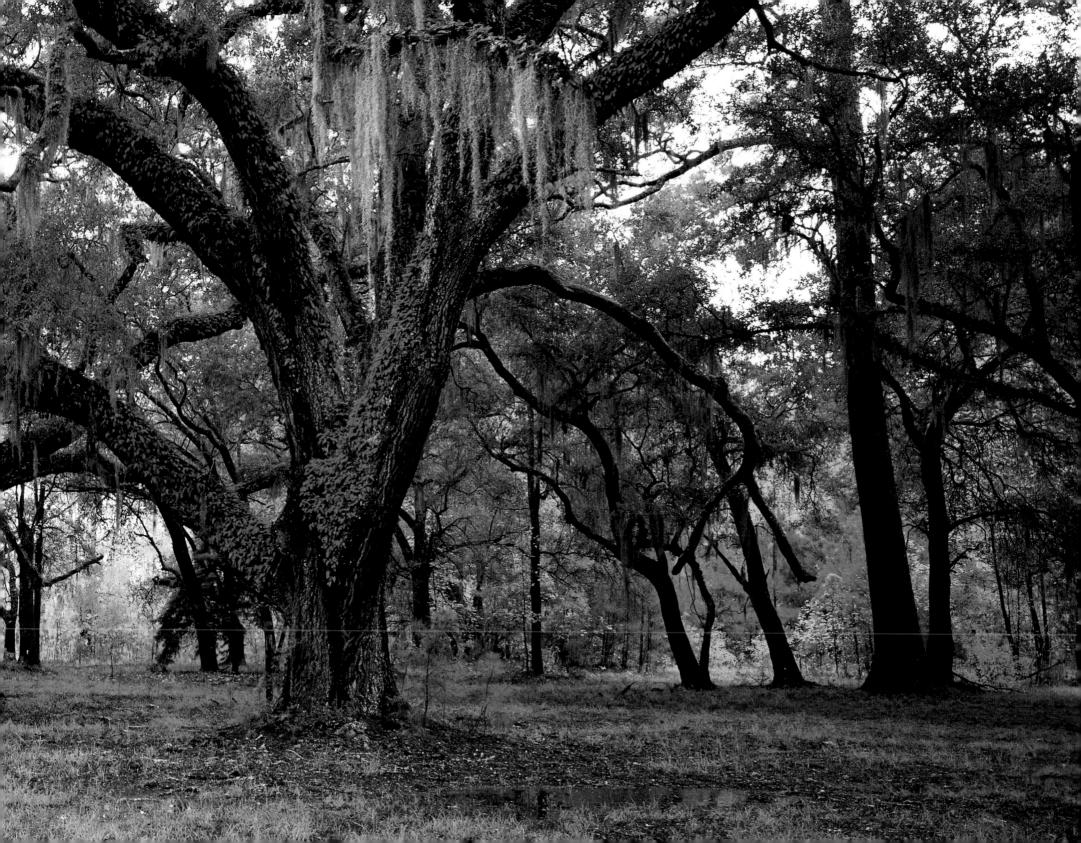

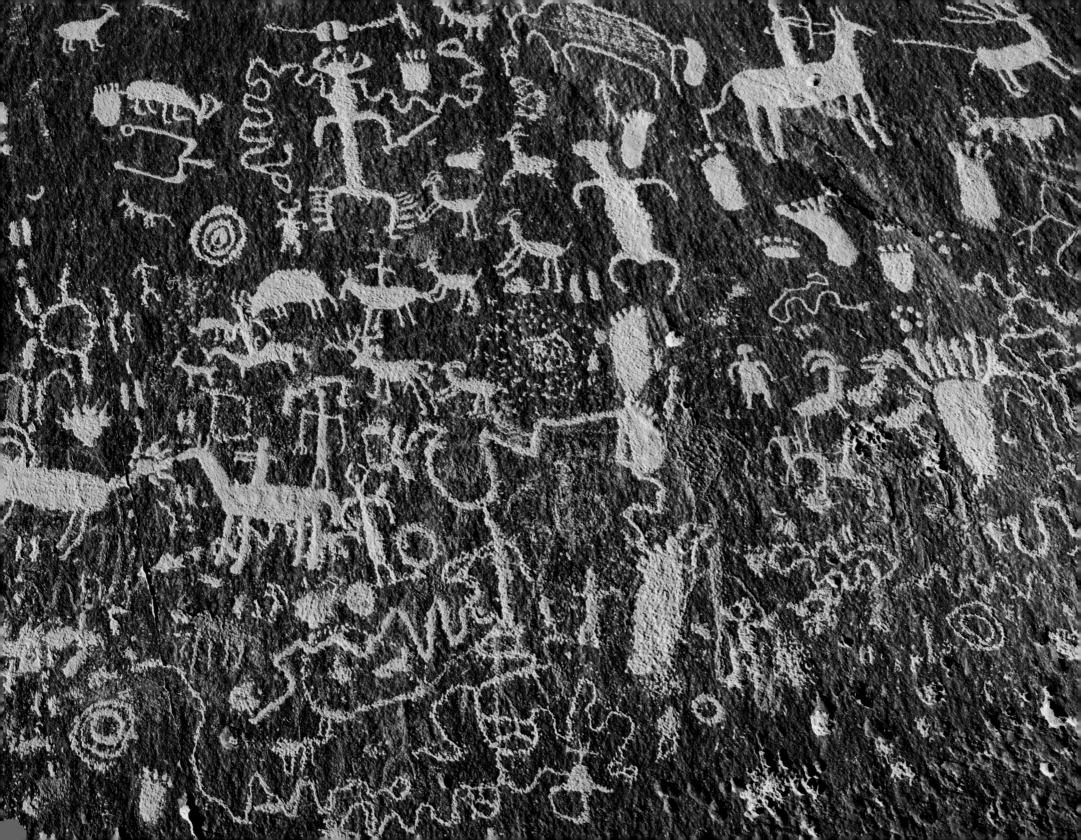

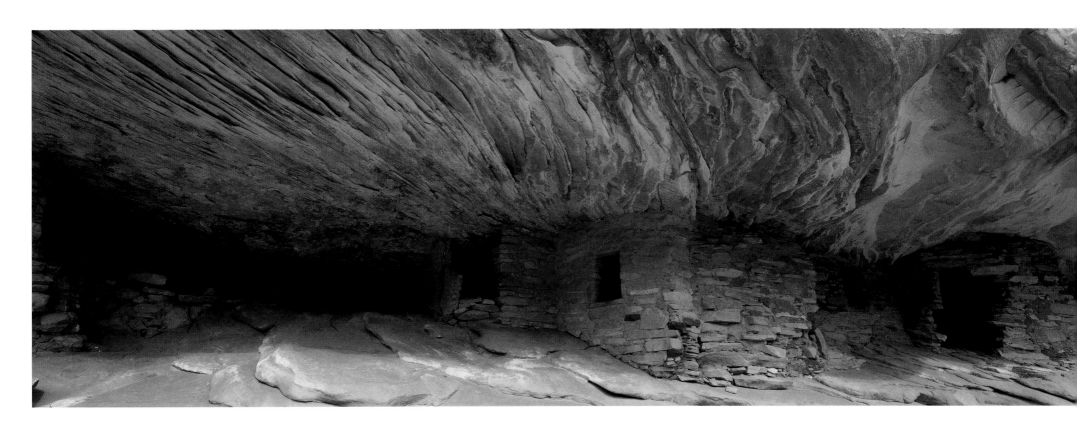

U T A H
Fire Rock, ancestral Anasazi site.

U T A H
Petroglyphs, Newspaper Rock.

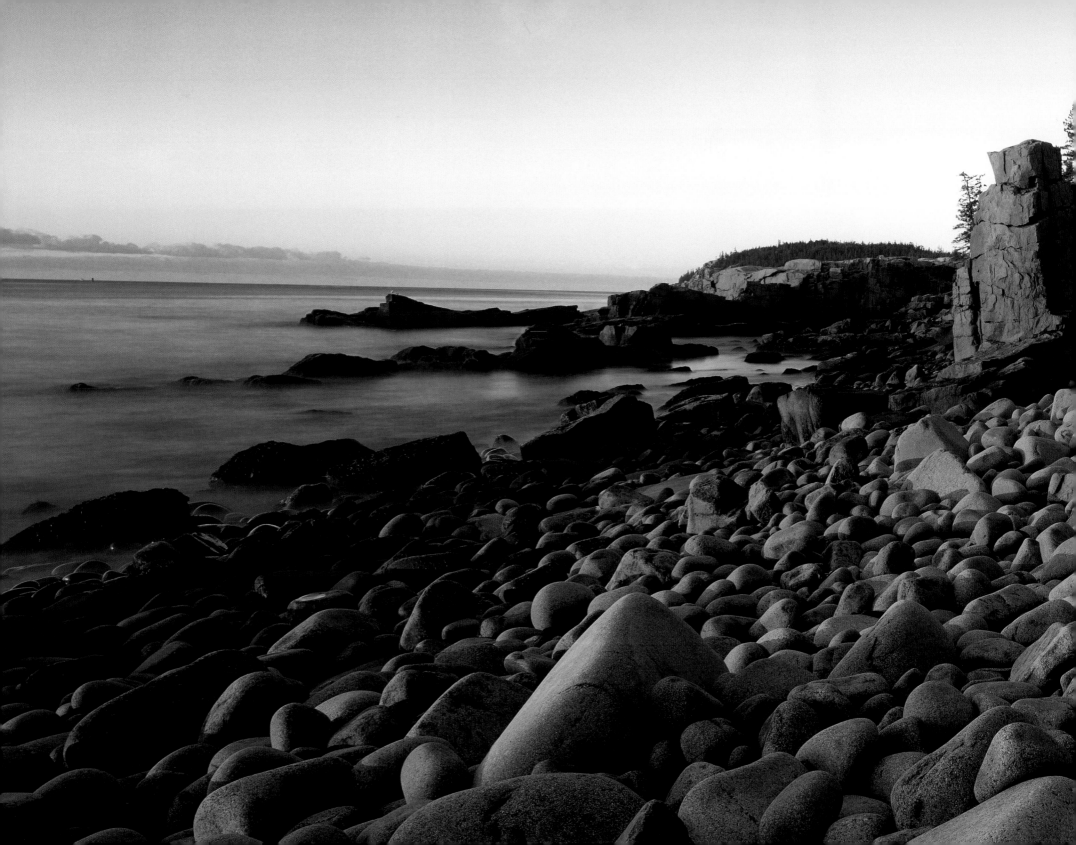

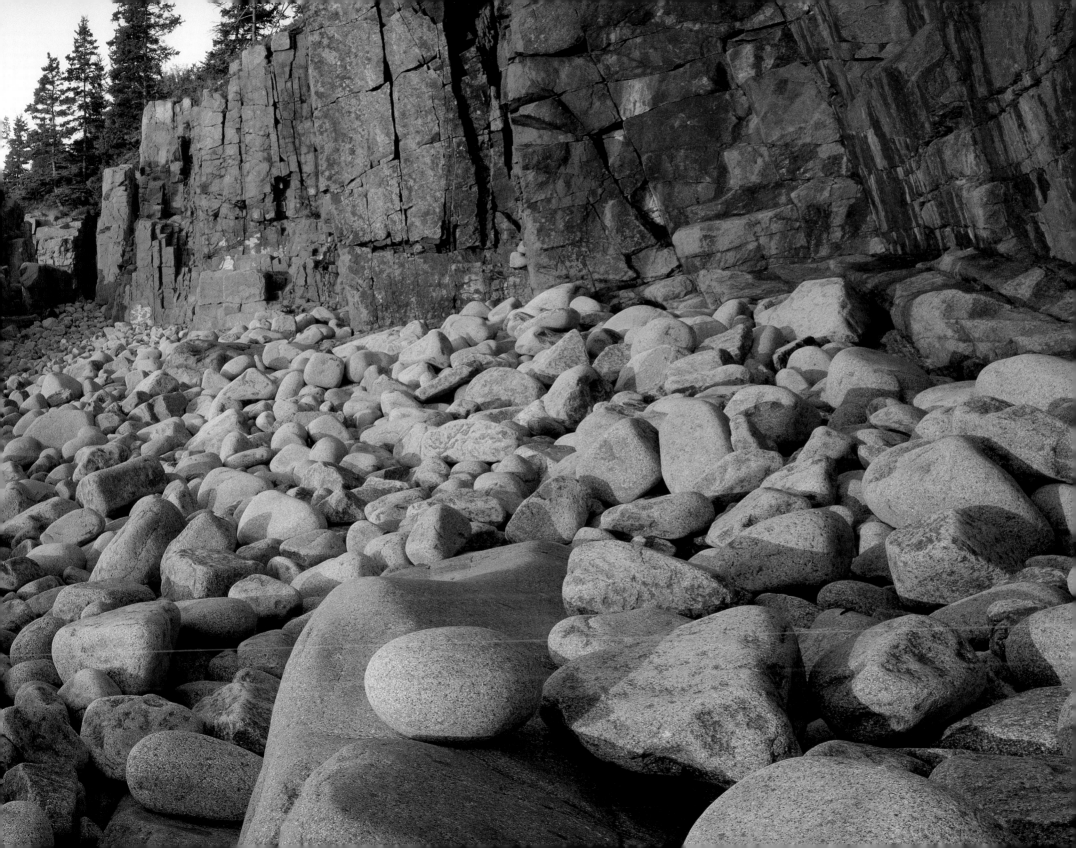

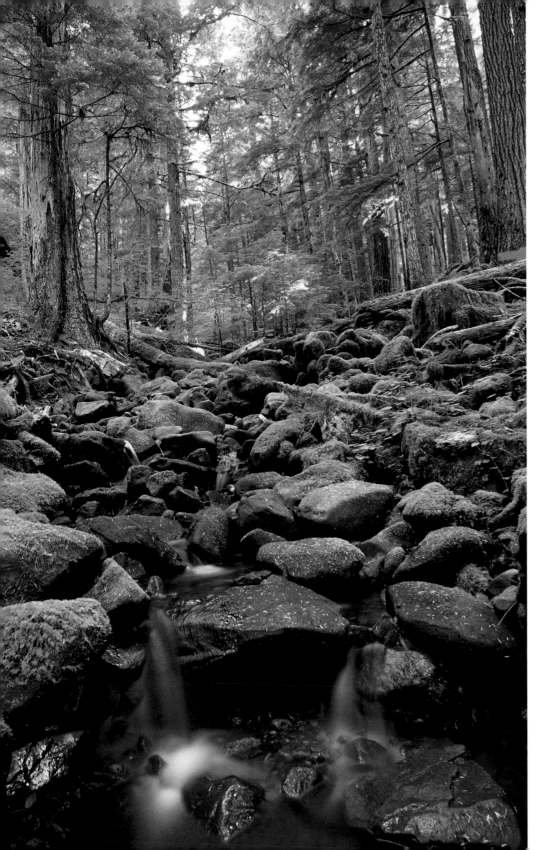

DEPTH &
DIMENSION

**Time stands still in silent places,
worlds within a world.** I search
for new dimensions to unravel
the secrets of an ancient
landscape. Blending into the
scene, I feel my smallness in the
scale of nature. A different angle,
an unexpected viewpoint -
and what lies beyond the lens
remains a mystery.

WASHINGTON

Olympic National Park.

previous page: Otter Point, Mount Desert Island,
Acadia National Park, **MAINE**.

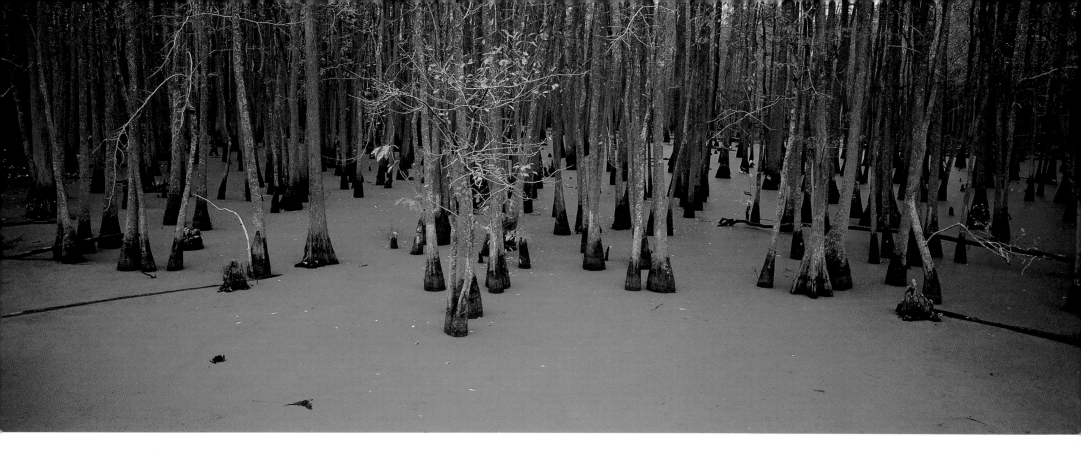

Cypress trees, Grantsburg Swamp.

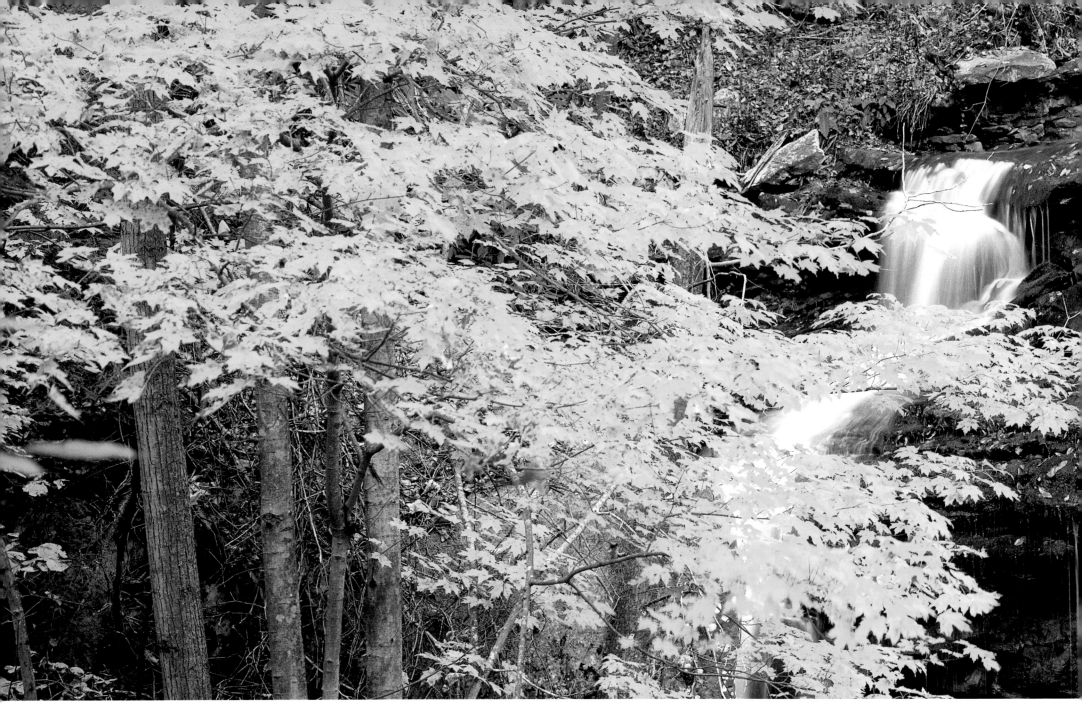

WEST VIRGINIA
Forest falls, Glade Creek.

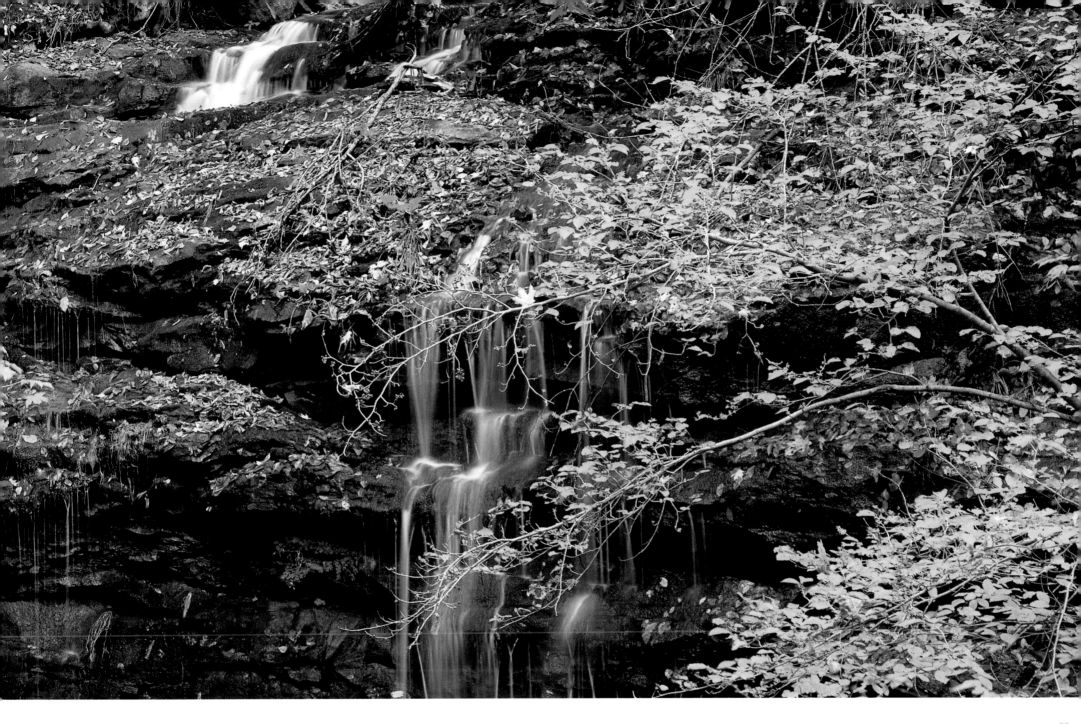

overleaf: Clingman's Dome, Great Smoky Mountains National Park, TENNESSEE.

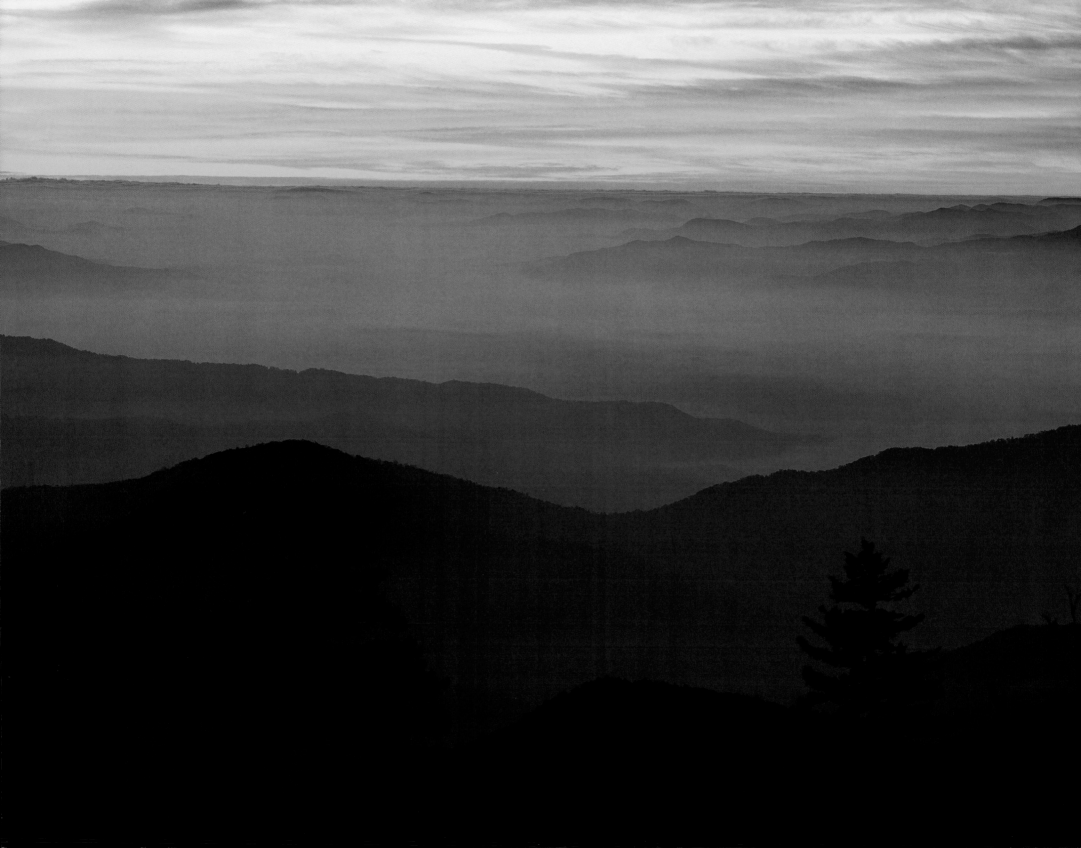

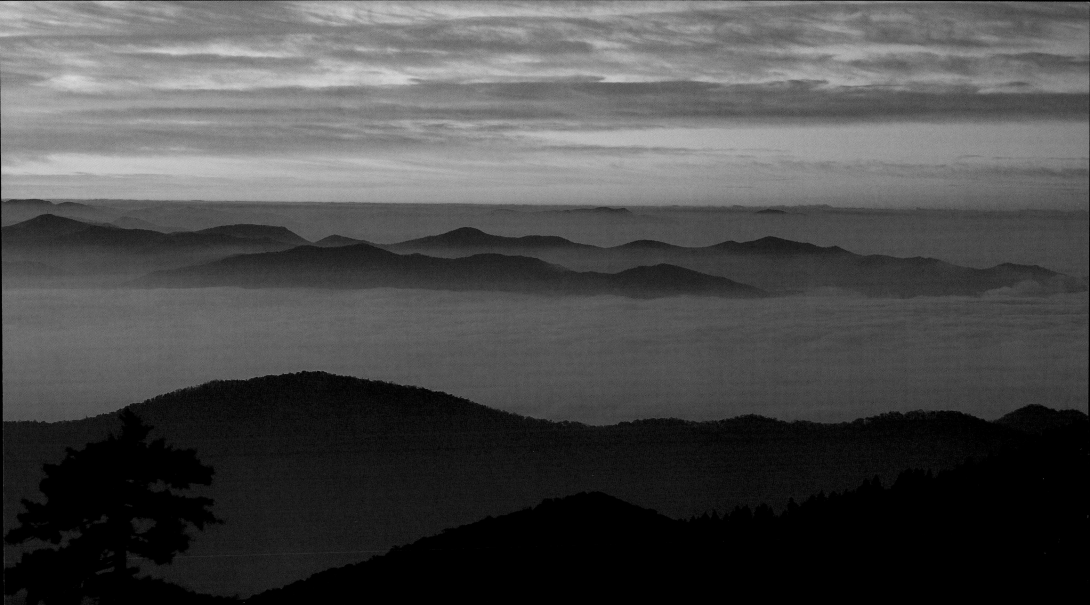

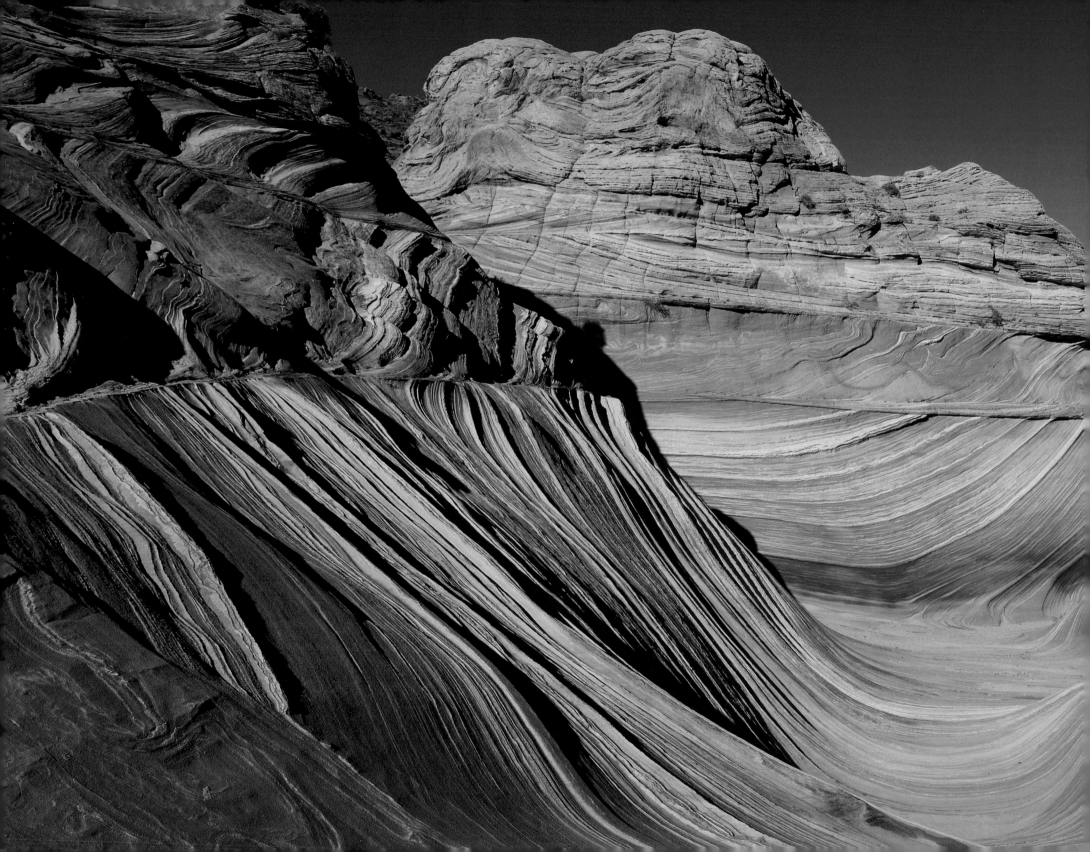

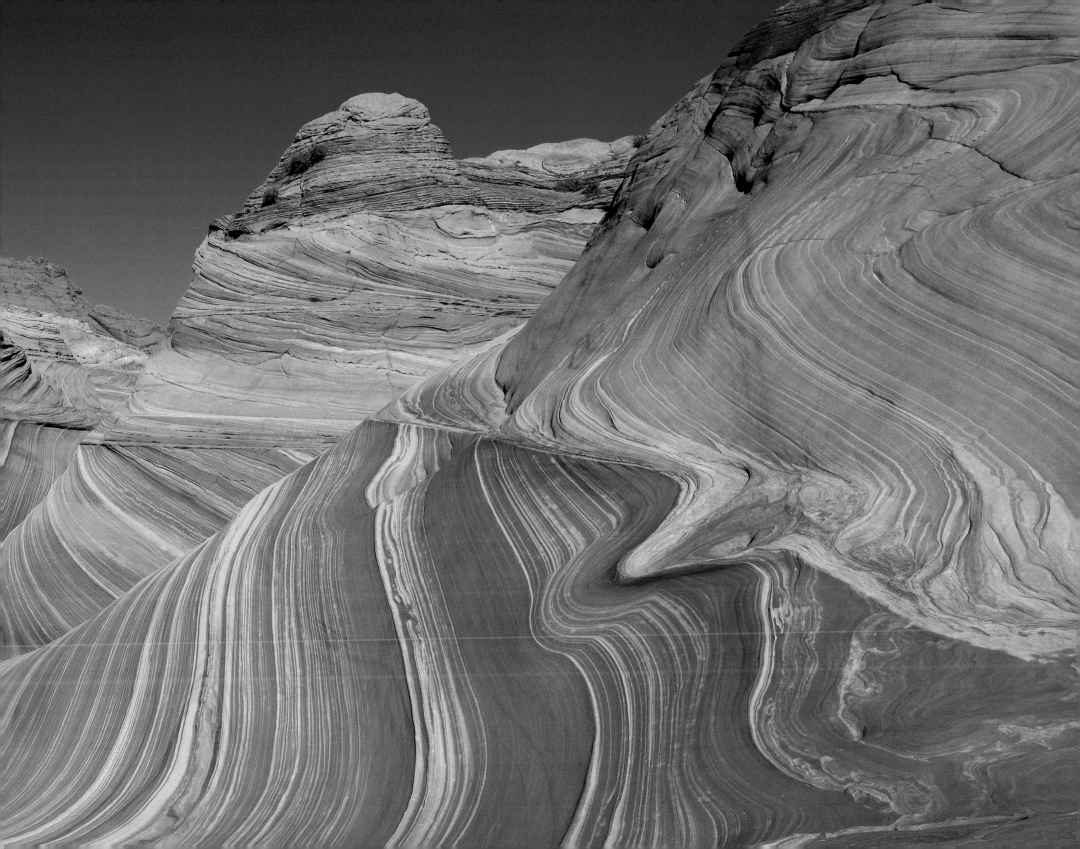

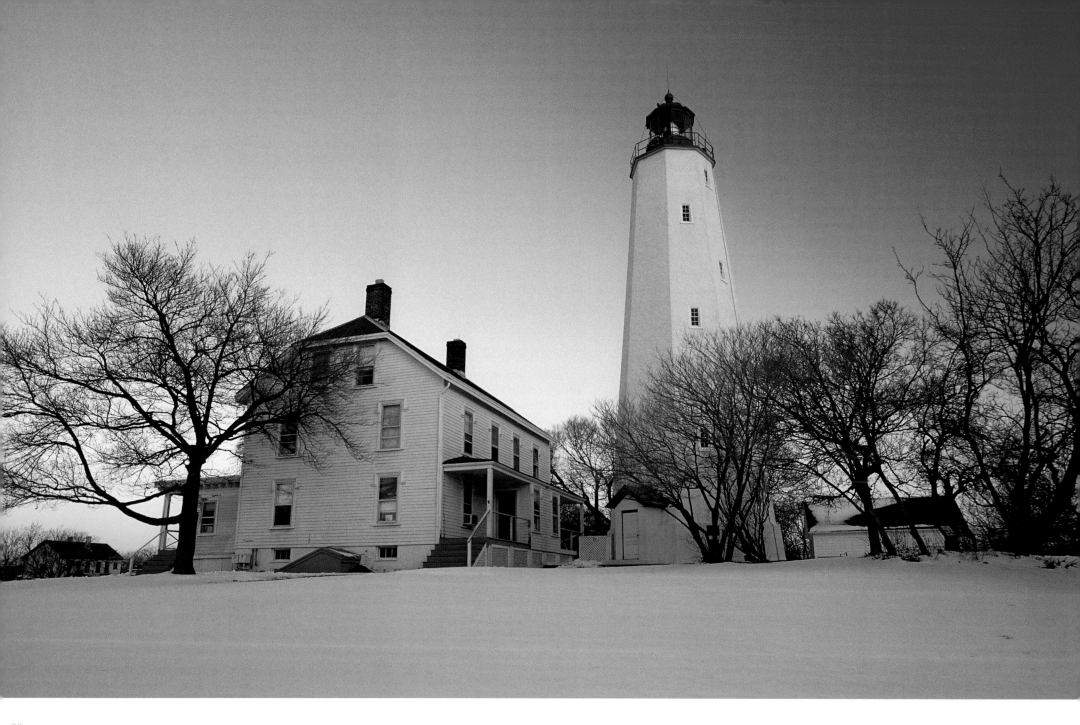

N E W J E R S E Y
Sandy Hook Lighthouse.

previous page: Vermilion Cliffs Wilderness. **ARIZONA**.

Atlantic Ocean, Edisto Island.

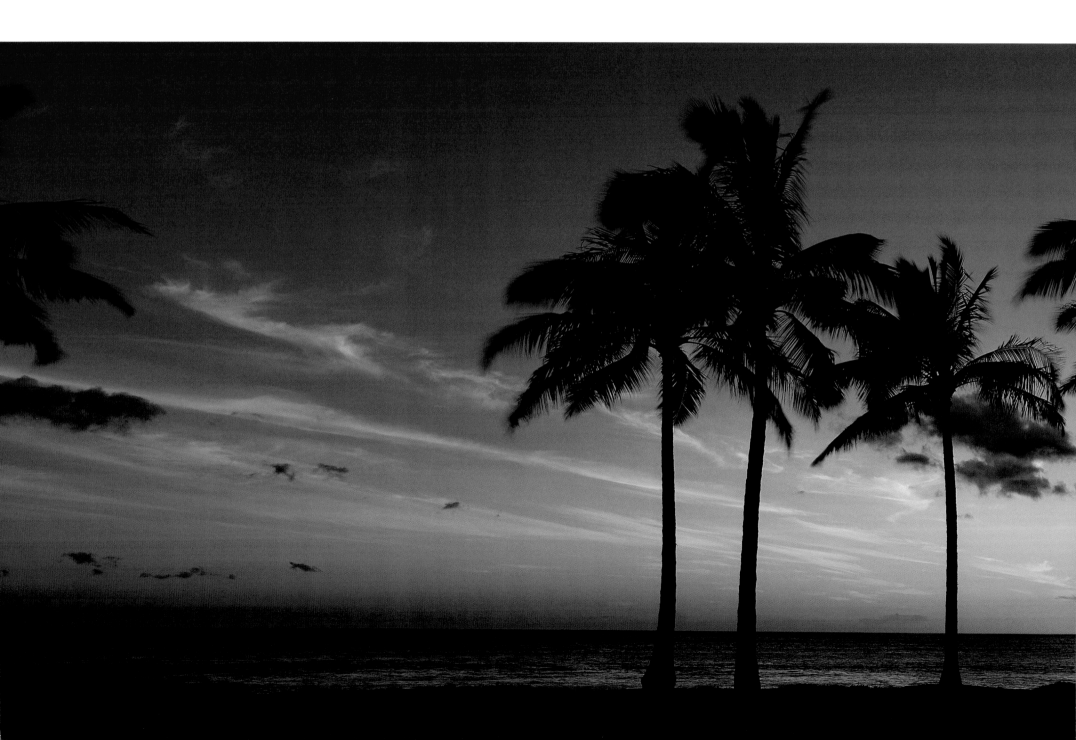

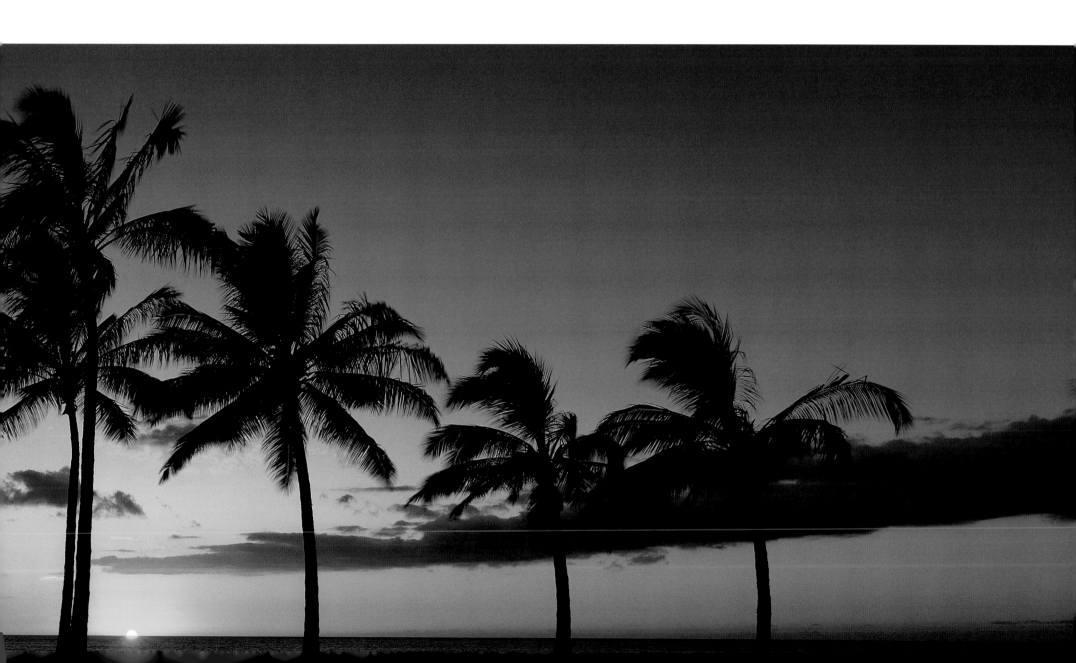

It's in our nature to search for some kind of calm – a sanctuary to take us away from it all. My place of peace has always been the deserts. The more time I spend there the deeper my connection with the land grows and I've learnt to enjoy the silences and just 'be'. I am very fortunate to have had the opportunity to spend so much time in the most beautiful places on this earth – my work is my passion and my life.

Everyone's special place is different and I am sensitive to that in my work. Through photography my goal is to share with the viewer the experience of 'being there'. But all the technique in the world is not worth an ounce of the feeling I get when an image just appears before me and all the essential elements magically fall into place. It's what I strive for, and when everything comes together it's an awesome moment - I know immediately when I've nailed the shot.

Mother Nature consistently inspires and delights me, and the images I capture are a collaboration of her work and mine. Because I'm self-taught I often go against the traditional rules of photography, and this has shaped my style in a positive way. I don't allow myself to be constrained by doing the 'right' thing and this instinctive method of shooting produces the most authentic results. The frustration of my craft lies in the knowledge that in an instant that 'perfect' moment for which I've waited so long, is gone. That's where the true essence of landscape photography lies - you can be a master of technique, but you will never master Mother Nature. The challenge is to be willing to adapt and accept what you are given on the day, and let it go when the moment's gone.

On my journey there were places I just couldn't have taken a bad picture – everything was inexplicably right. Nature presented me with an opportunity and I simply accepted the gift. On days like that my job is easy and I truly feel in tune with the land. Often though, I can chase an image for hours and end up finding nothing. But that's what keeps me searching - the challenge to preserve the spirit of the place and just bring back what was there. I tread softly and listen to the land.

93

CALIFORNIA
California Poppy, Antelope Valley.

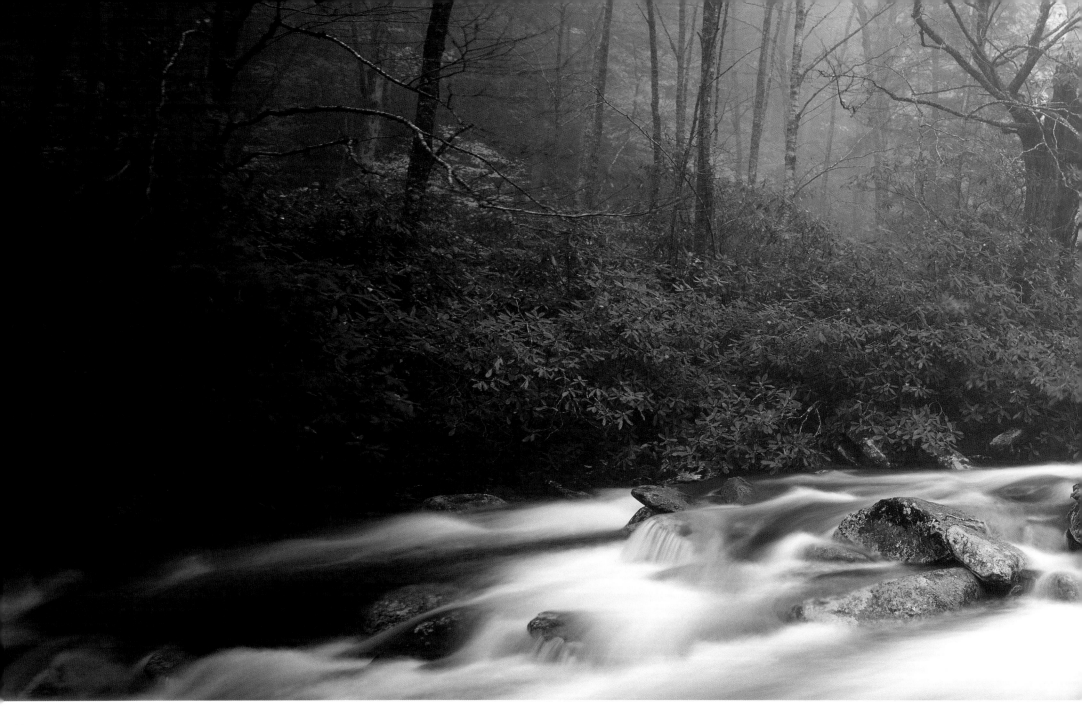

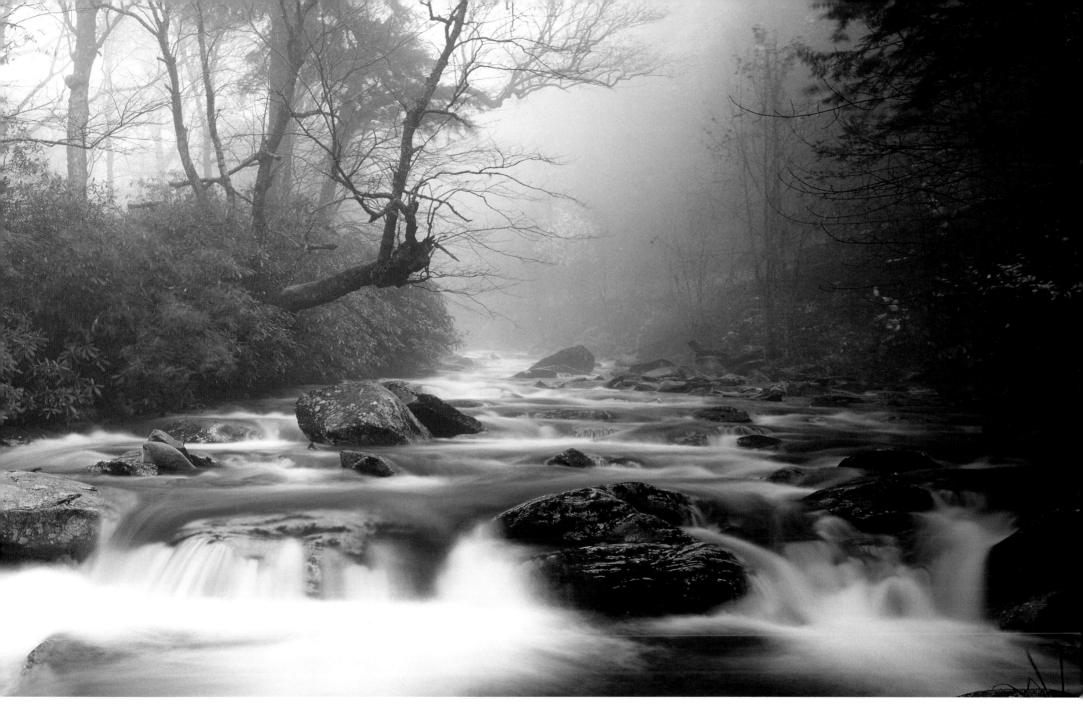

TENNESSEE

Little Pigeon River, Great Smoky Mountains National Park.

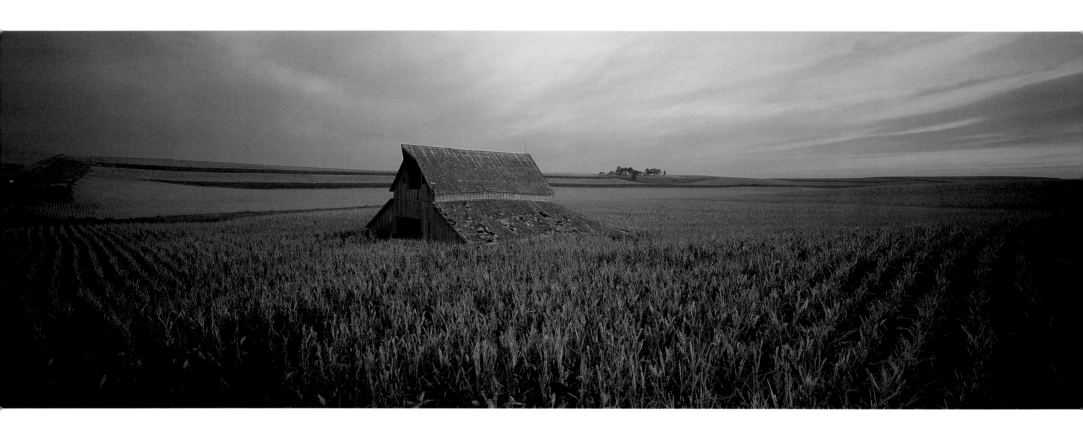

IOWA
Guthrie Center.

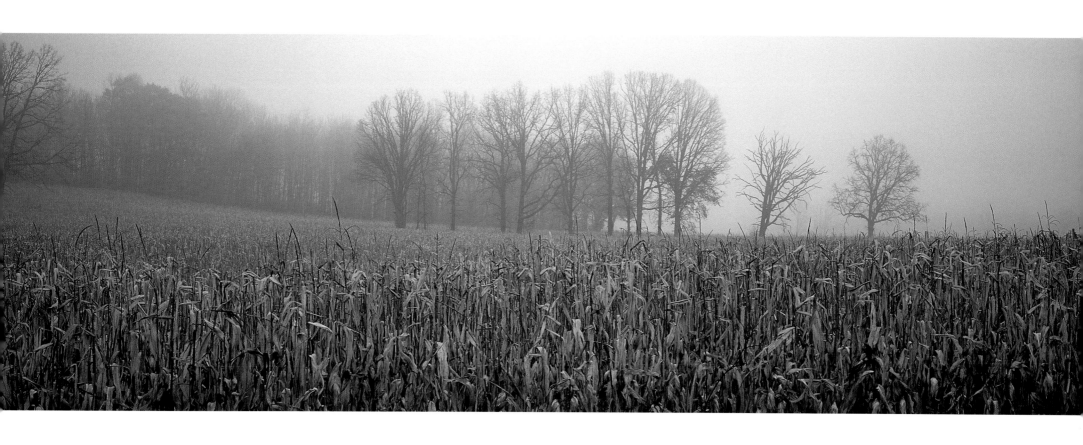

K A N S A S

Misty morning.

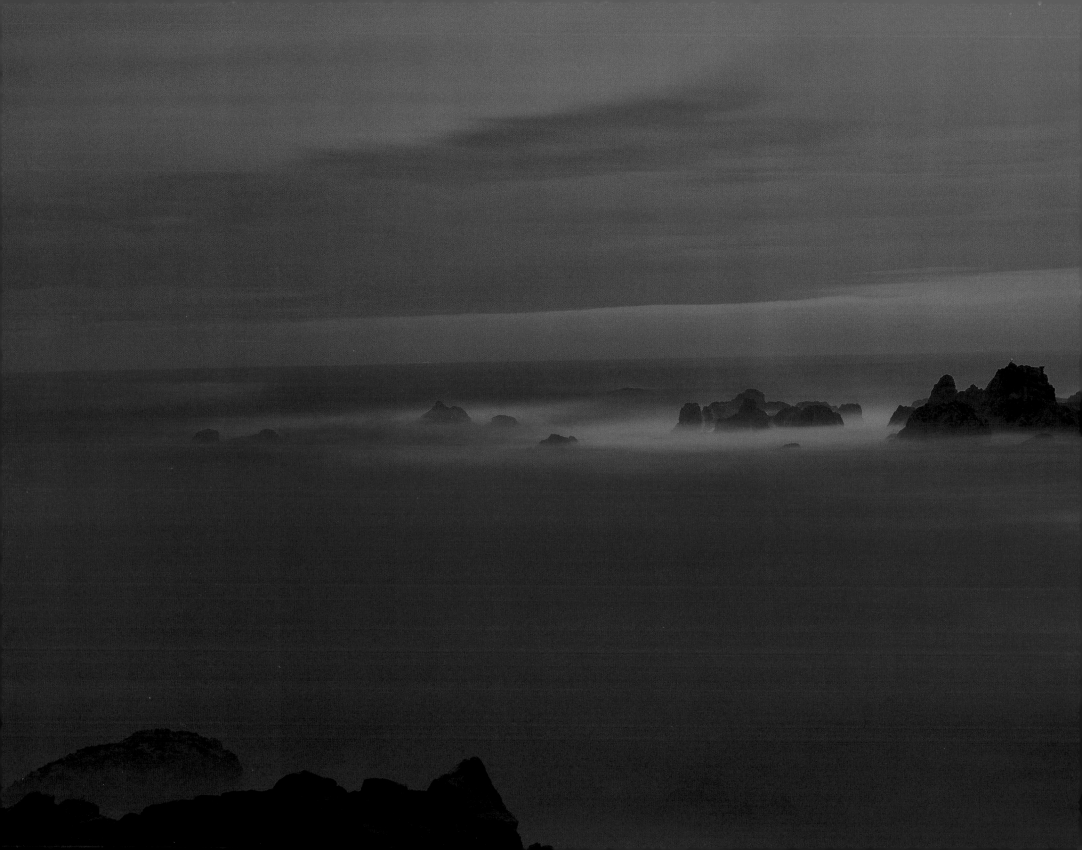

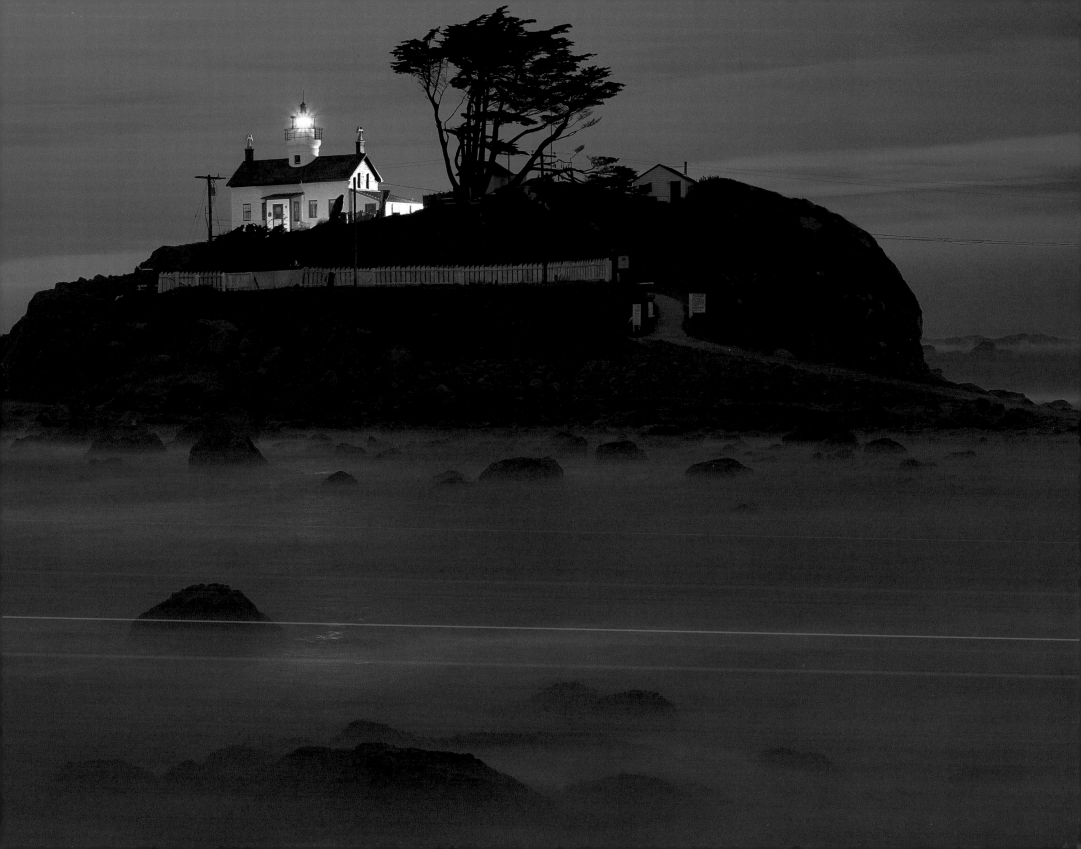

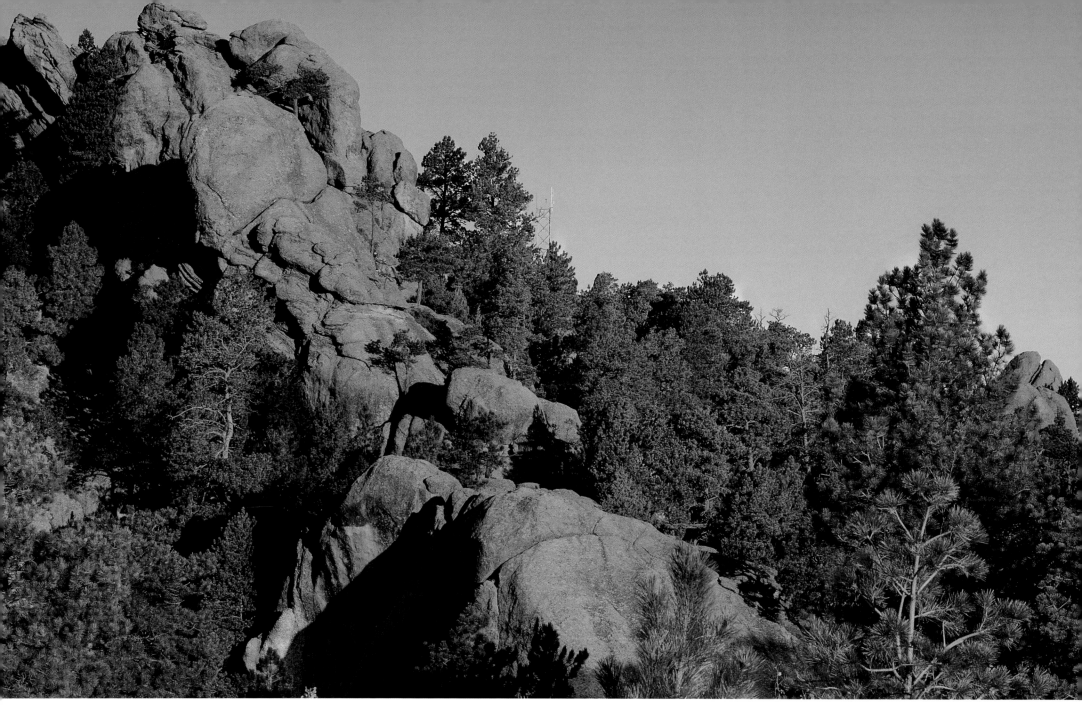

previous page: Crescent City Lighthouse - The Prince of Tides, **CALIFORNIA**.

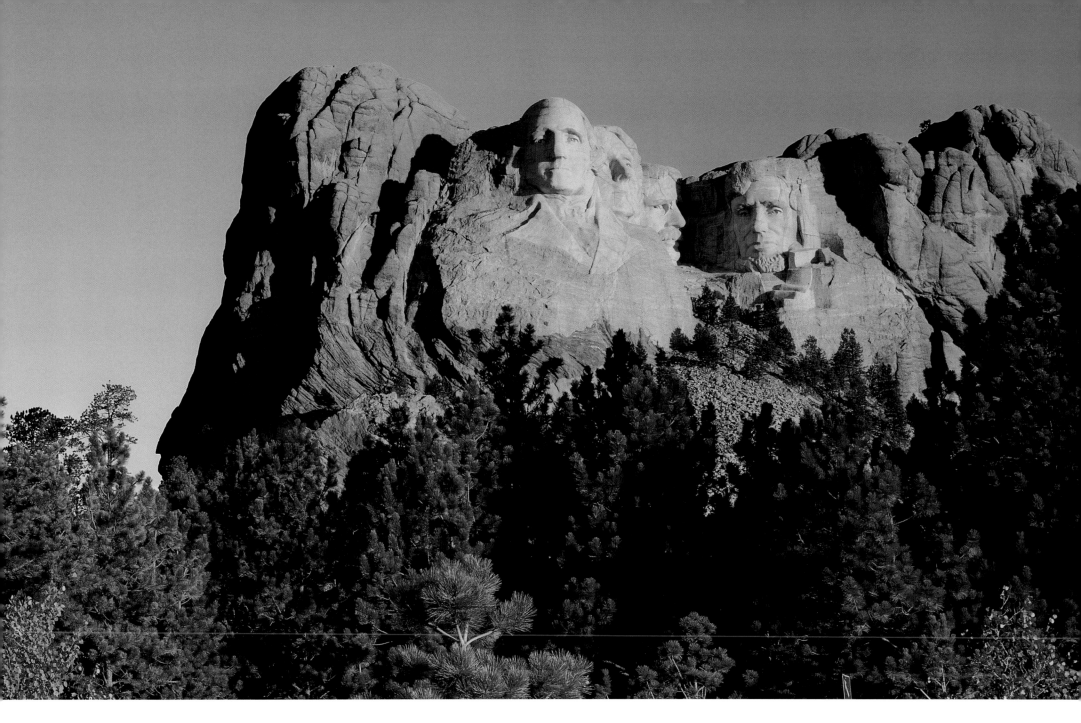

SOUTH DAKOTA
Mount Rushmore National Monument.

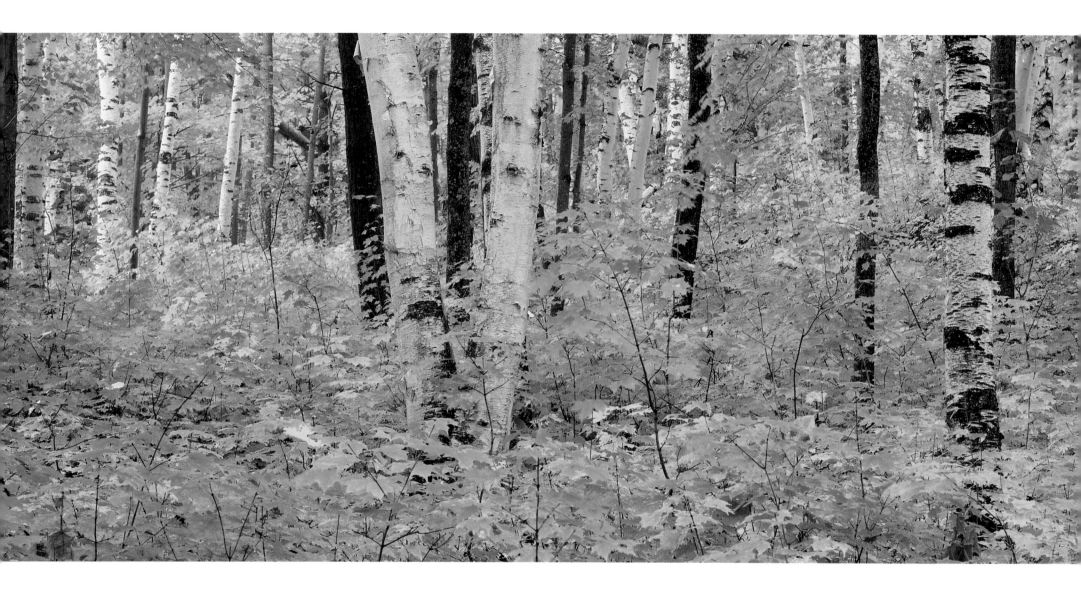

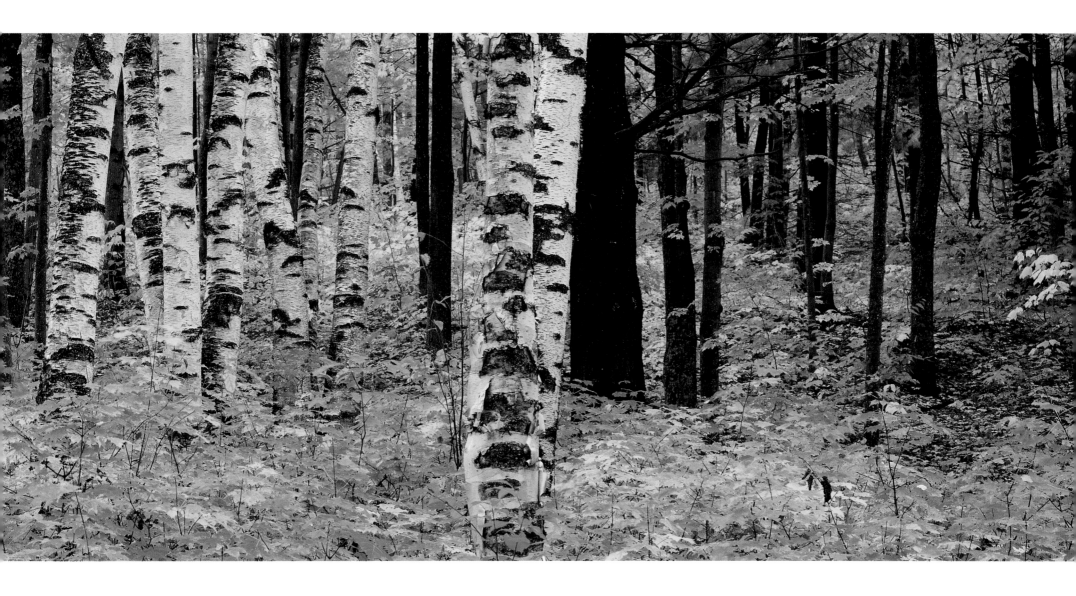

VIRGINIA
Woodland Mosaic.

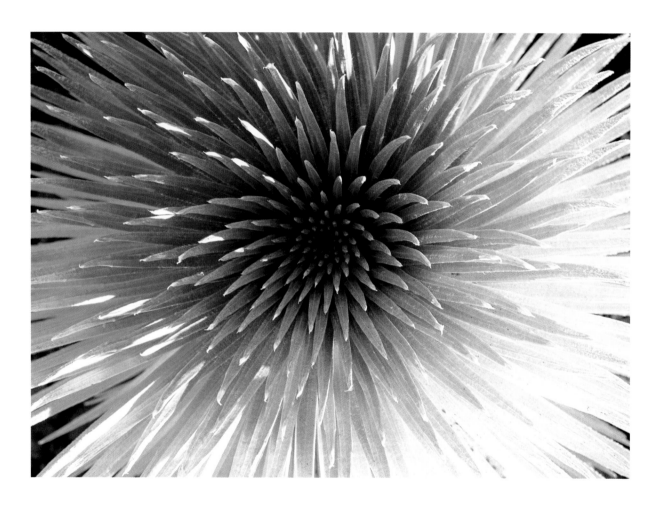

HAWAII

Silver Sword, Haleakala Crater, Maui.

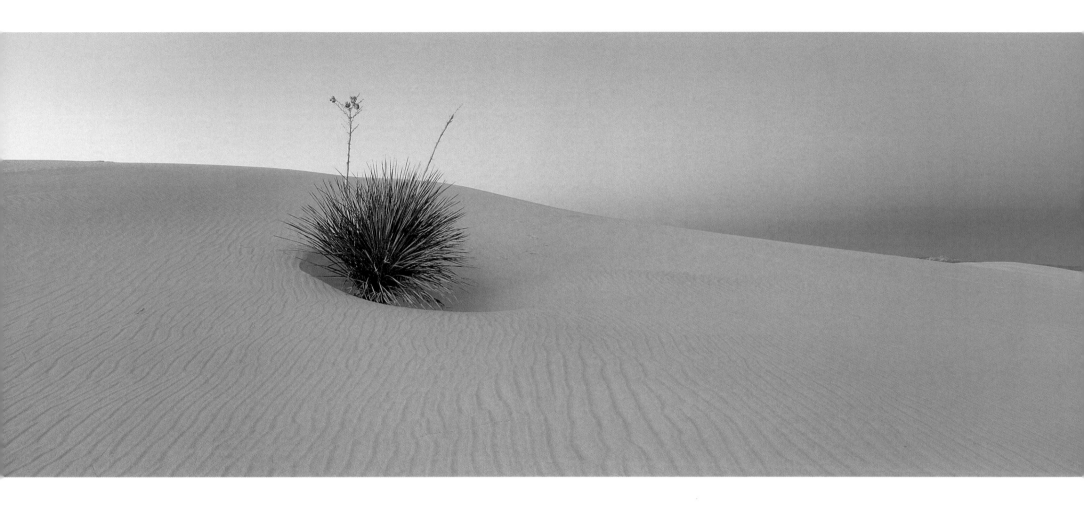

NEW MEXICO

White Sands National Monument, Chihuahuan Desert.

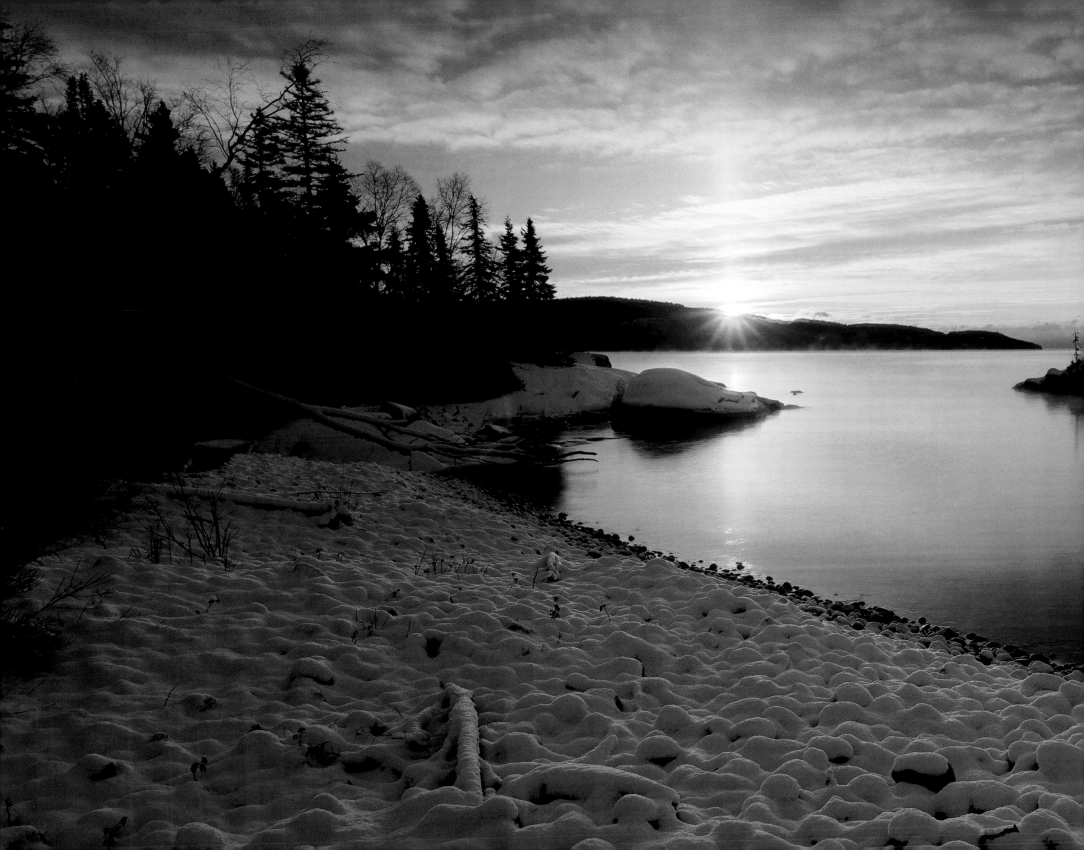

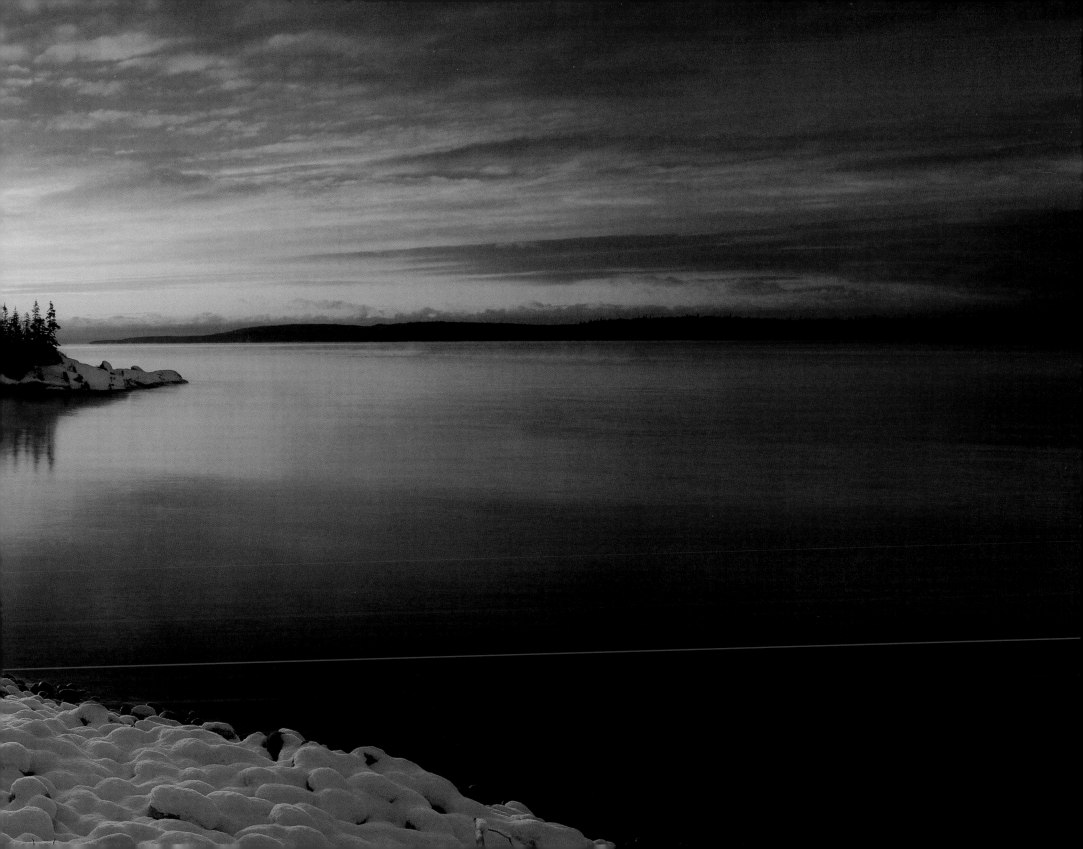

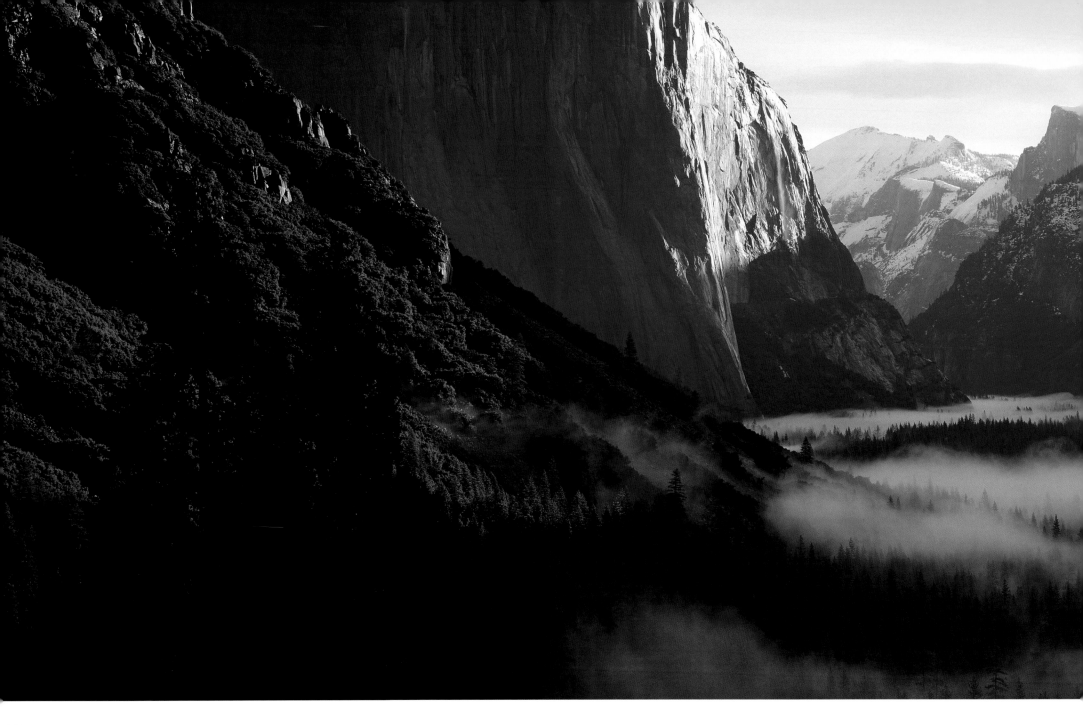

previous page: Winter's aura, **LAKE SUPERIOR**.

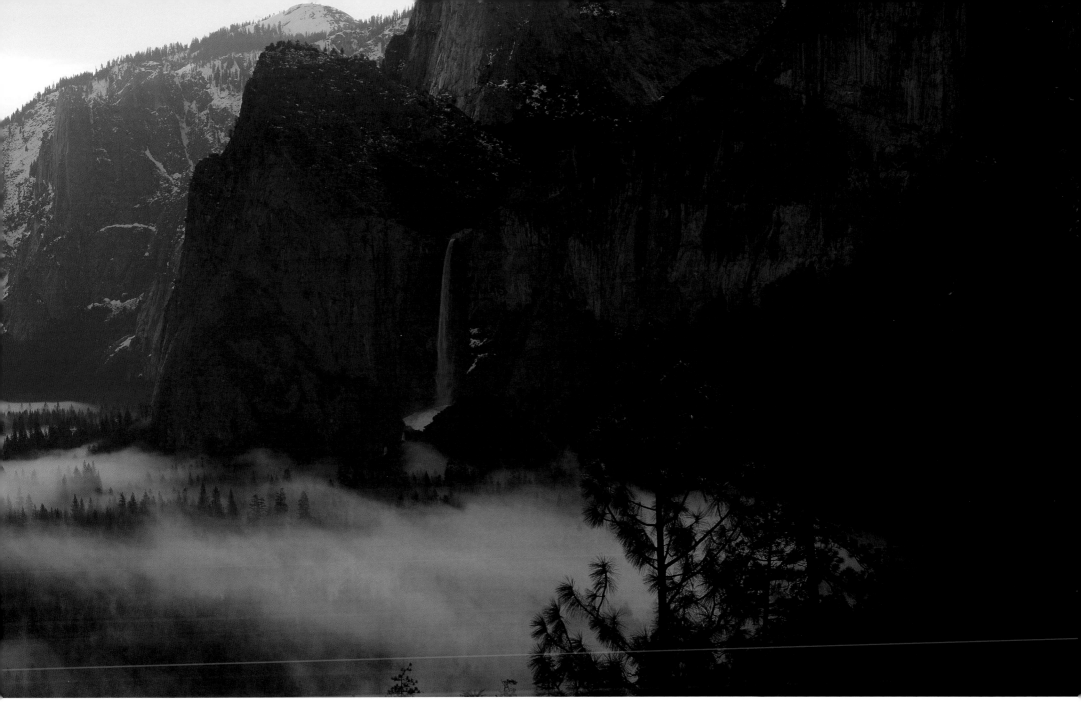

CALIFORNIA

Tunnel View, Yosemite National Park.

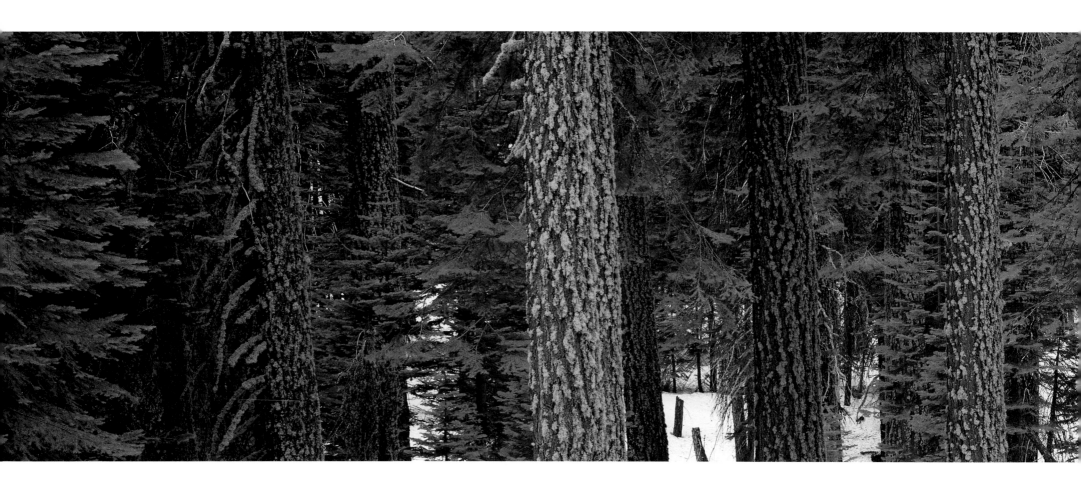

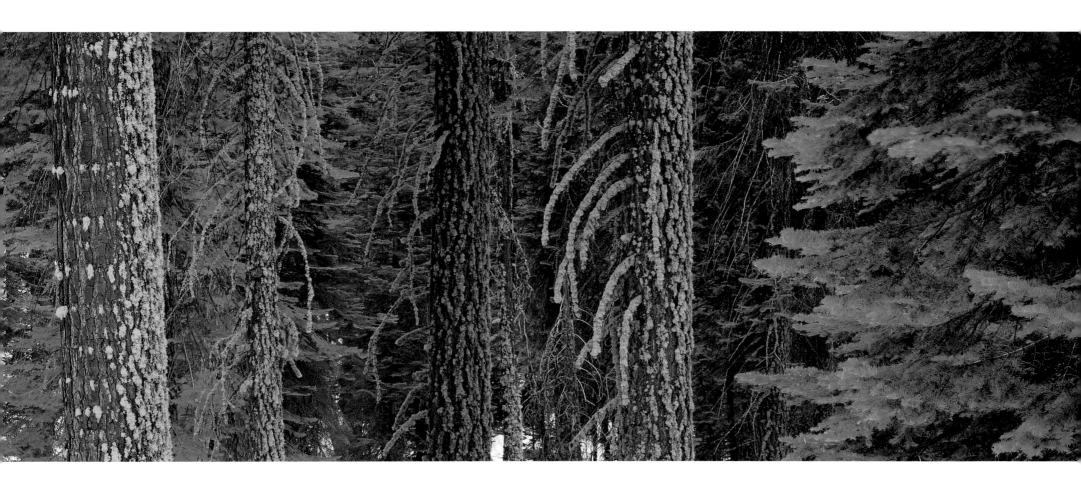

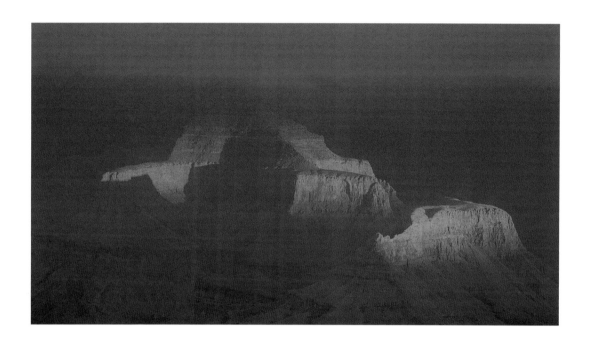

A R I Z O N A
Grand Canyon.

N E V A D A
Red Rock Canyon.

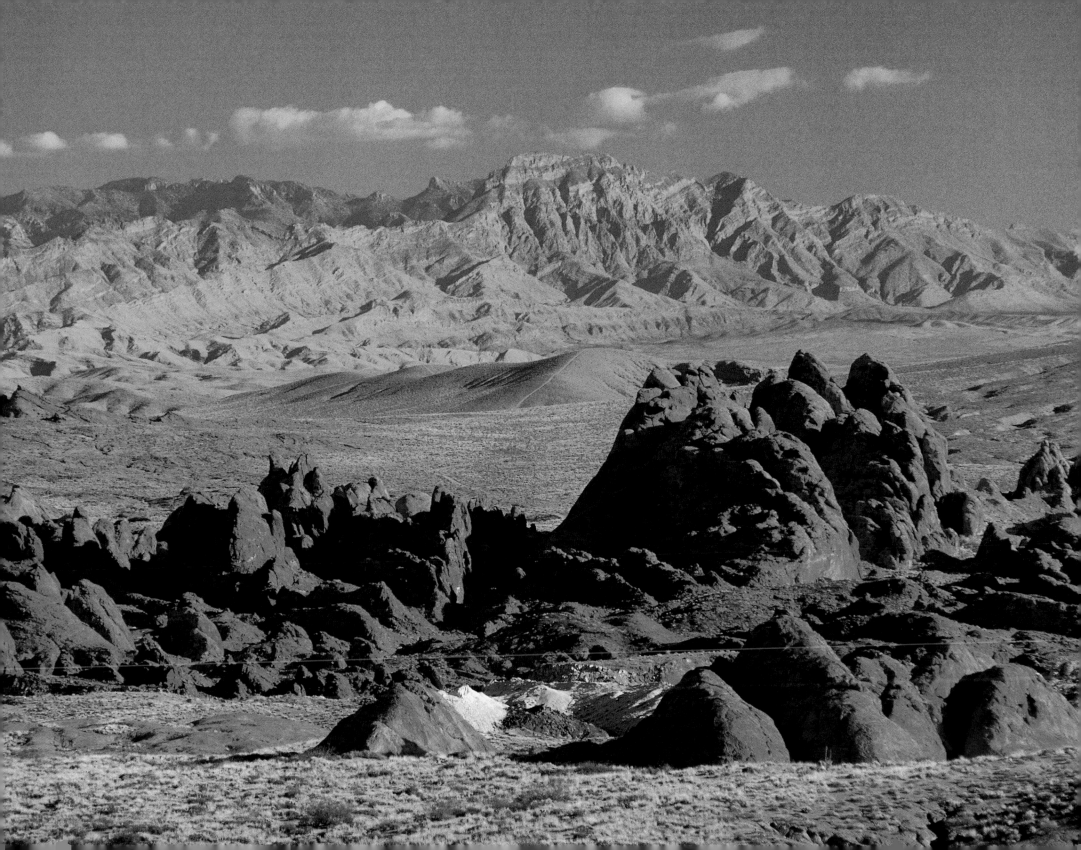

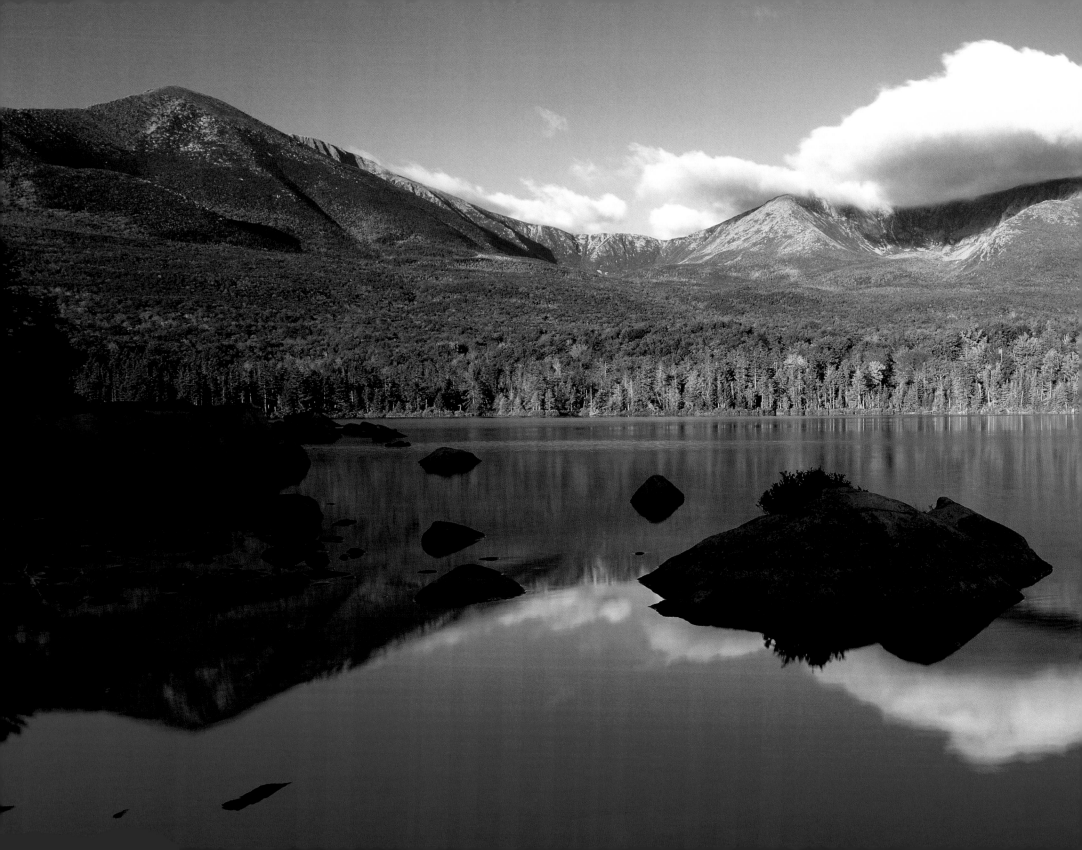

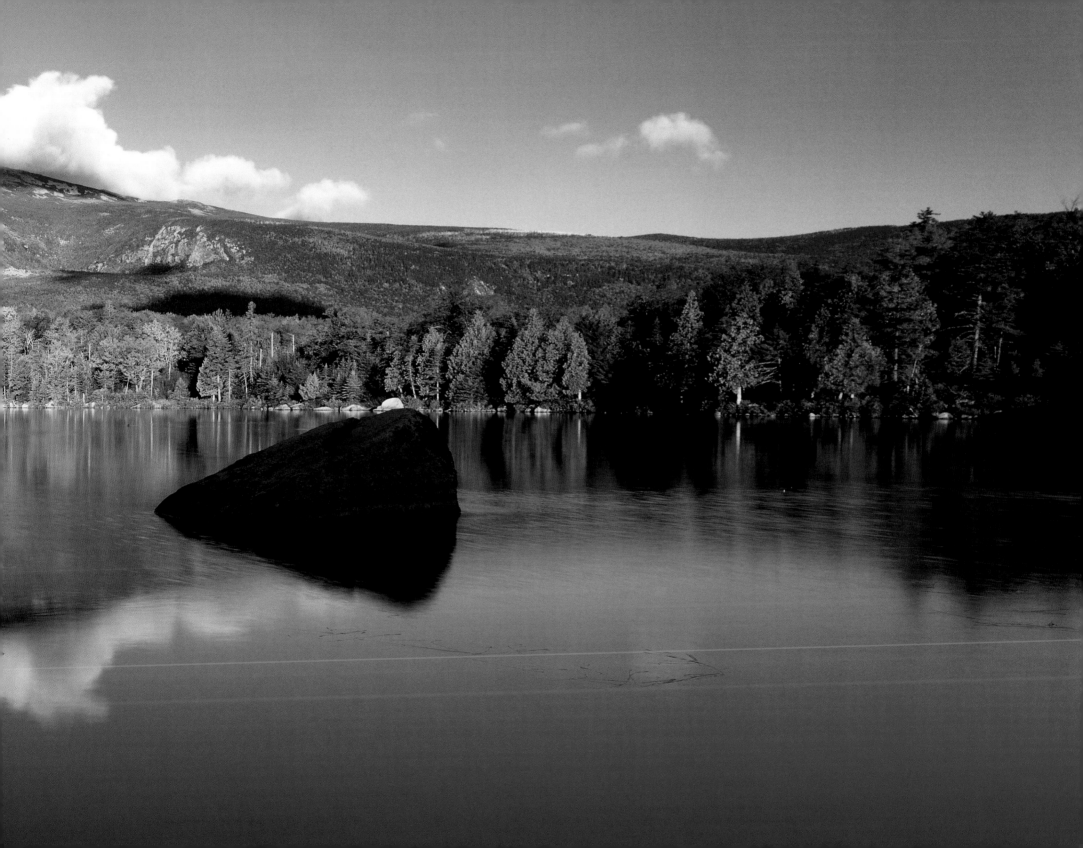

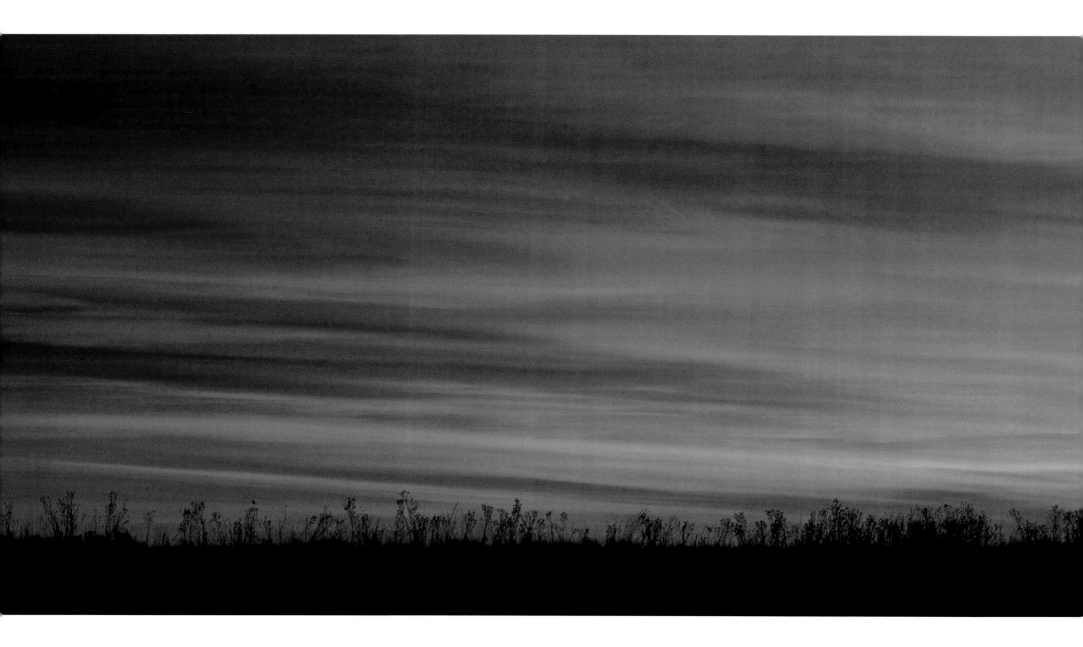

previous page: Sandy Stream Pond, Baxter State Park, **MAINE**.

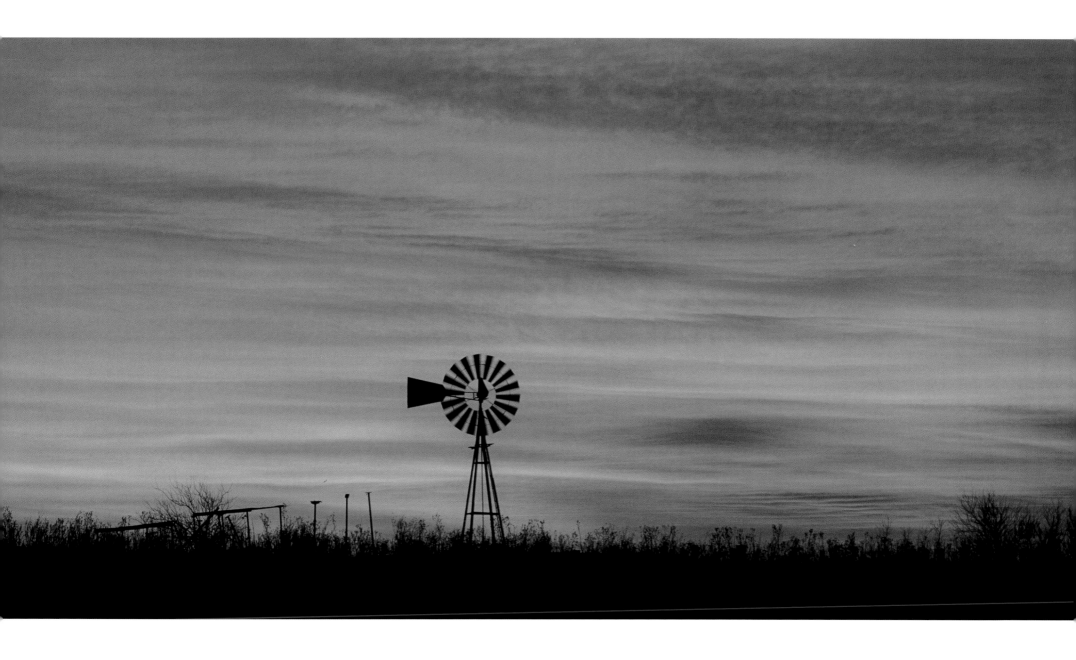

OKLAHOMA

Harvest silhouette, Elk City.

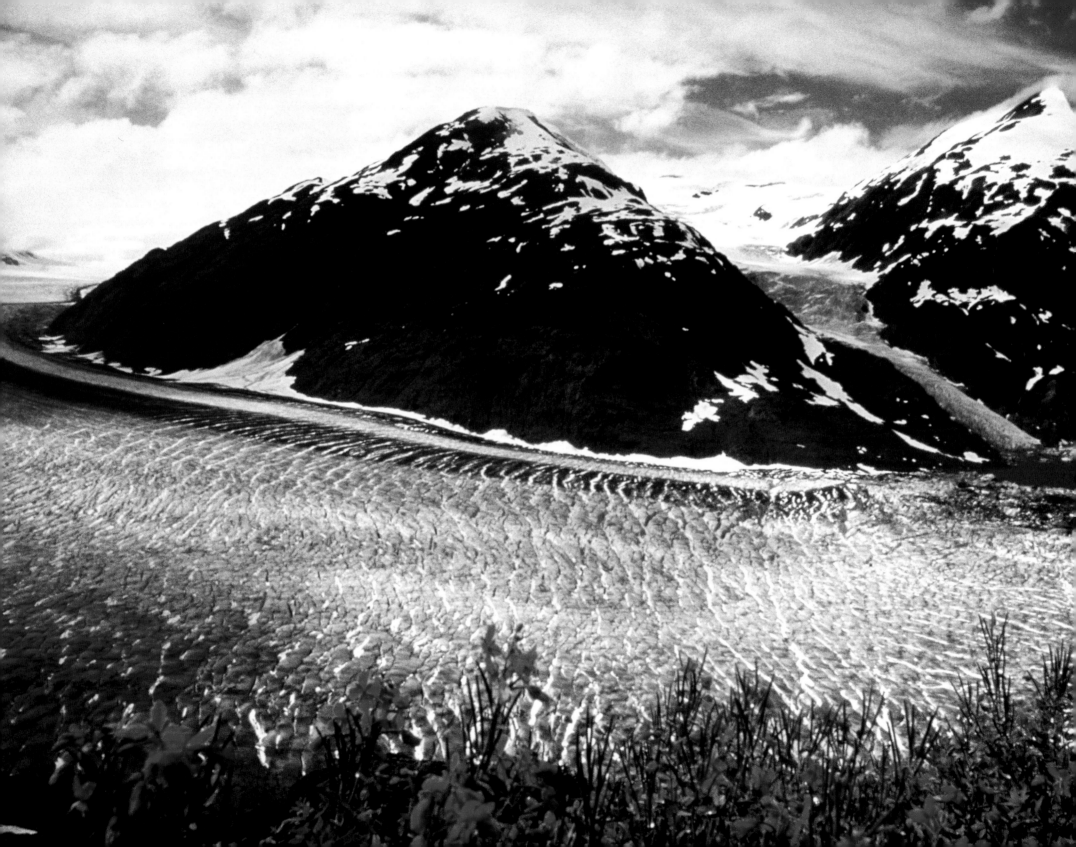

ON THE EDGE

The art of landscape photography is by its nature a medium of extremes. In order to capture the image, I am always searching for some inaccessible vantage or an angle that hasn't been shot before. Often that challenge takes me on a journey to the very edge of my physical, mental and creative limits. Harsh weather conditions, equipment failure and awkward locations appear to conspire against me, but some of my best work has been conceived under pressure.

My use of the panoramic format pushes me to explore the boundaries of photography. With traditional 35mm cameras I find it relatively easy to compose an image within the boundaries of the frame, but shooting panoramic means there is three times the area to fill and three times as many variables to consider. Shooting verticals is even more demanding because the format is designed to encompass a wider field of view, and as the camera is so close to the foreground it can play havoc with perspective. It is awkward composing a vertical panoramic shot – but when done properly it can be incredibly powerful and worth the effort. Exposure is another consideration I constantly push to the limit. Working with slow film and low light means I am often using very long exposures. Add to that the extra stops needed to compensate for a polariser and a ND Grad filter, and a ten-minute exposure can blow out to thirty. It means that at crucial times of the day I literally only get one chance at the image.

It kills me when I know I've missed a shot and I never forget the ones that got away! One evening driving through the open plains of Kansas I could feel the tension of a storm brewing. The air was oppressive and pressure was building, intensifying the sky to an angry magenta. I started tearing up and down the deserted back roads trying desperately to find something to put in the shot. It was driving me crazy – all I could see was this incredible painted thunderhead in my rear vision mirror with nothing in front but open road. I refused to settle for second best because I just knew something would appear that could complete the perfect shot. Unfortunately I was wrong – and I was devastated. I had to watch helplessly as the dramatic lightshow darkened and faded into black.

My existence is a reverse cycle of everyone else's - the prime times for shooting are sunrise and sunset when I'm racing against the clock, fuelled purely by the adrenaline rush of capturing the perfect image. I only have a very short window of light in which to work. I spend the whole day searching for locations and compositions, then about five or ten intense minutes in which to get the shot. I live my life constantly on the edge - the edge of a road, the edge of a cliff, on the edge of the day and on the edge of the perfect opportunity.

I chase the light - and sometimes I get it right.

ALASKA
Glacier, Hyder.

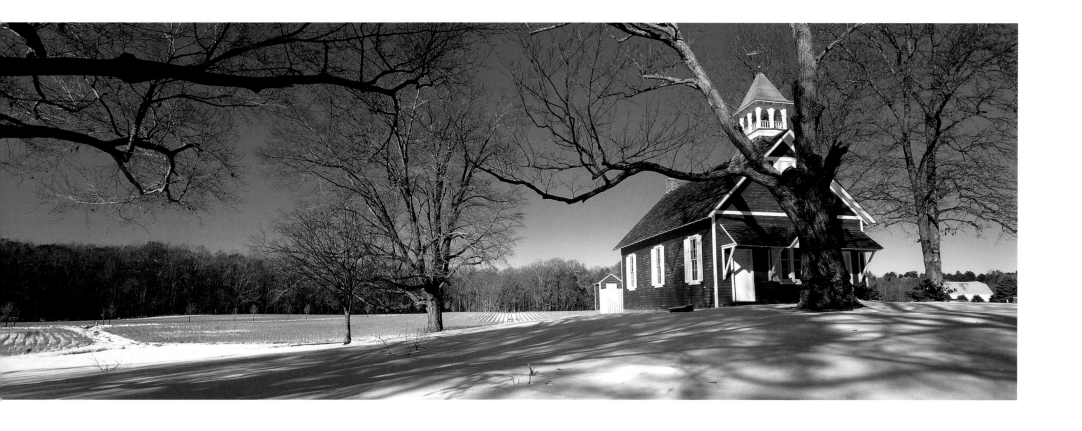

MARYLAND

Little red school house, Wye Mills.

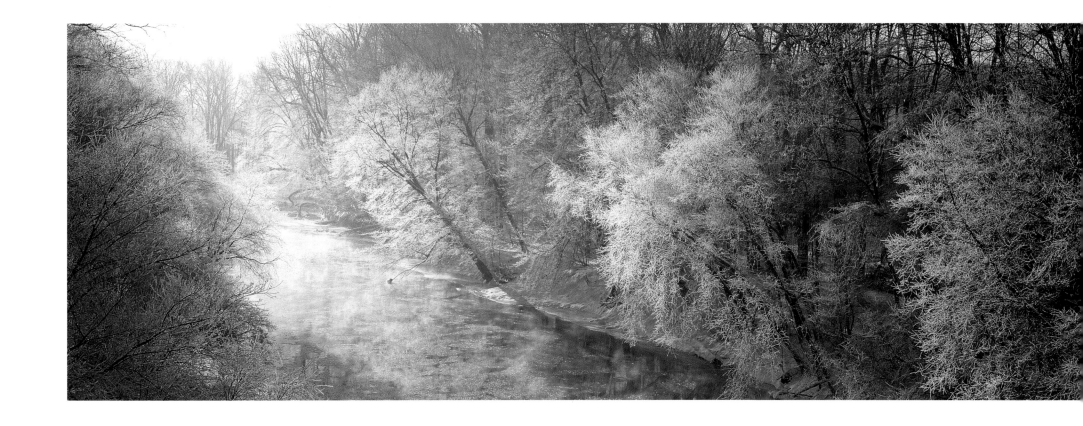

O H I O

Early frost, Wayne National Forest.

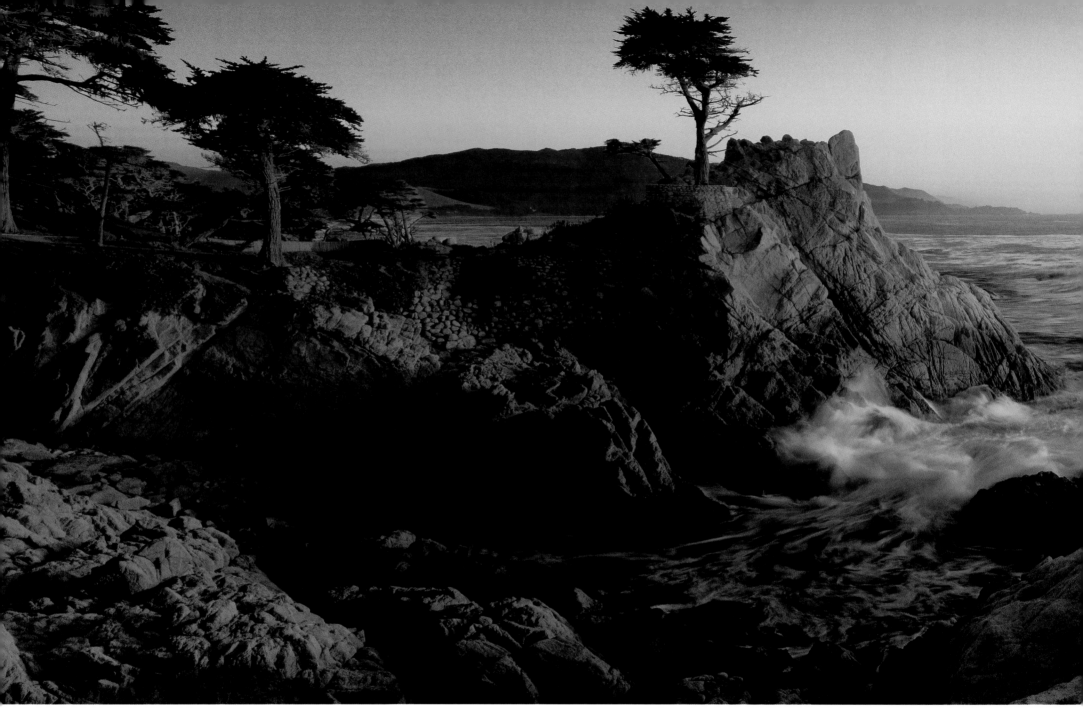

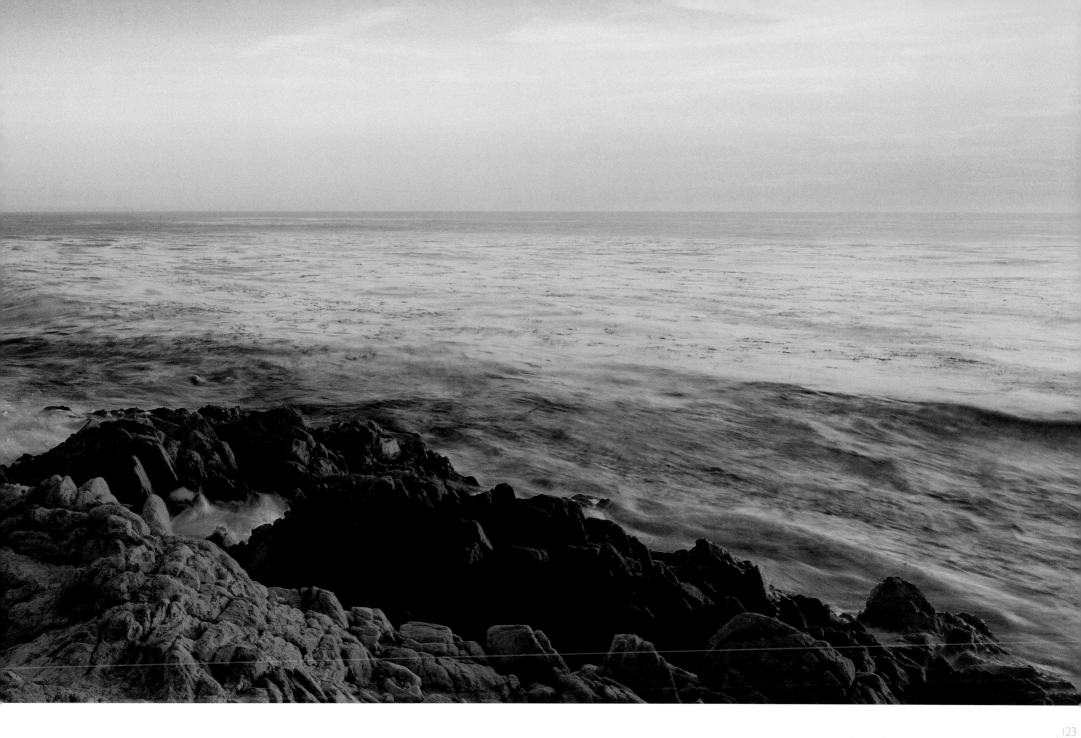

Lone Cypress, Carmel.

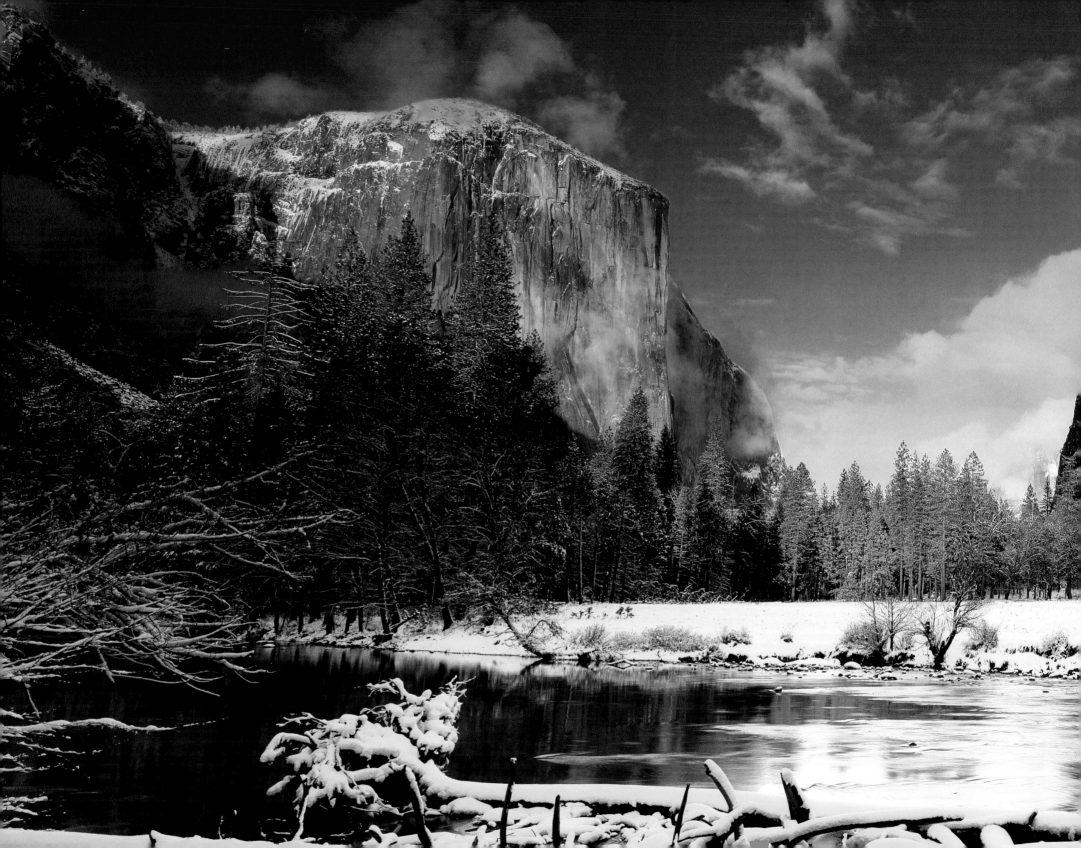

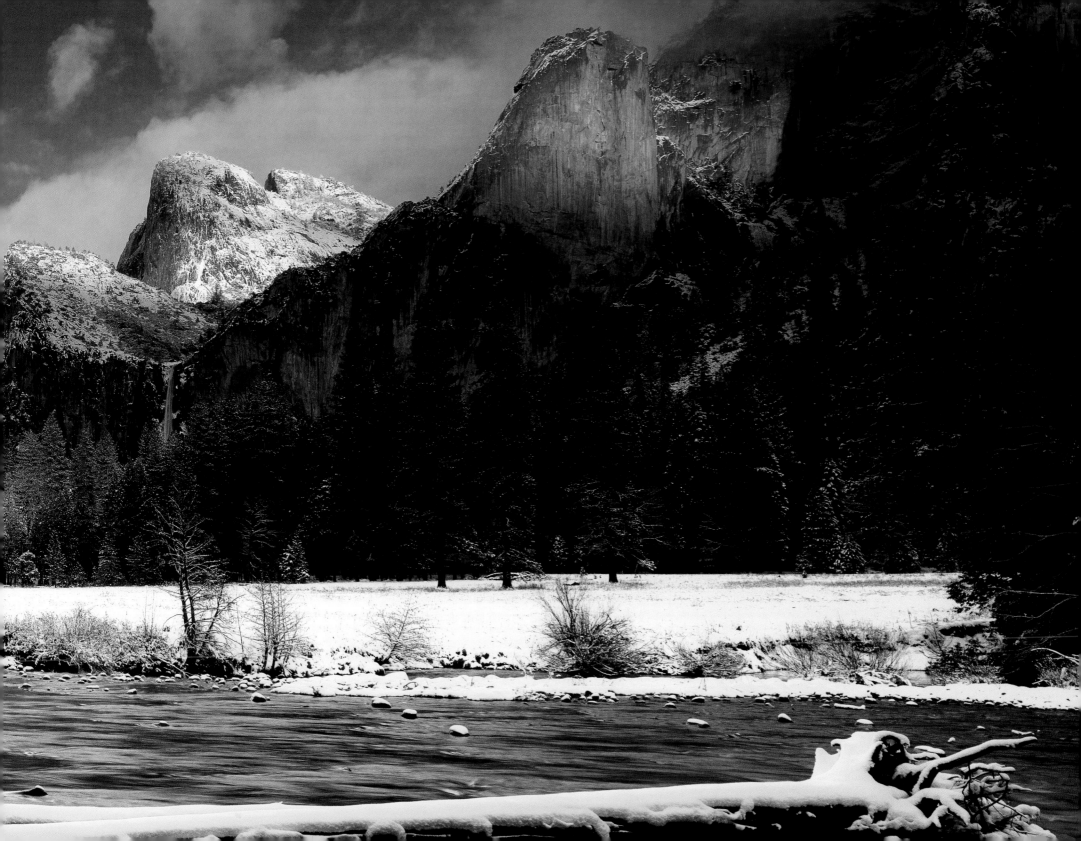

Light paints the picture - the photographer records it. A perfect moment, a perfect hue or a perfect shadow disappears in an instant. The elusive right time to shoot – a secret place and an indefinable mood. I chase the shadows which sculpt the land and observe the light

IDAHO

previous page: Icy waters, Yosemite National Park, **CALIFORNIA**.

Salmon River.

126

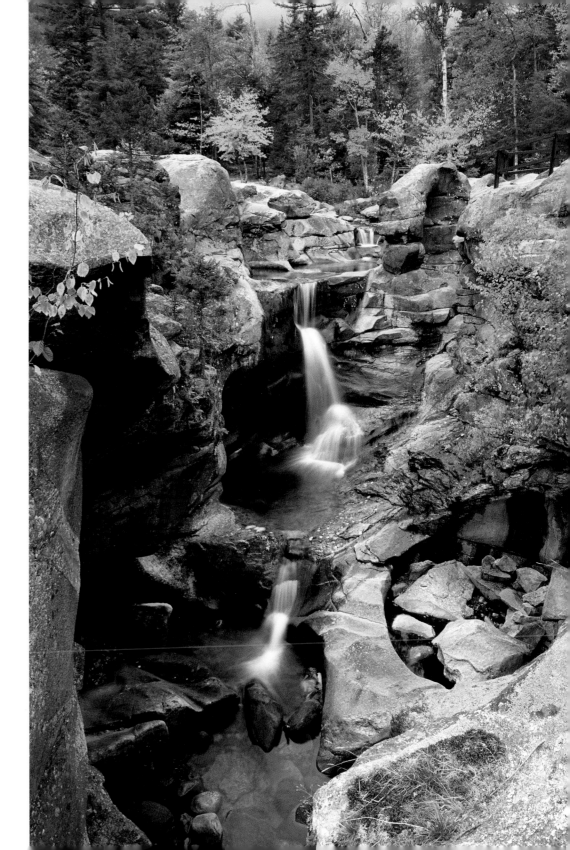

MAINE

Screw Auger Falls, Grafton Notch State Park.

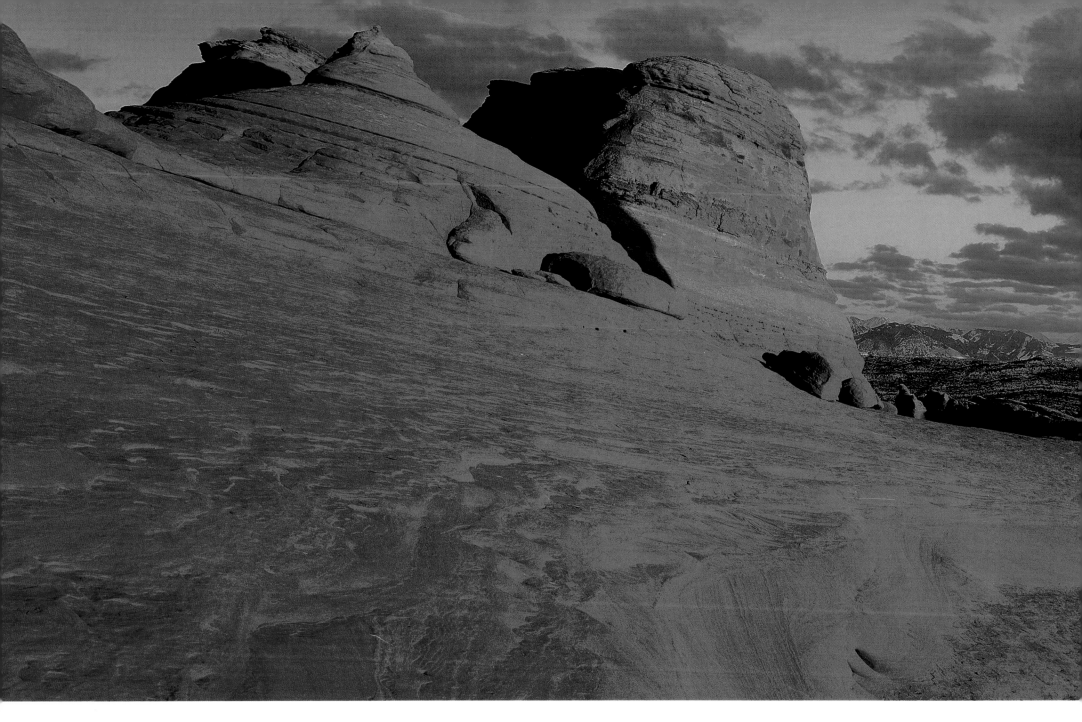

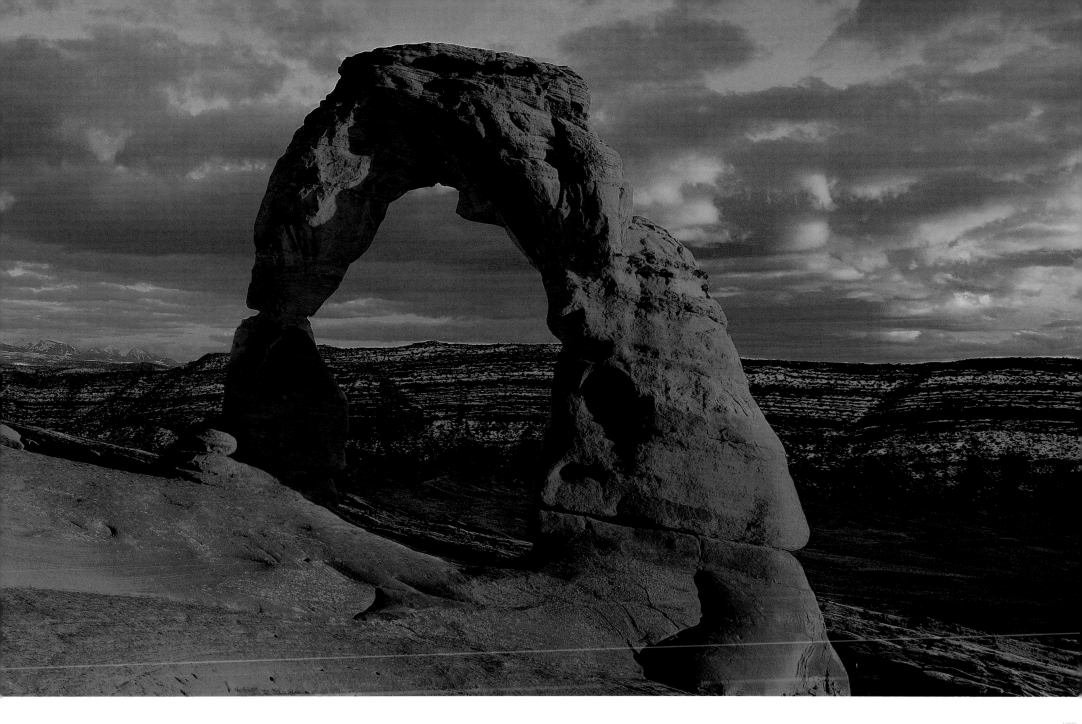

Delicate Arch, Arches National Park.

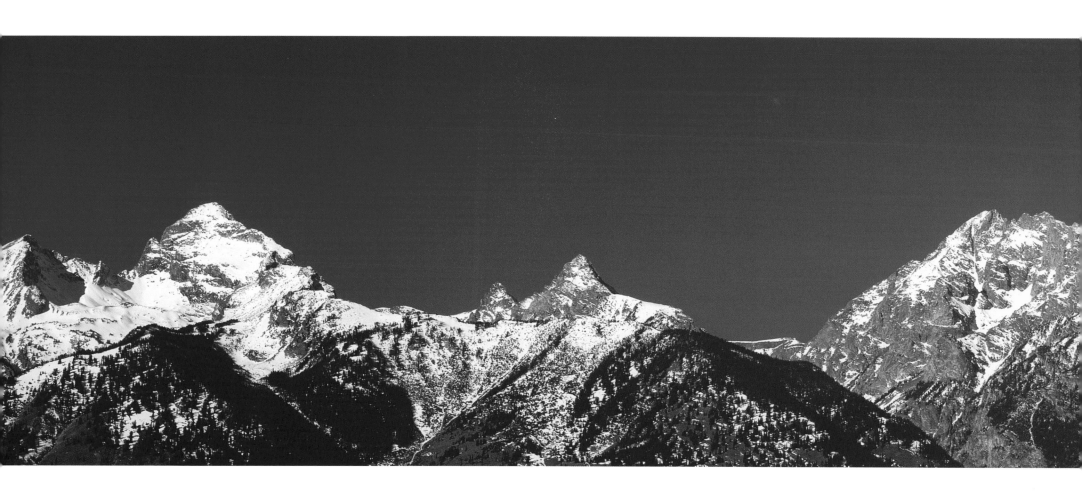

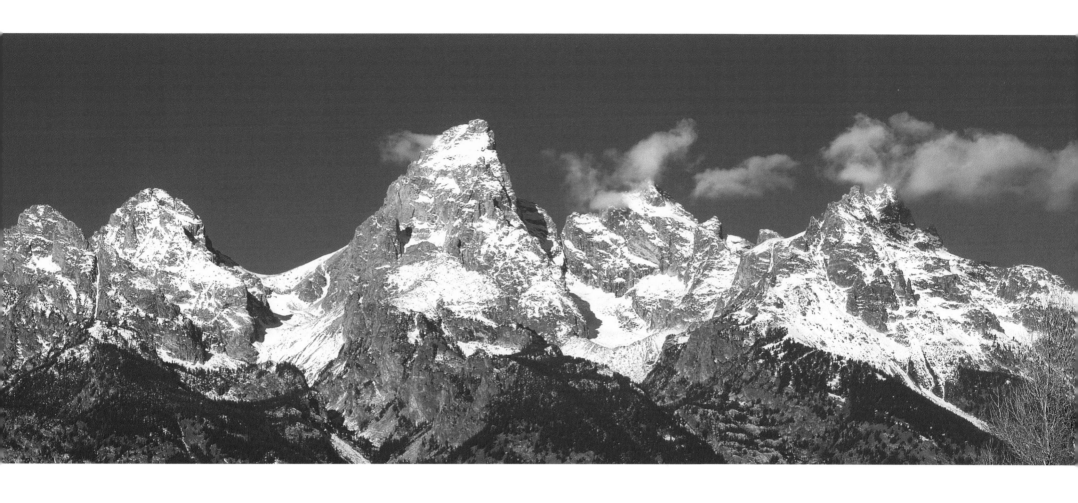

WYOMING

Grand Teton National Park.

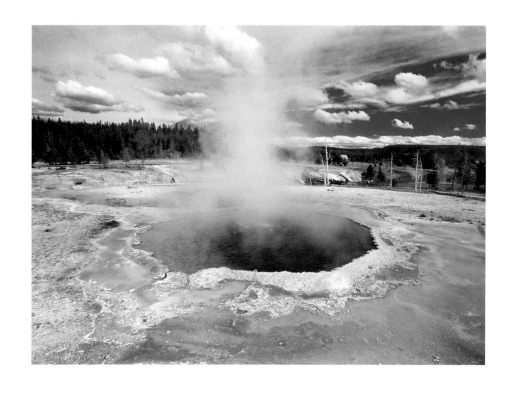

Hot Spring, Yellowstone National Park.

Artist Point, Lower Falls, Yellowstone National Park.

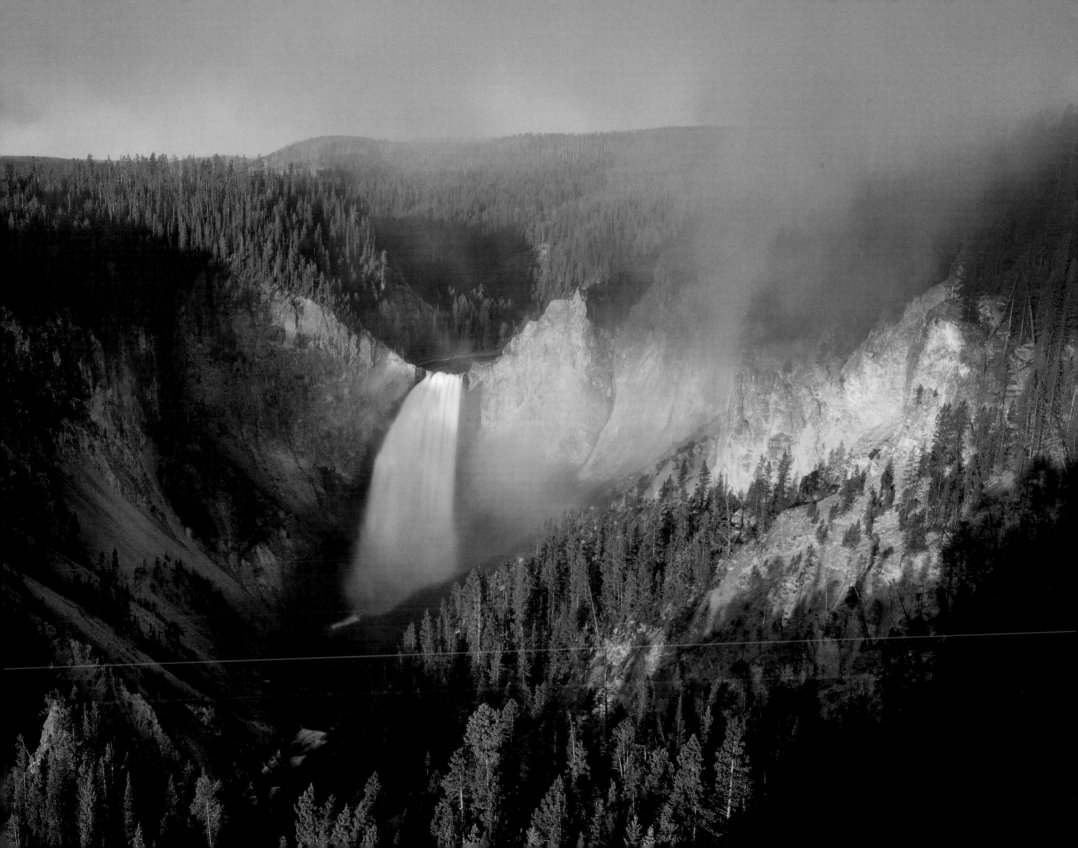

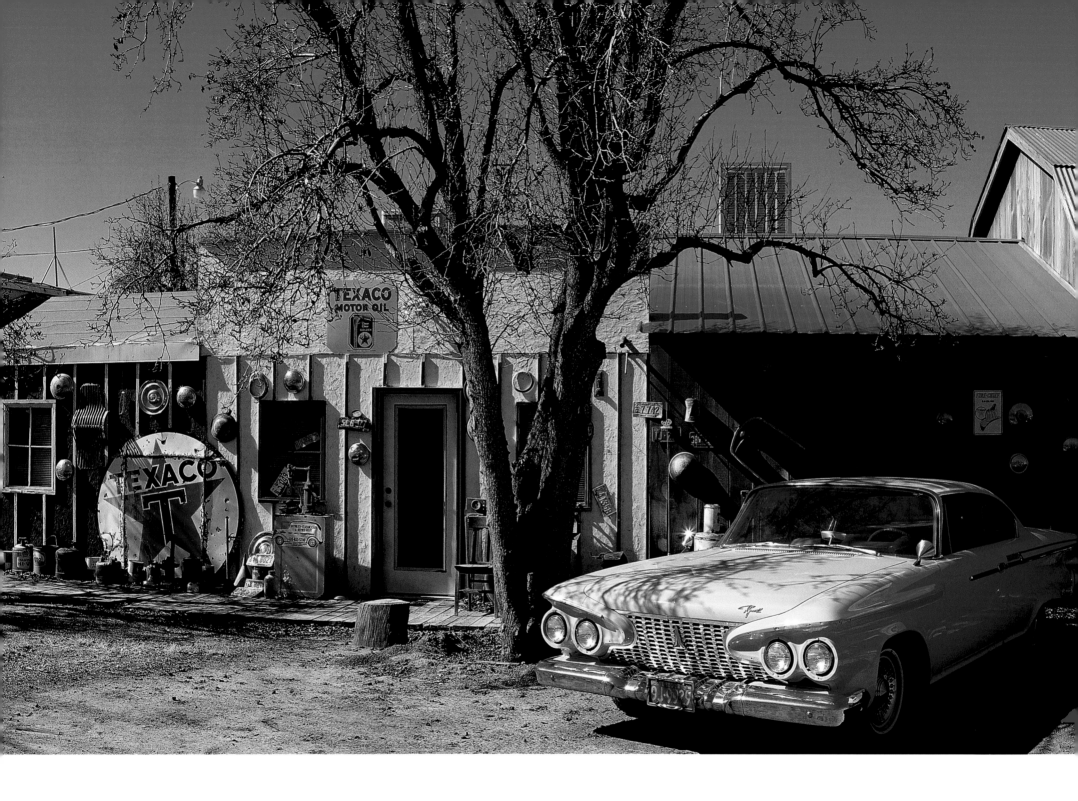

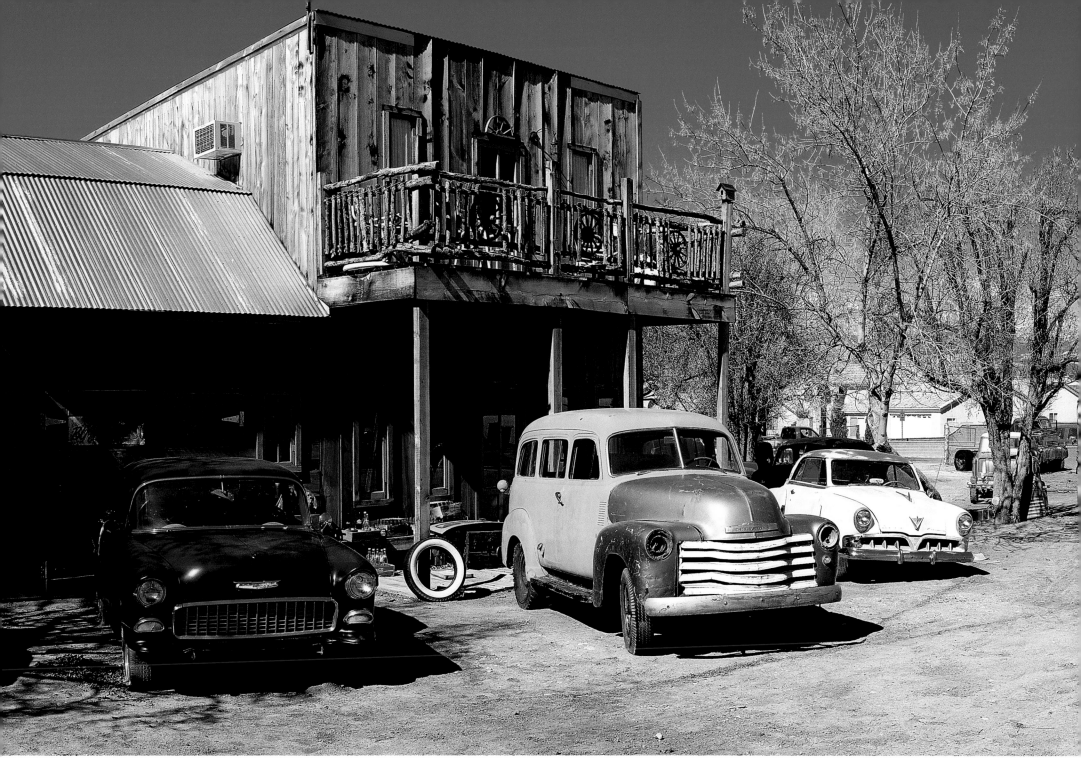

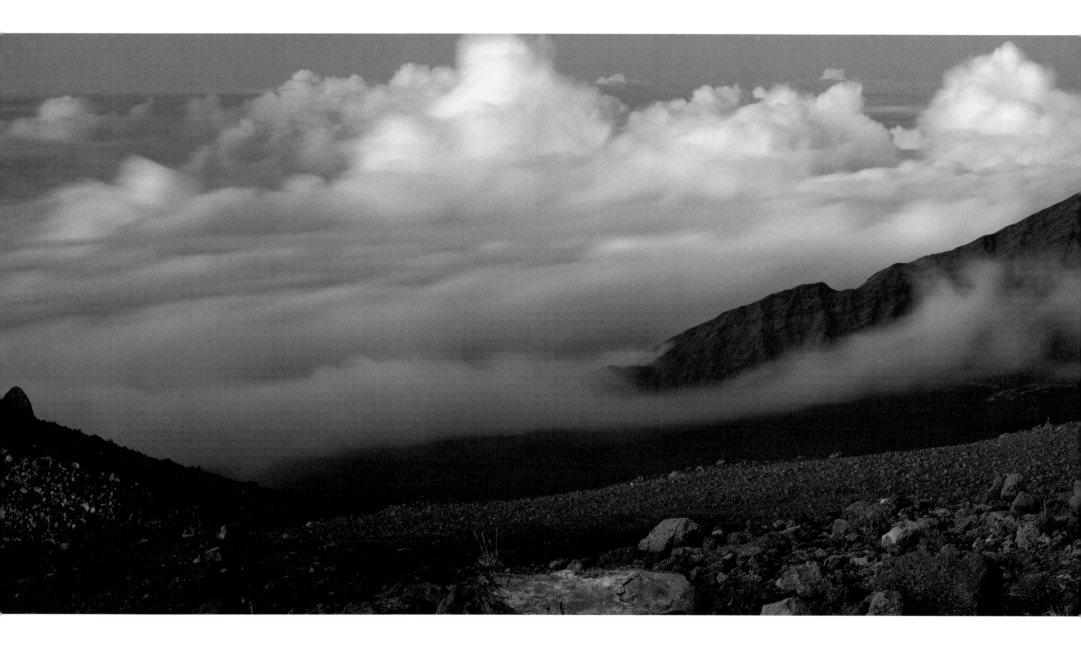

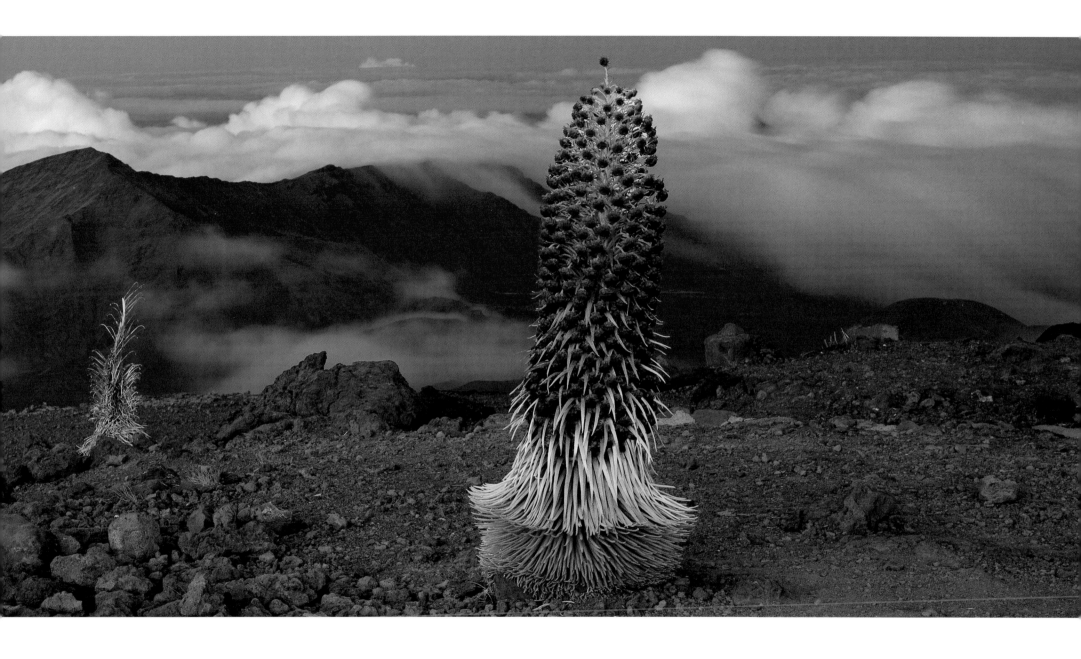

HAWAII

Silver Sword, Haleakala National Park, Maui.

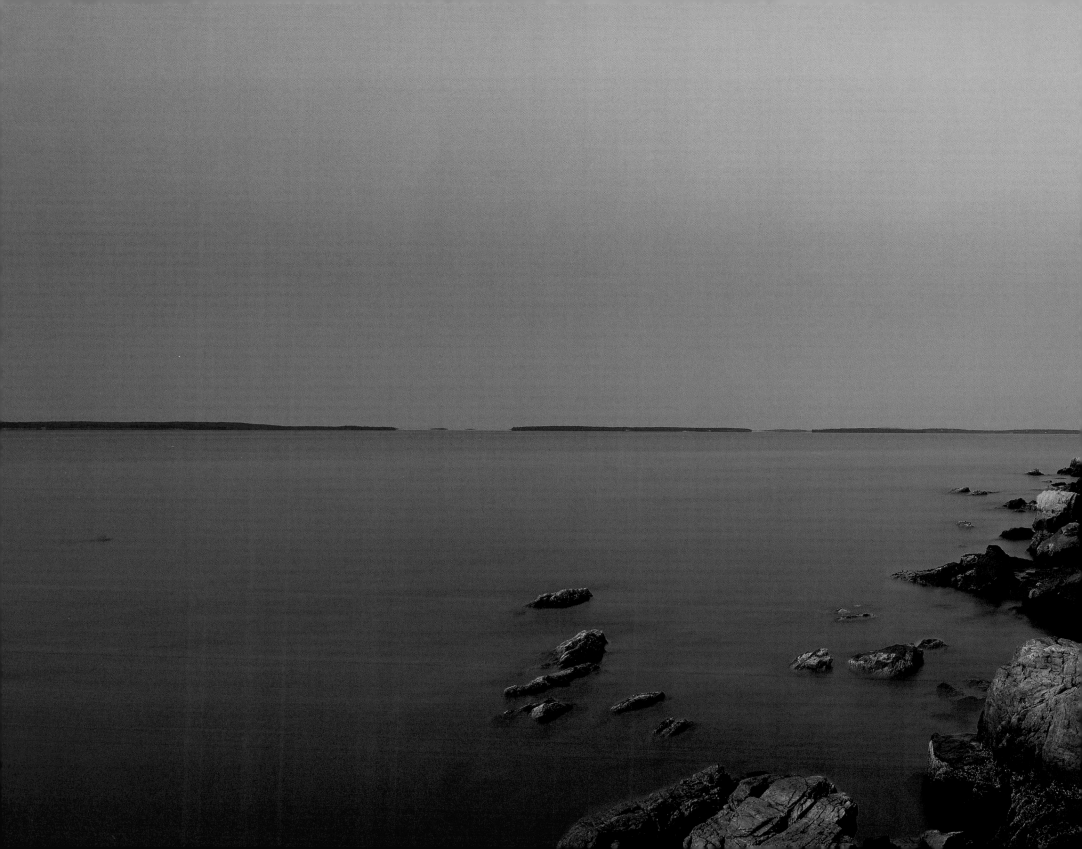

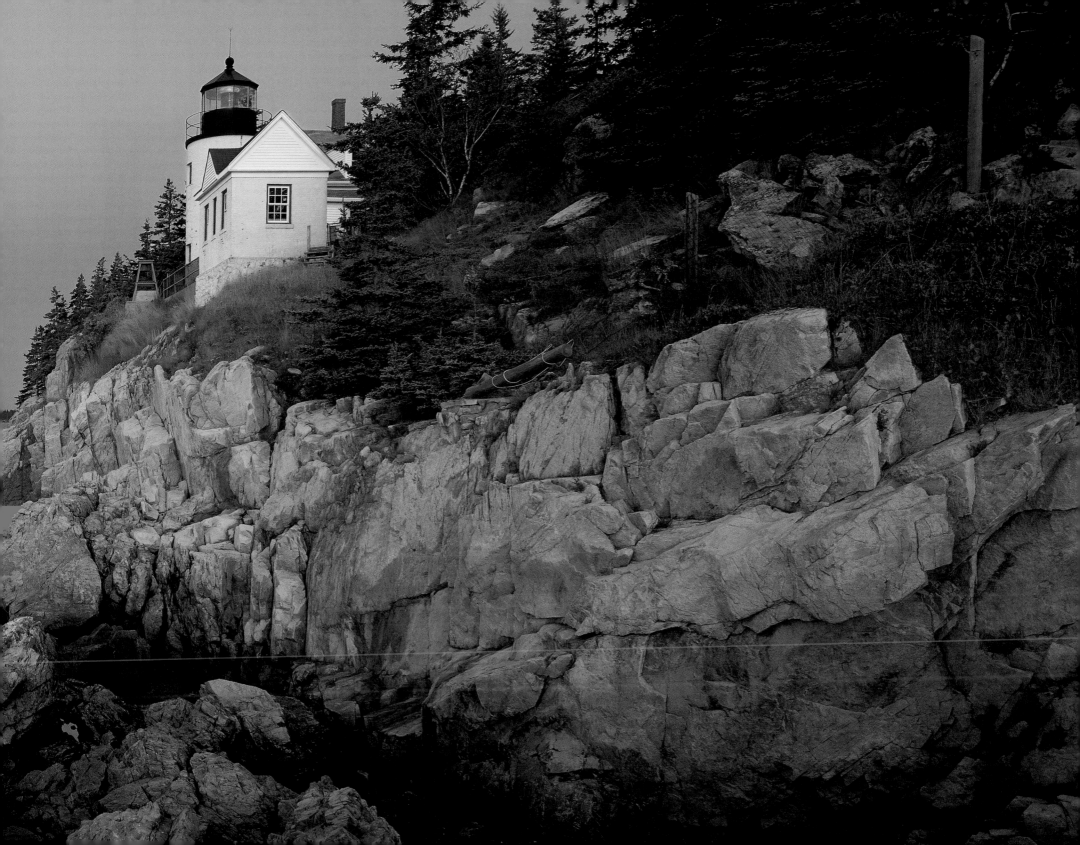

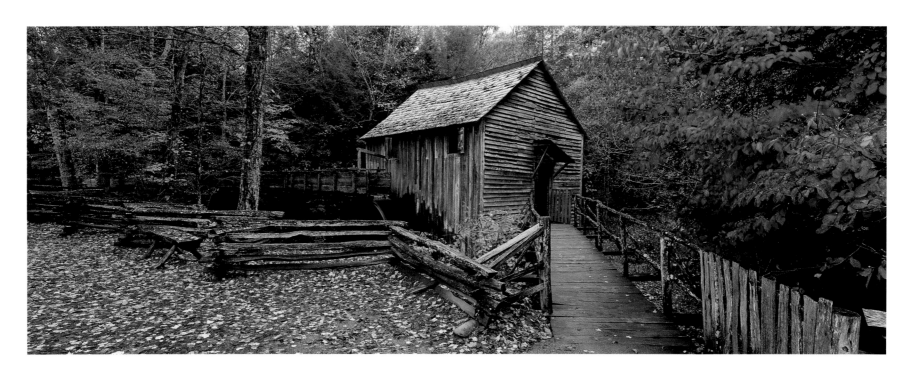

Cades Cove, Great Smoky Mountains National Park.

previous page: Bass Head Lighthouse, Acadia National Park, **MAINE**.

Great Smoky Mountains National Park.

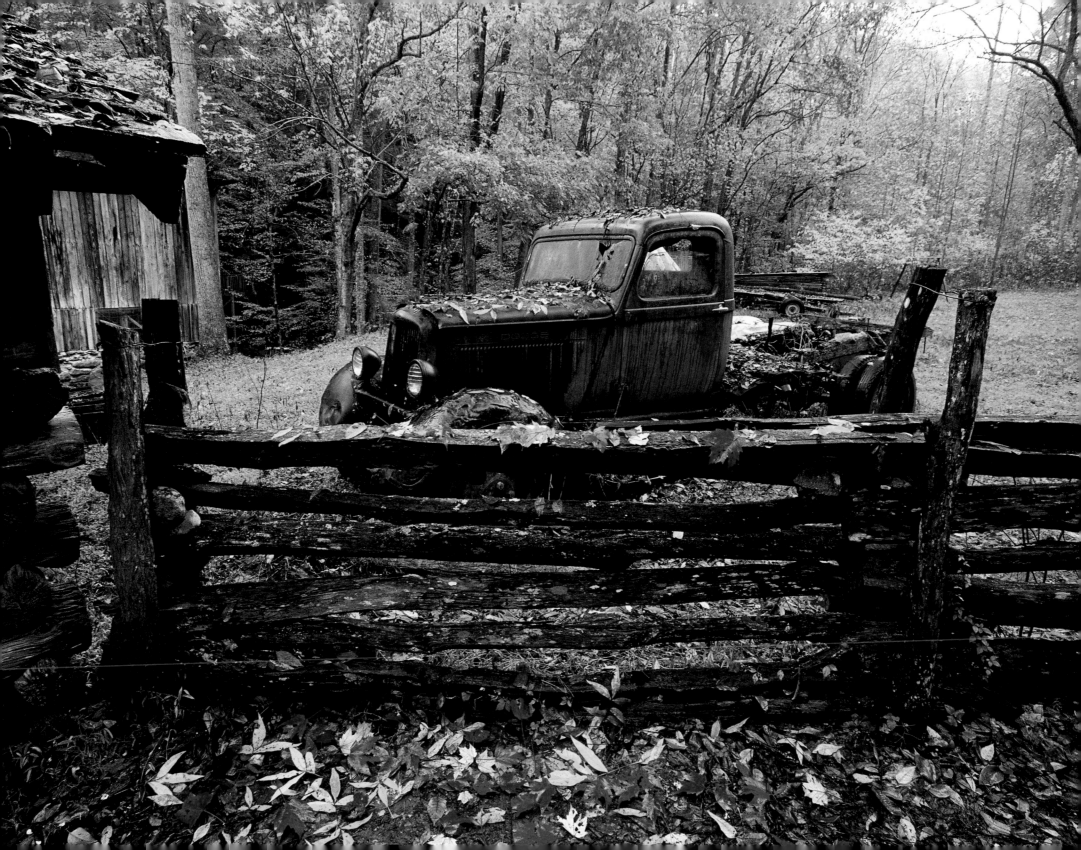

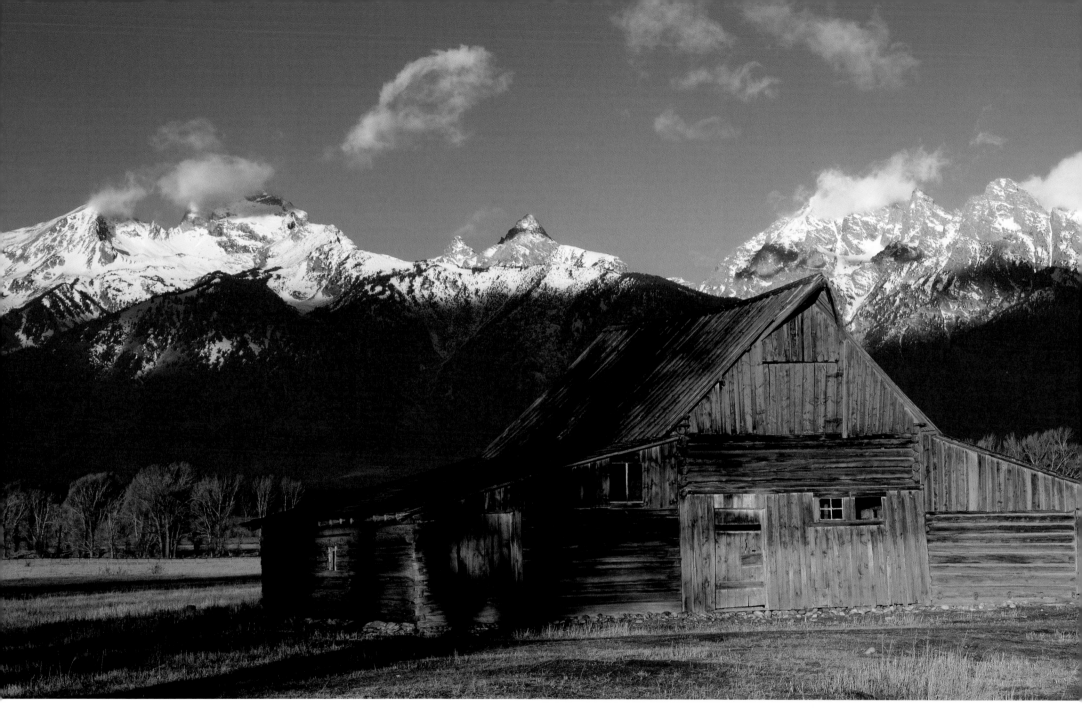

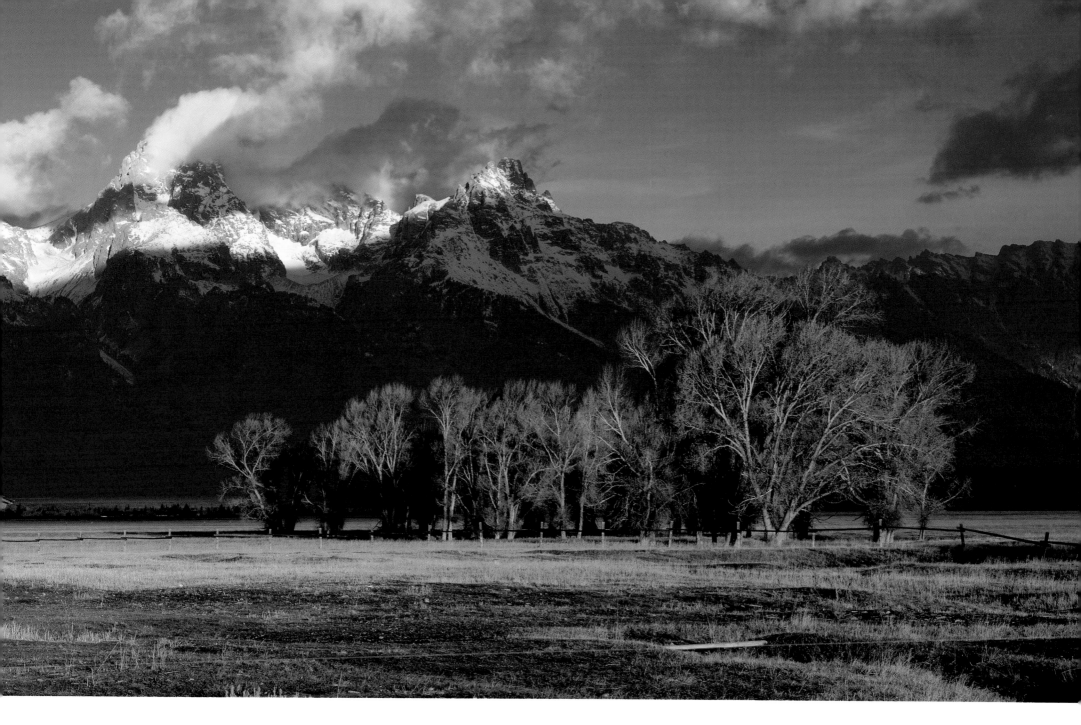

WYOMING

Grand Teton National Park.

Composition is governed by line, shape, tone and color, but sometimes the true strength of an image lies in what you leave out of the frame not what you put in. By isolating an individual element, or choosing an unusual focal subject I often discover a whole new dimension. I've learnt to see beyond the visible landscape – to scale down and really look into a scene.

While shooting the fall colors, low light and slow film meant I sometimes had to wait days for the right conditions. I nearly always imagine a shot before I actually see it, then my real challenge is in finding it. With perseverance it's a technique that can work well, but sometimes I end up searching for shots that don't exist. A subject as broad and abstract as the fall has no real defining features, and I found myself having to look within the larger picture for my image.

I was overwhelmed by a confusion of color as I explored New England. I had no specific landmarks to look for, no 'must see' locations –

STRENGTH IN SIMPLICITY

I was searching more by instinct. Time and time again I would drive over a hill and be faced with an explosion of orange, yellow and all shades of red and green. It literally took my breath away - I had never seen such a concentrated variety of colors and textures. Even so, it was incredibly hard to find the perfect composition that encompassed the entire spectrum of the fall palette. Unpredictable as ever, on more than one occasion Mother Nature delivered me a magic image then a huge gust of wind would carry the shot away in front of my eyes.

Being used to the dense and shadowy rainforests of Australia, I could only guess how the vibrant colors of the foliage would translate under these conditions. Light has a

profound effect on mood and atmosphere and by sitting out a few hours in the forest, I discovered the whole scene could take on an entirely different look from one moment to the next. Over several weeks I explored the subtle shapes and colors of the fall and looked for a new perspective at every opportunity. A symmetrical line up of luminous silver trunks, an intricate close up of a woodland pathway – I took my lead from nature and was inspired by her simplicity.

overleaf: Monument Valley Navajo Tribal Park, **ARIZONA**.

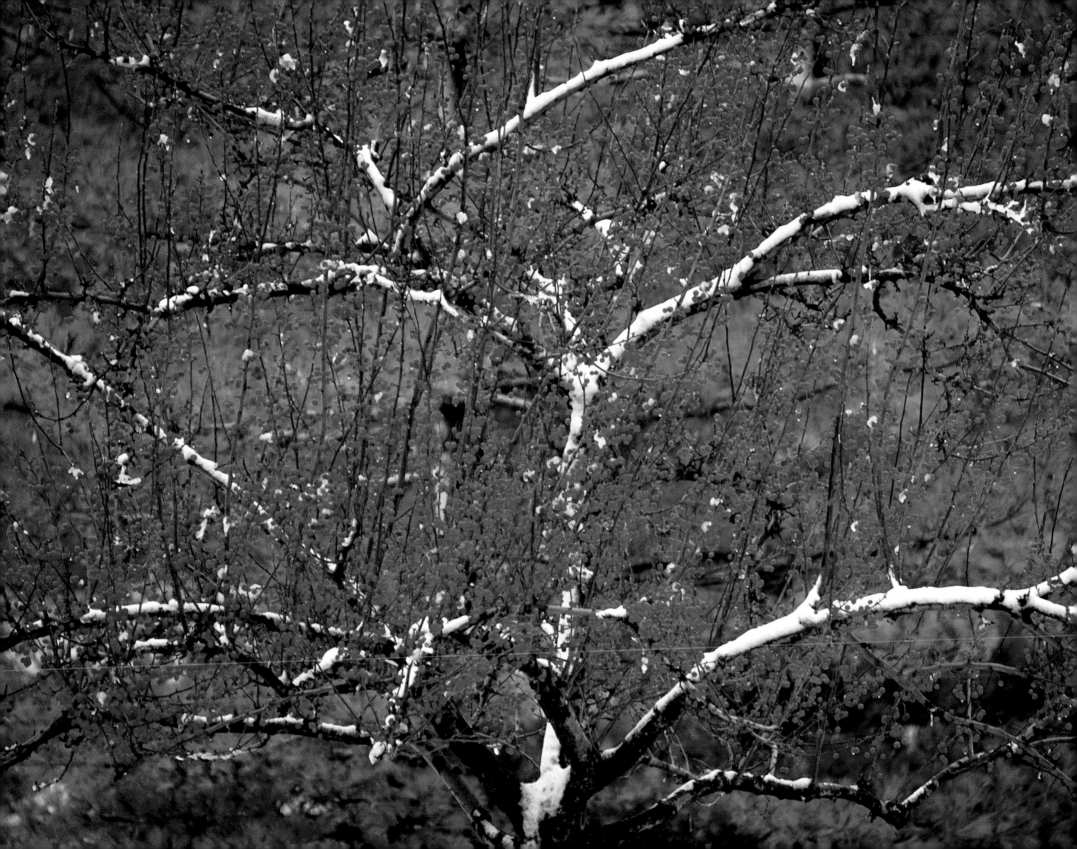

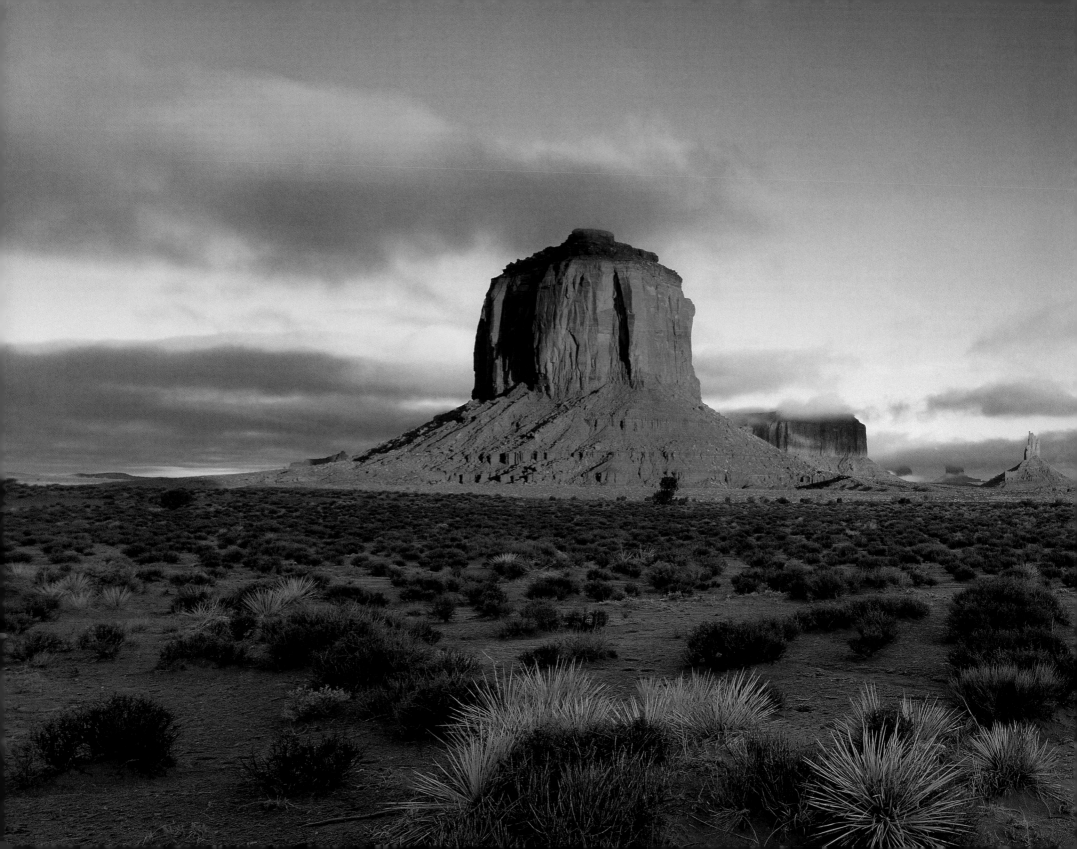

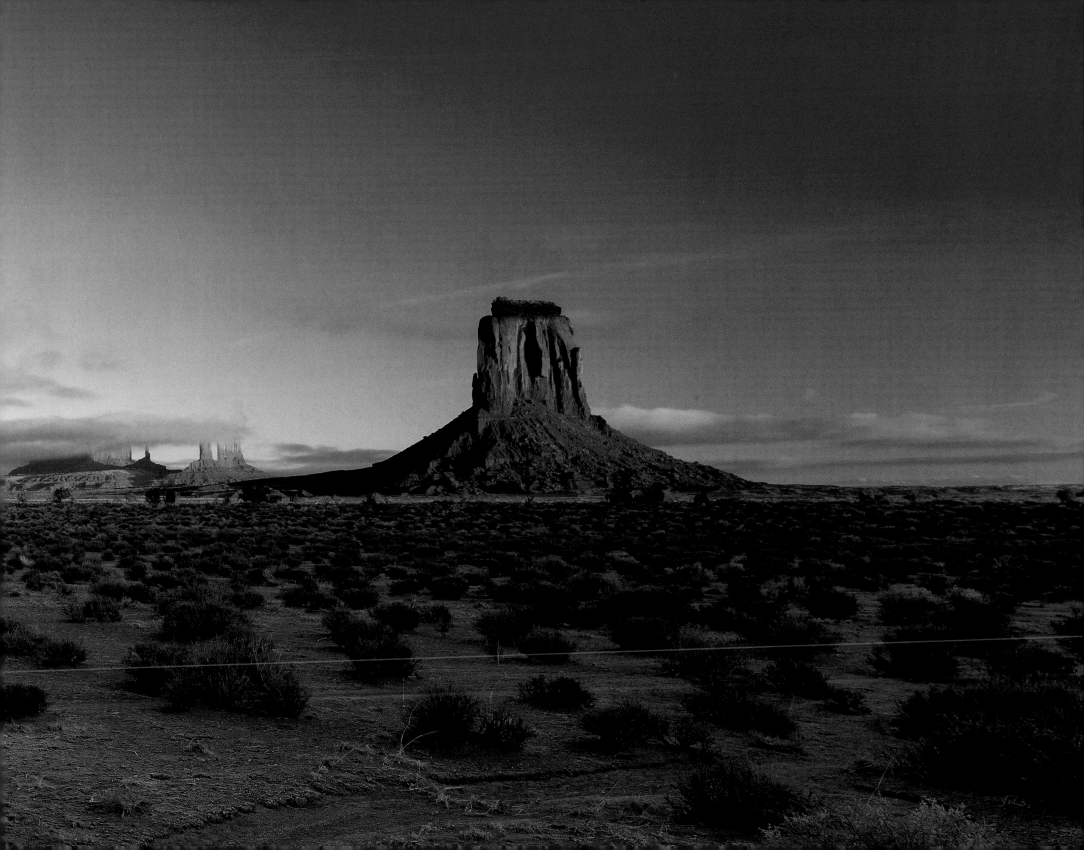

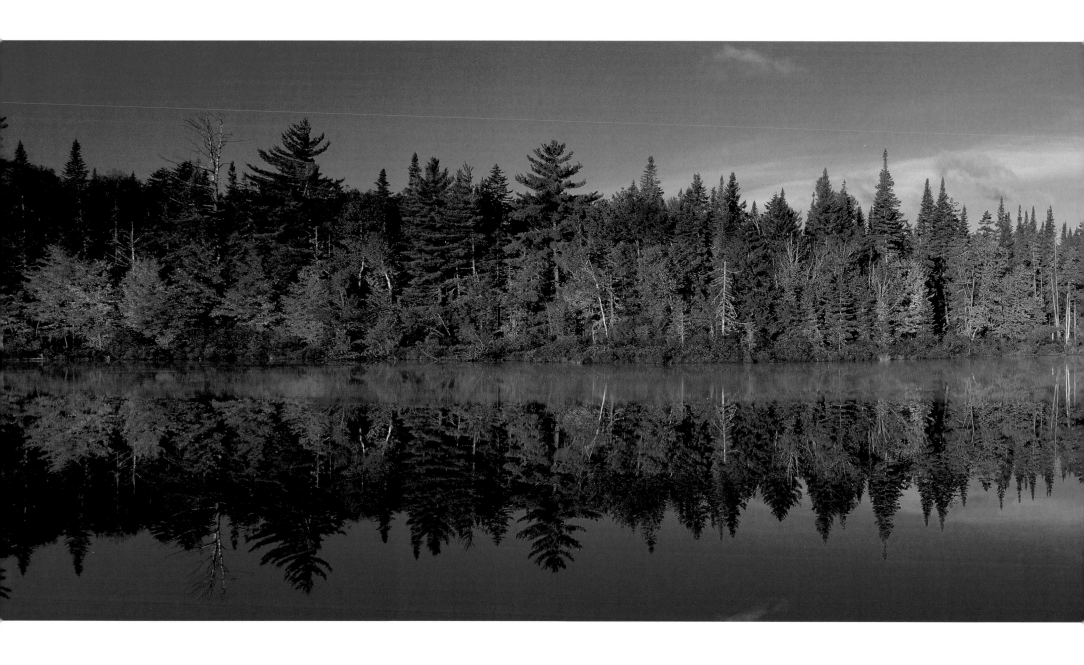

NEW HAMPSHIRE

Androscoggin River Reflections.

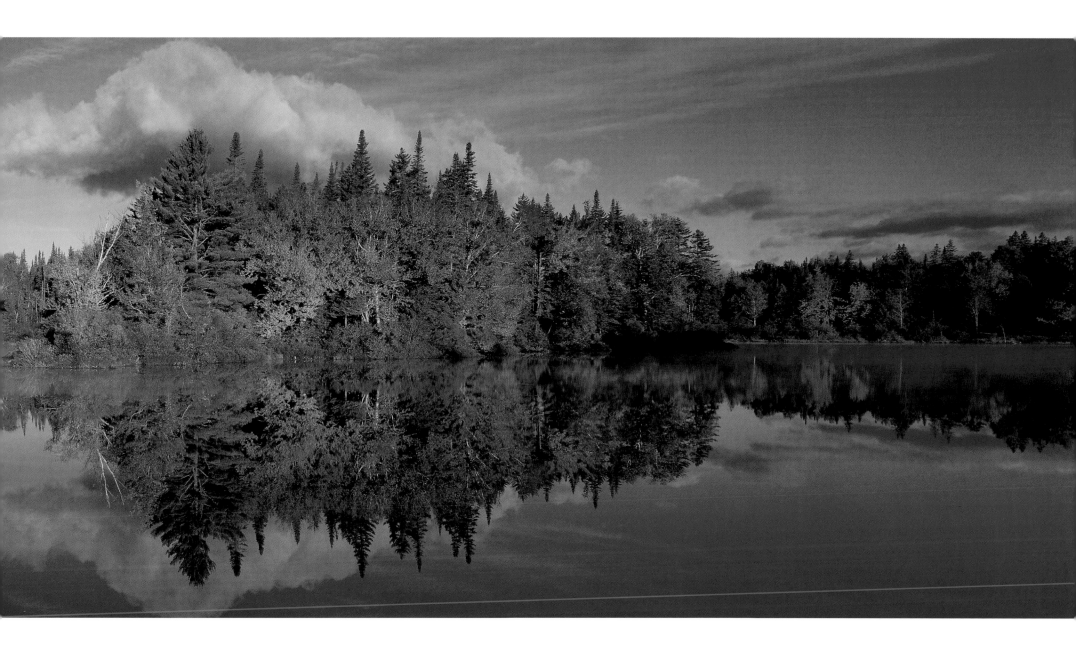

overleaf: Paria Canyon Wilderness, **UTAH**.

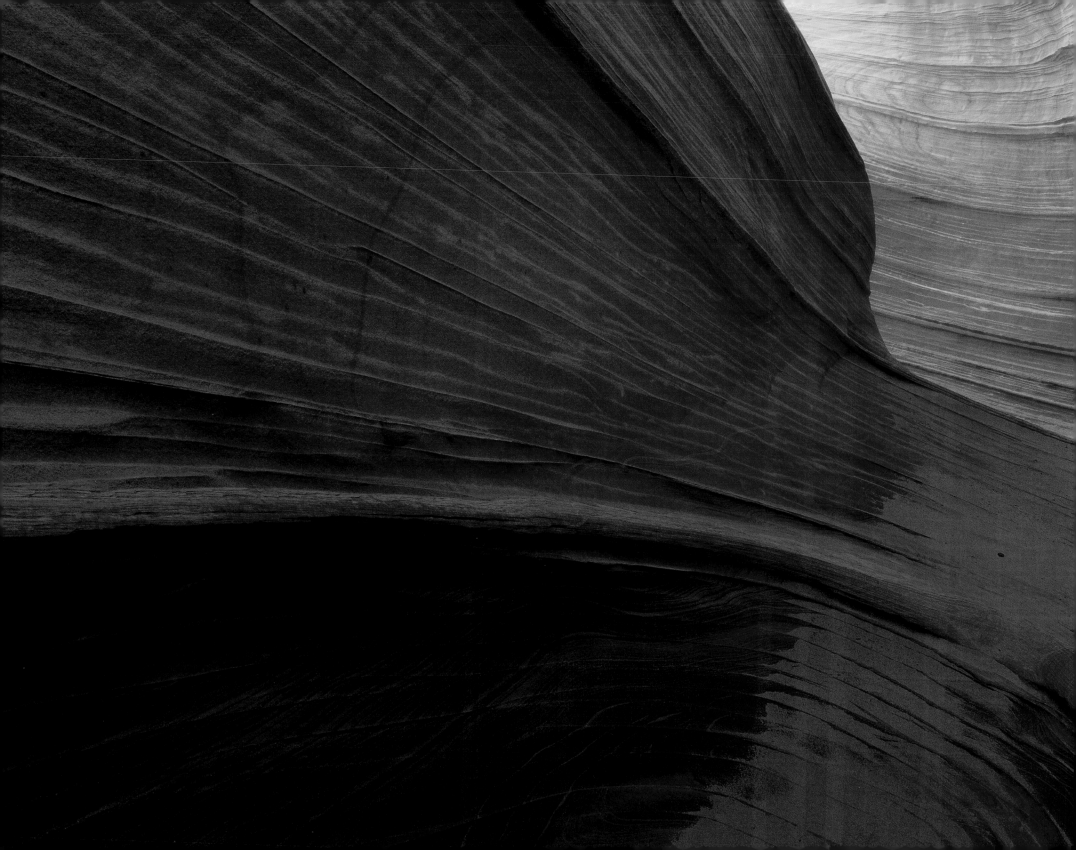

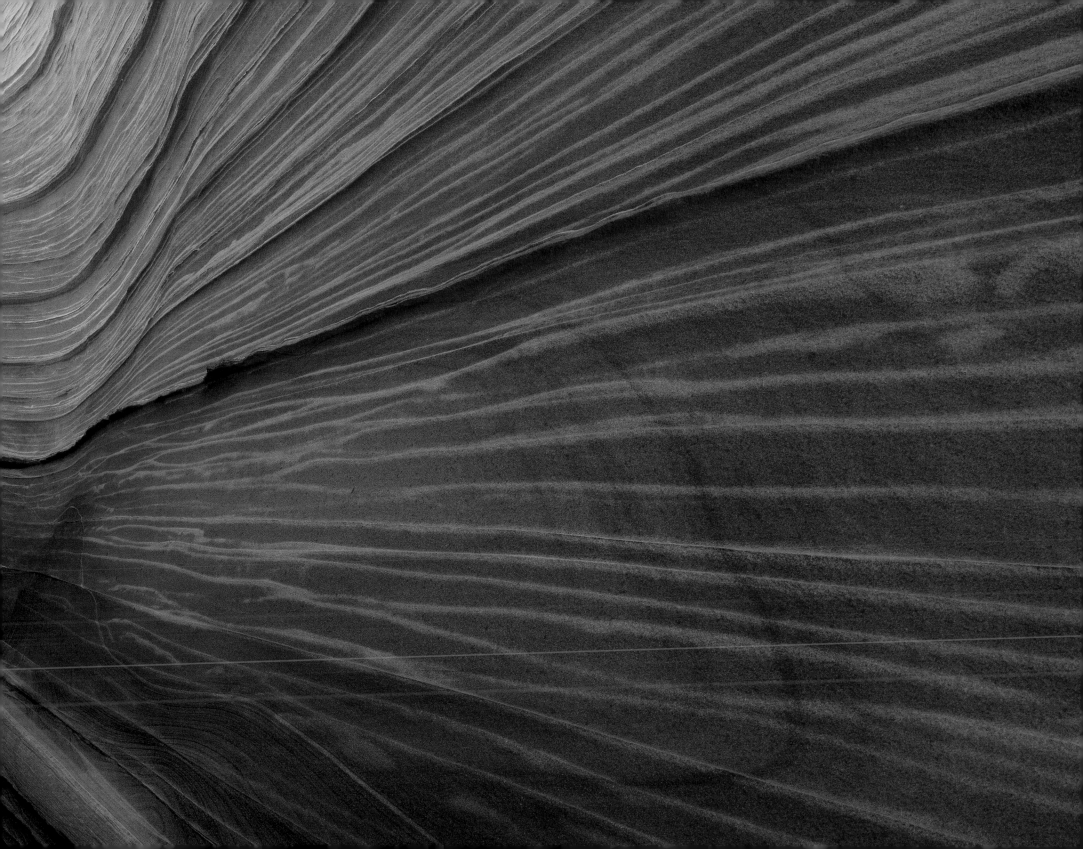

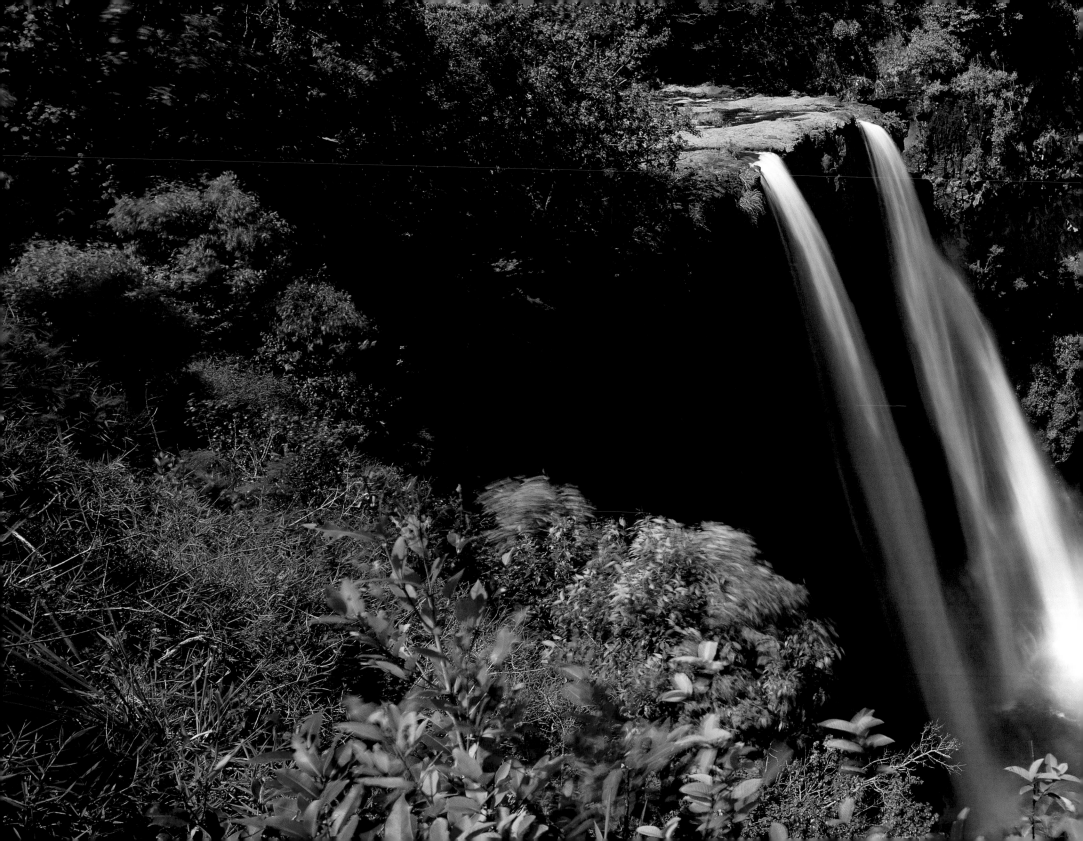

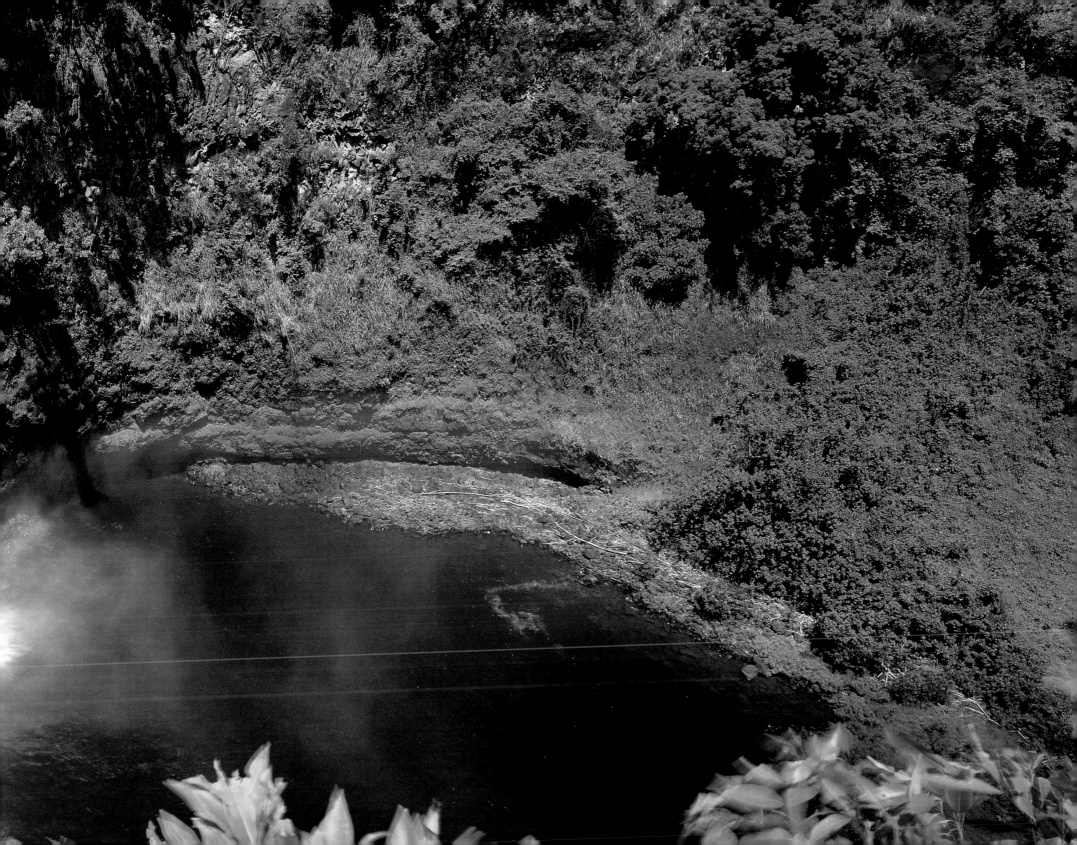

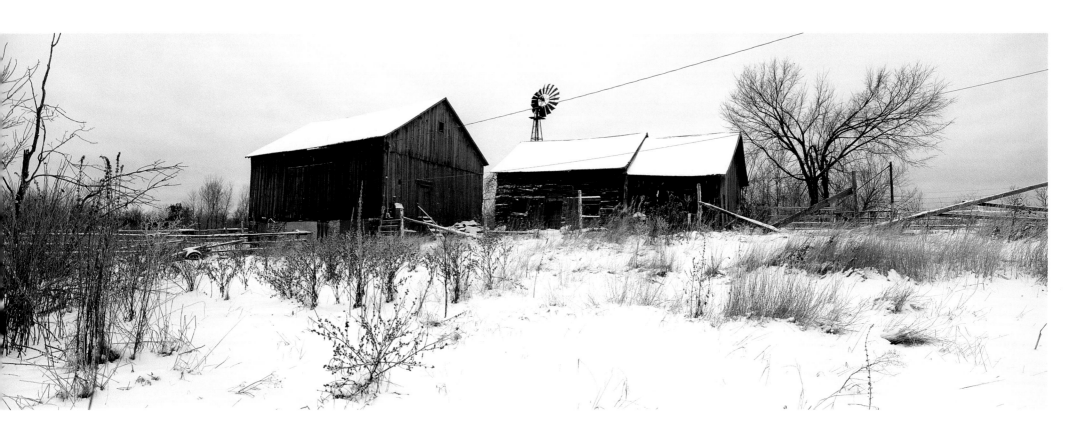

NEBRASKA

previous page: Wailua Falls, Kauai, **HAWAII**.

Winter farm, Central Nebraska.

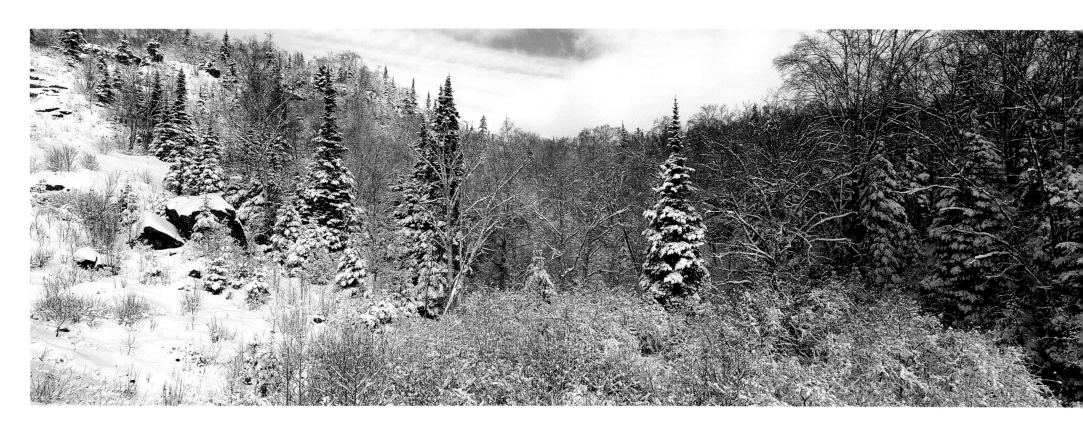

MONTANA
Glacier National Park.

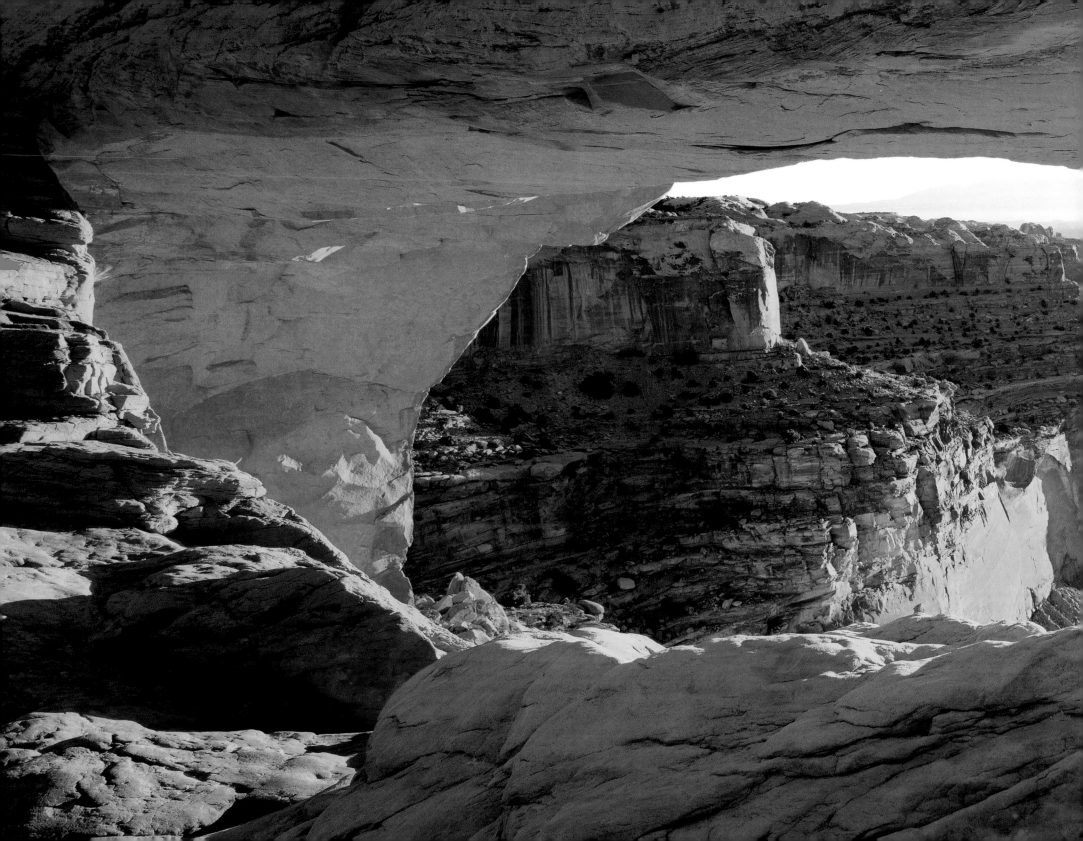

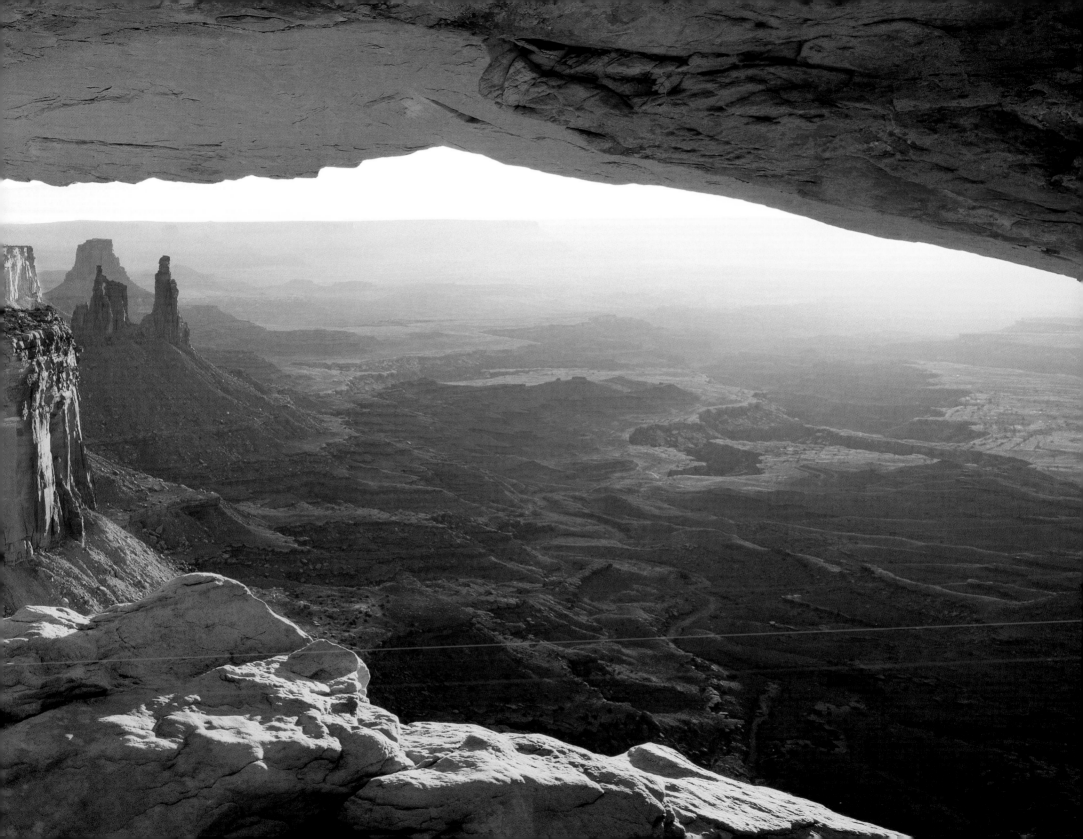

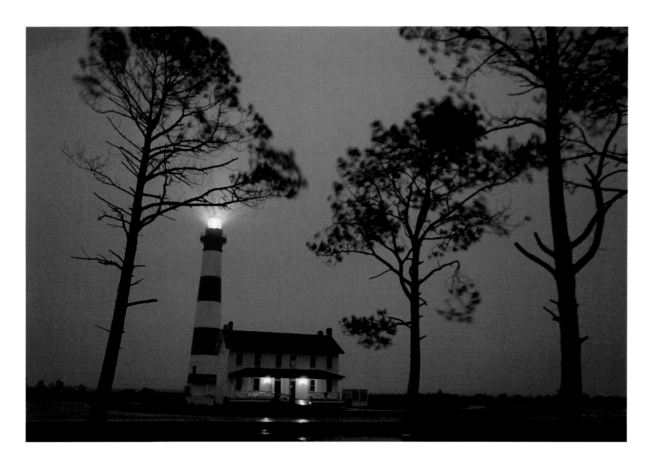

Bodi Island Lighthouse.

previous page: Mesa Arch, Canyonlands National Park, **UTAH**.

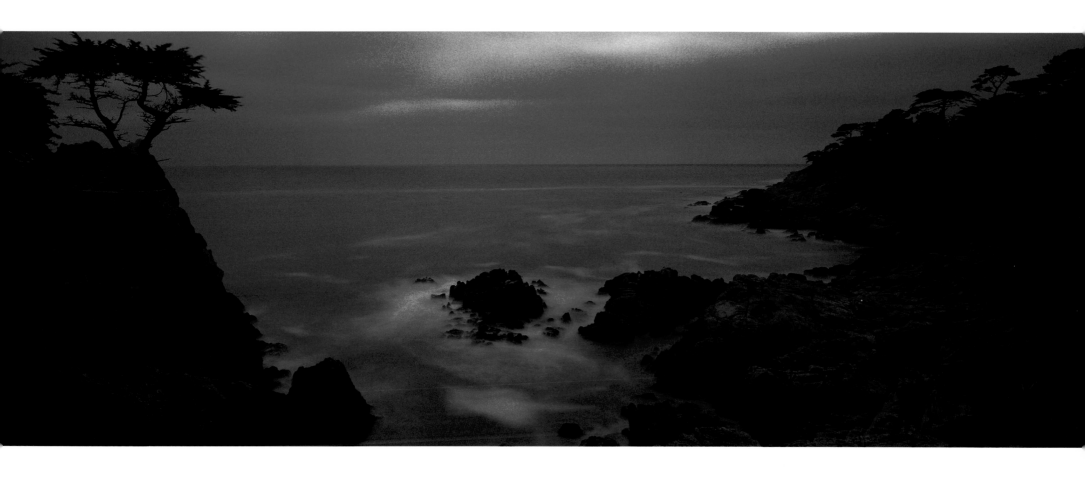

CALIFORNIA

Lone Cypress, Carmel.

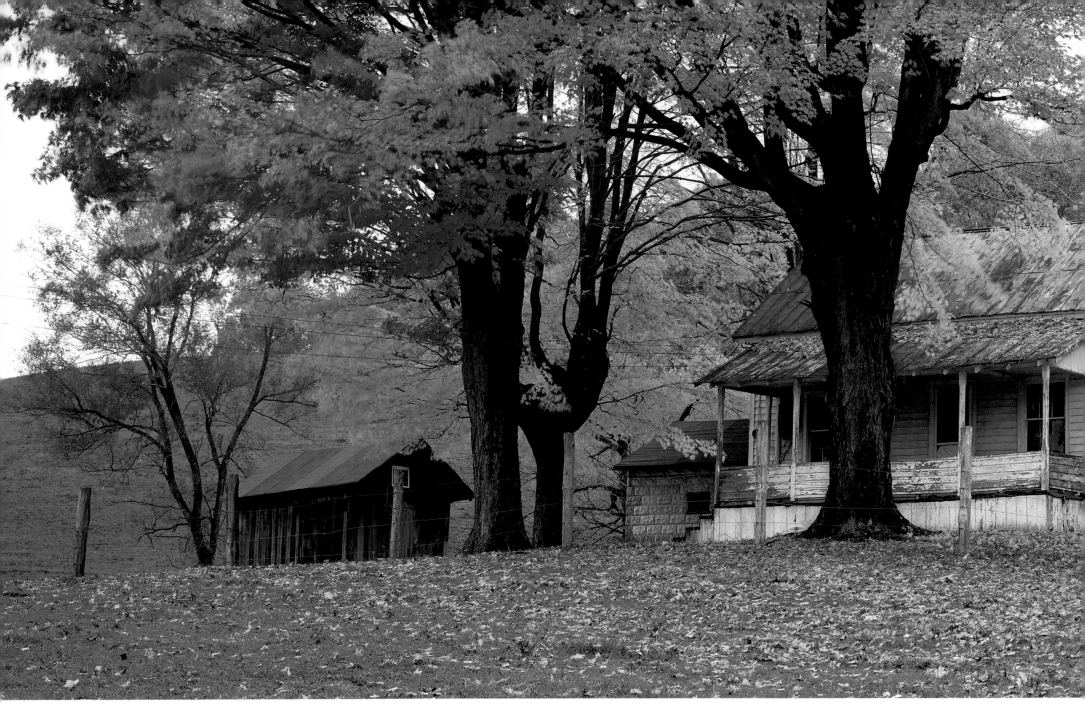

WEST VIRGINIA
Meadow River.

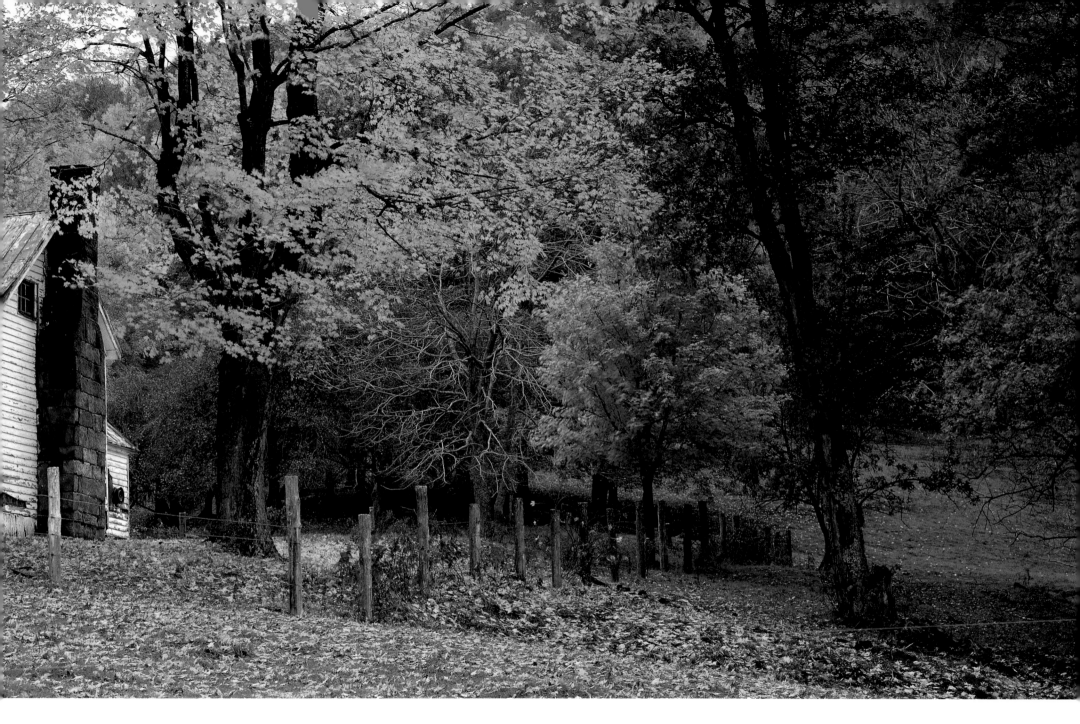

overleaf: Islamorada. Florida Keys, FLORIDA.

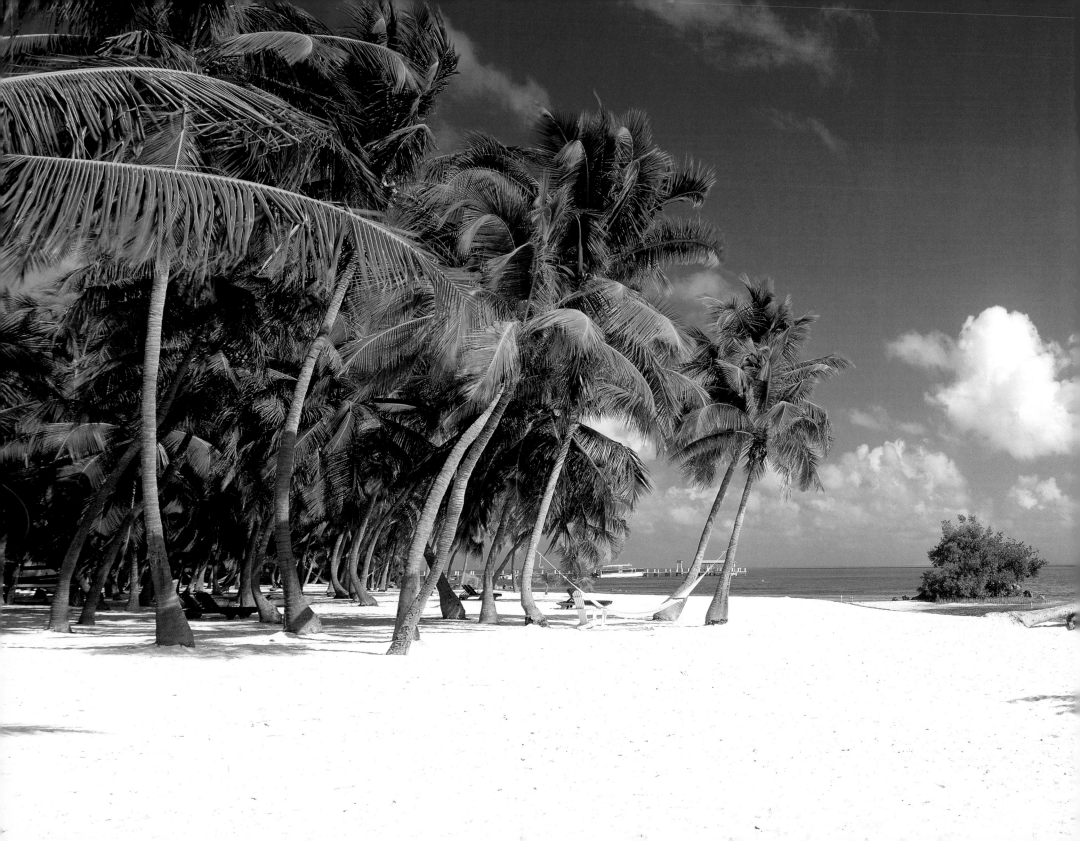

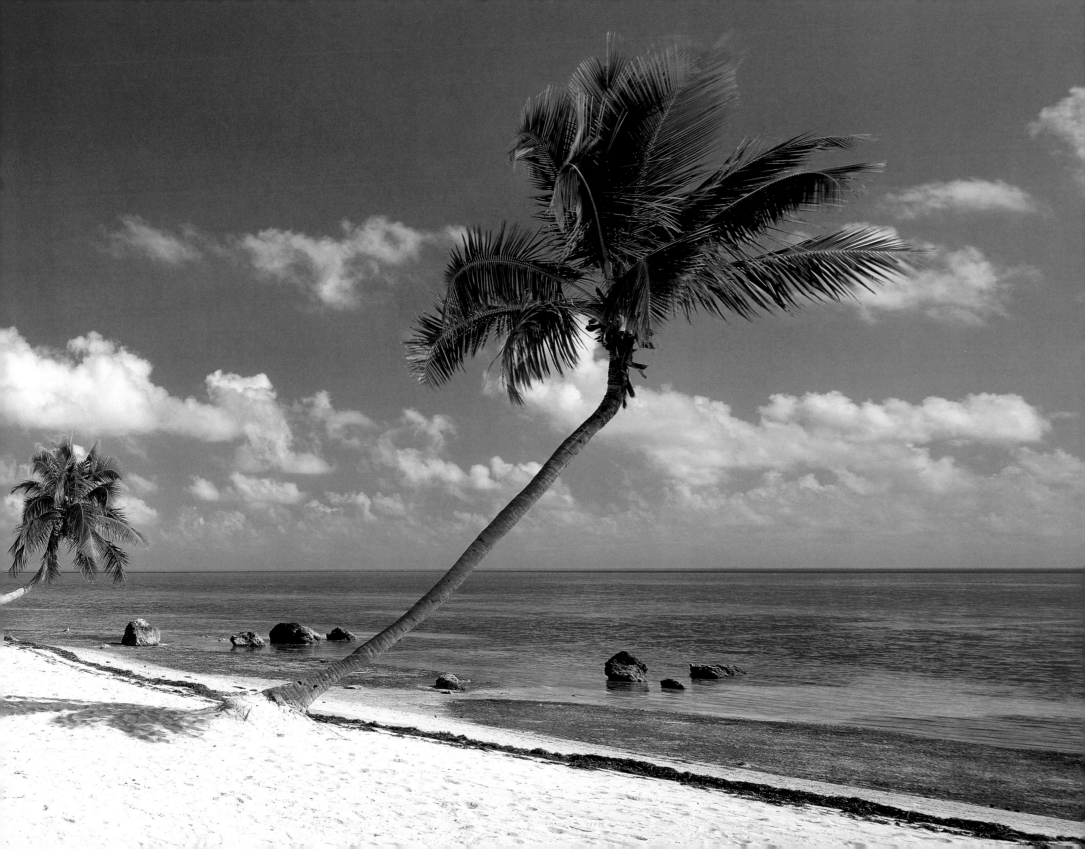

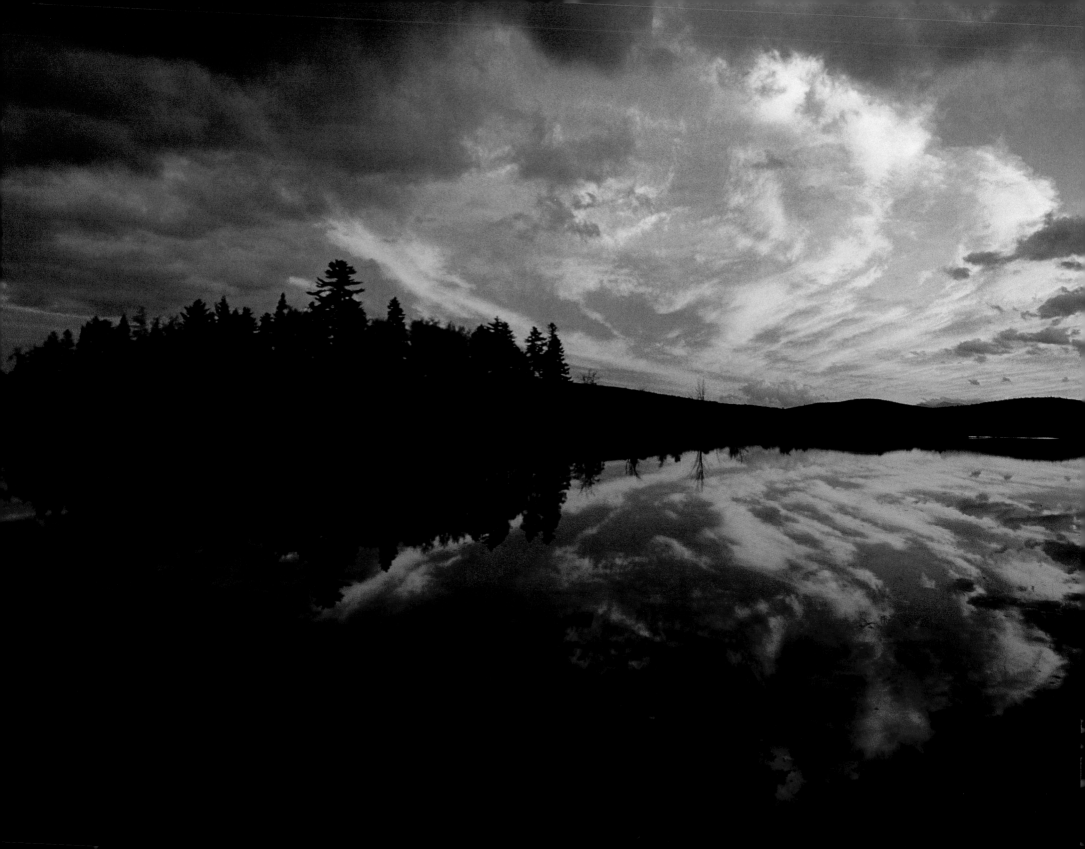

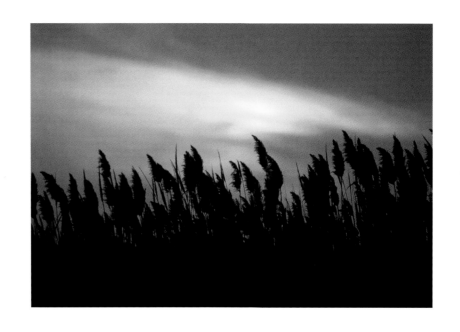

DELAWARE
Port Mahon.

NEW HAMPSHIRE
Sunset river reflections, Errol.

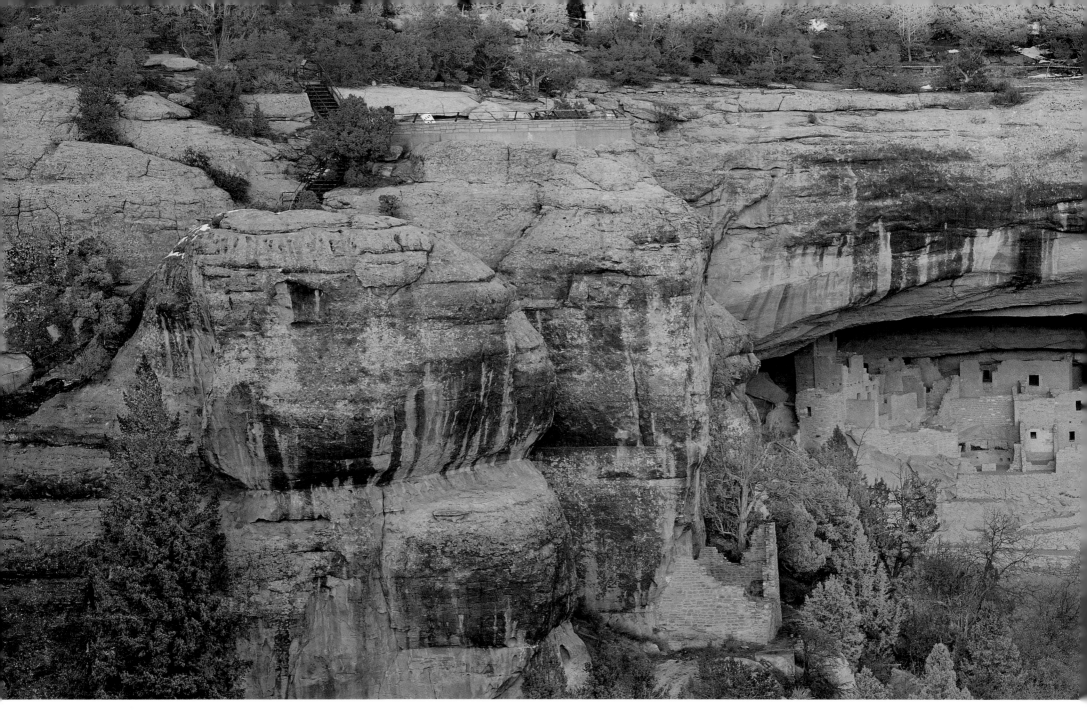

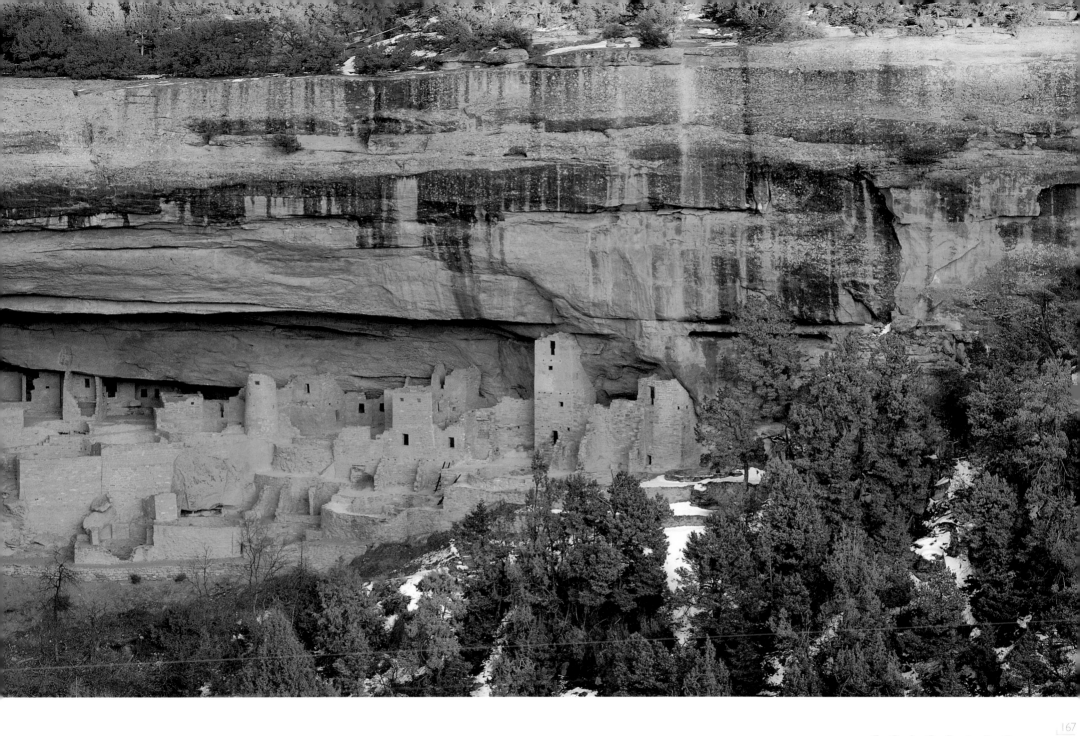

COLORADO

Ancestral Pueblo Indian dwellings, Mesa Verde National Park.

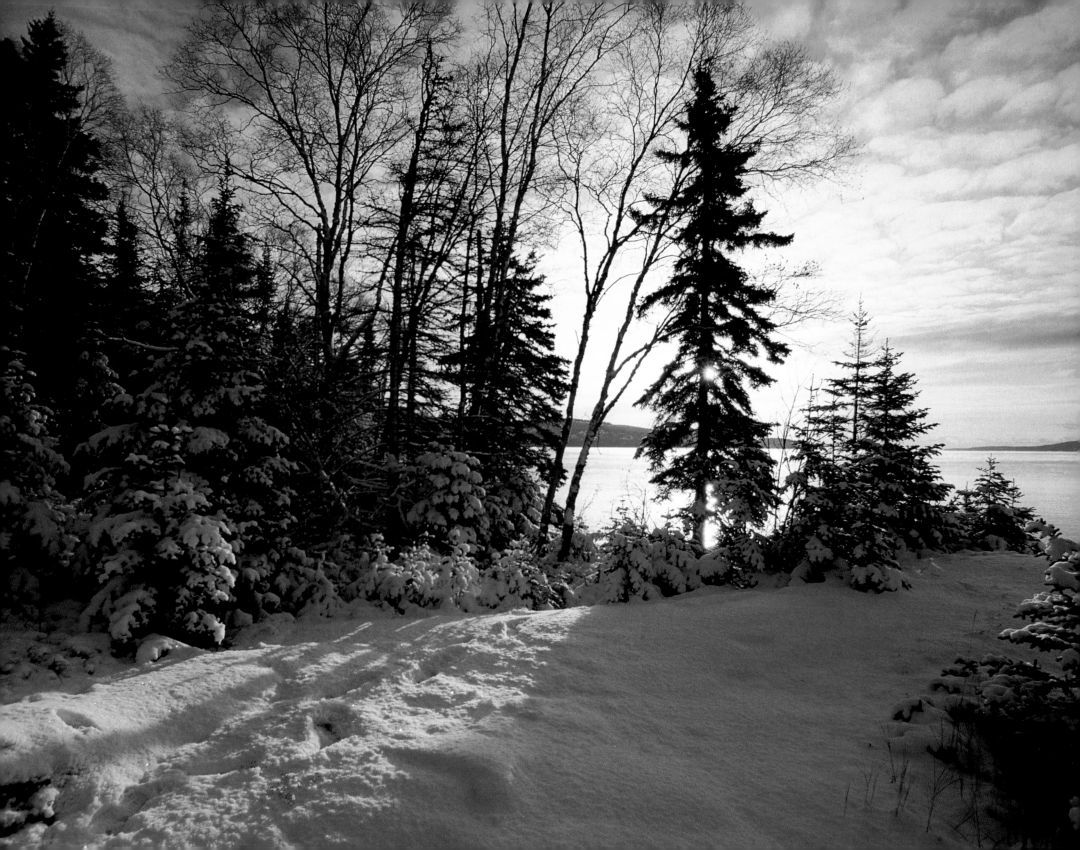

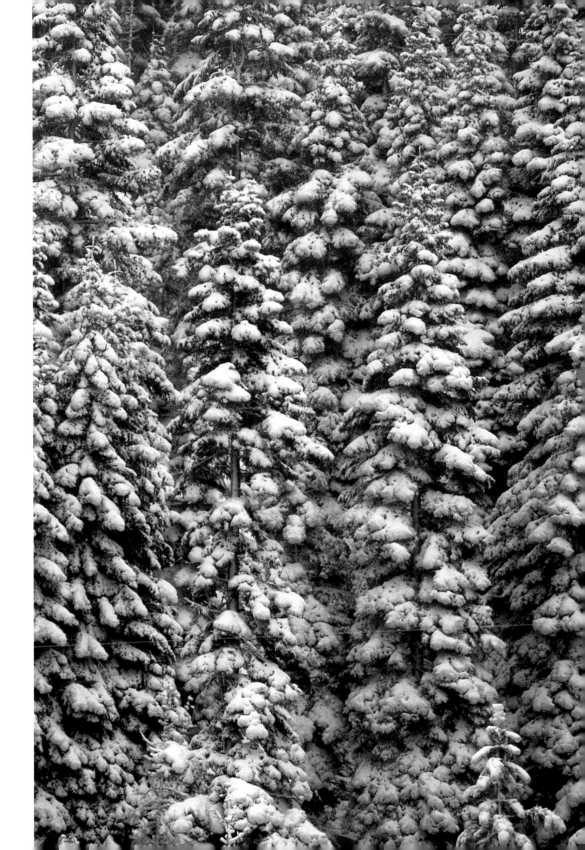

WISCONSIN

Alpenglow, Lake Superior.

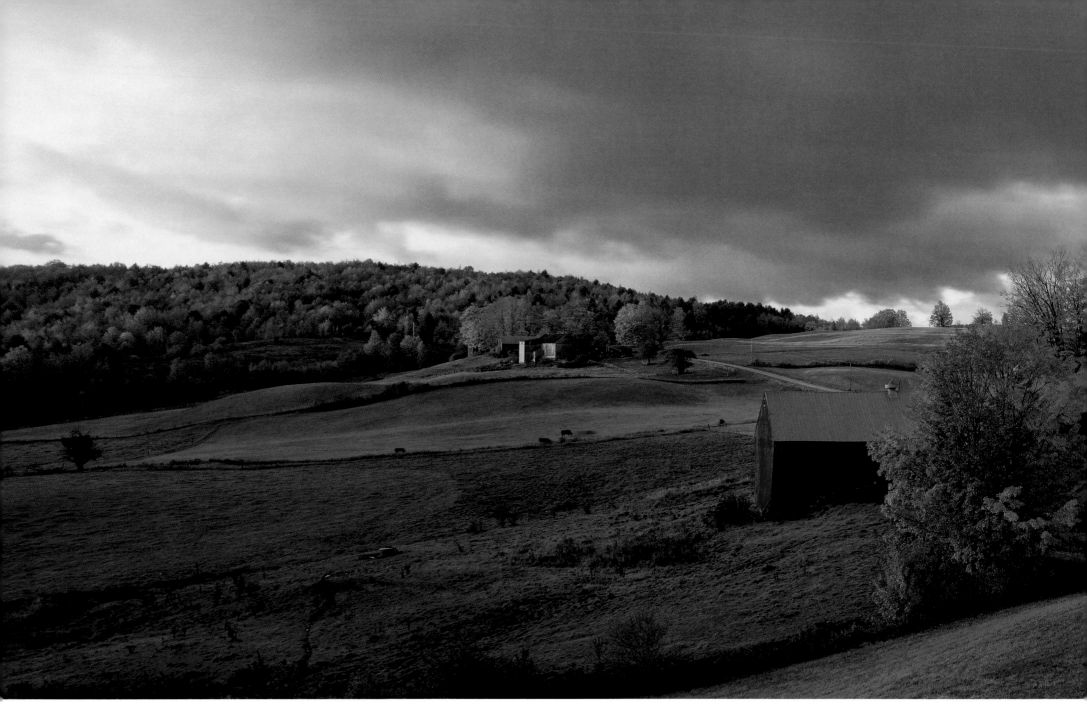

VERMONT

Jenne Farm, Woodstock.

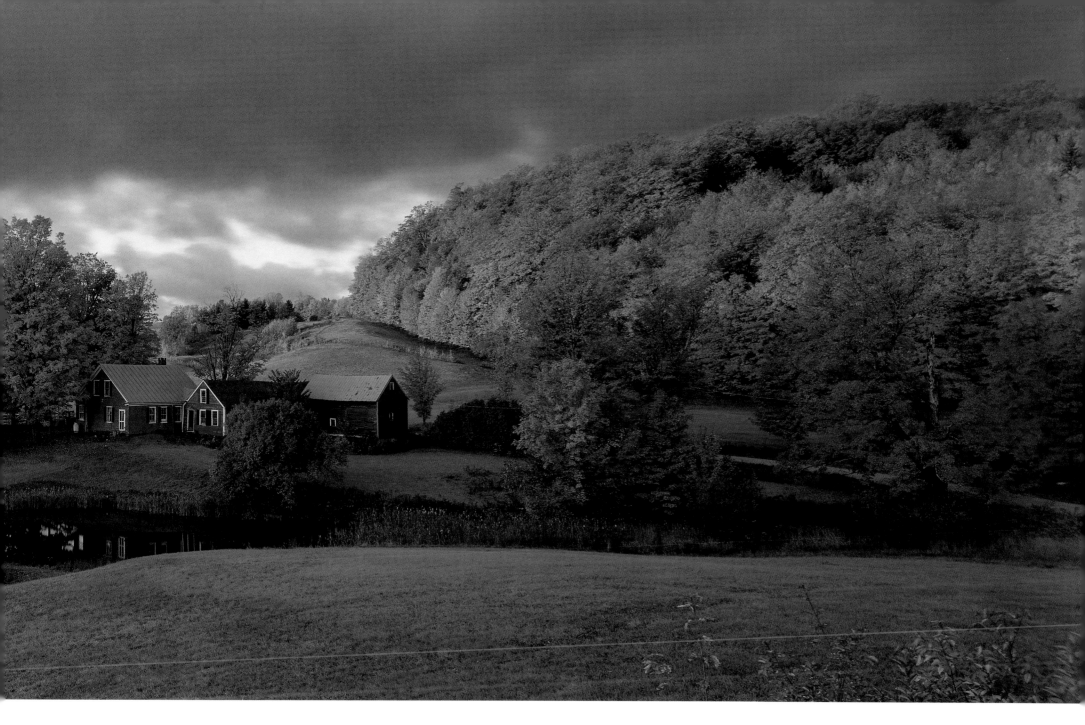

overleaf: Cypress trees, Banks Lake National Wildlife Refuge. **GEORGIA**.

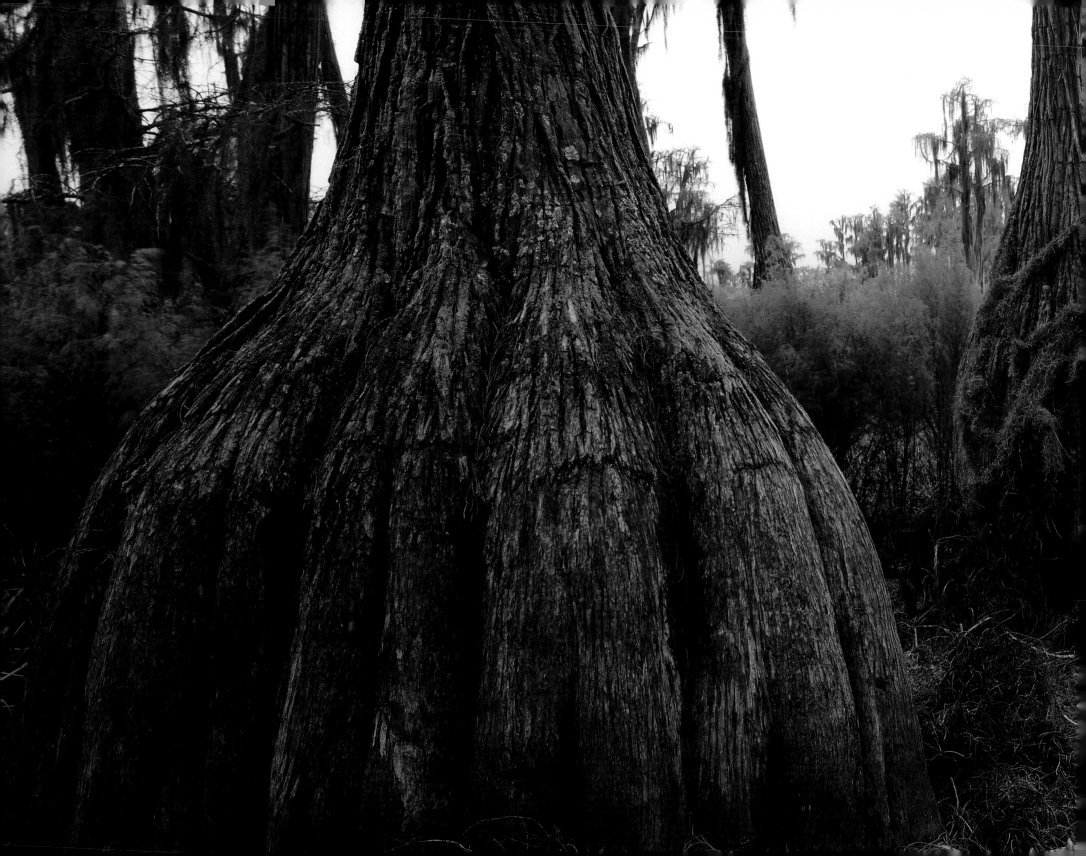

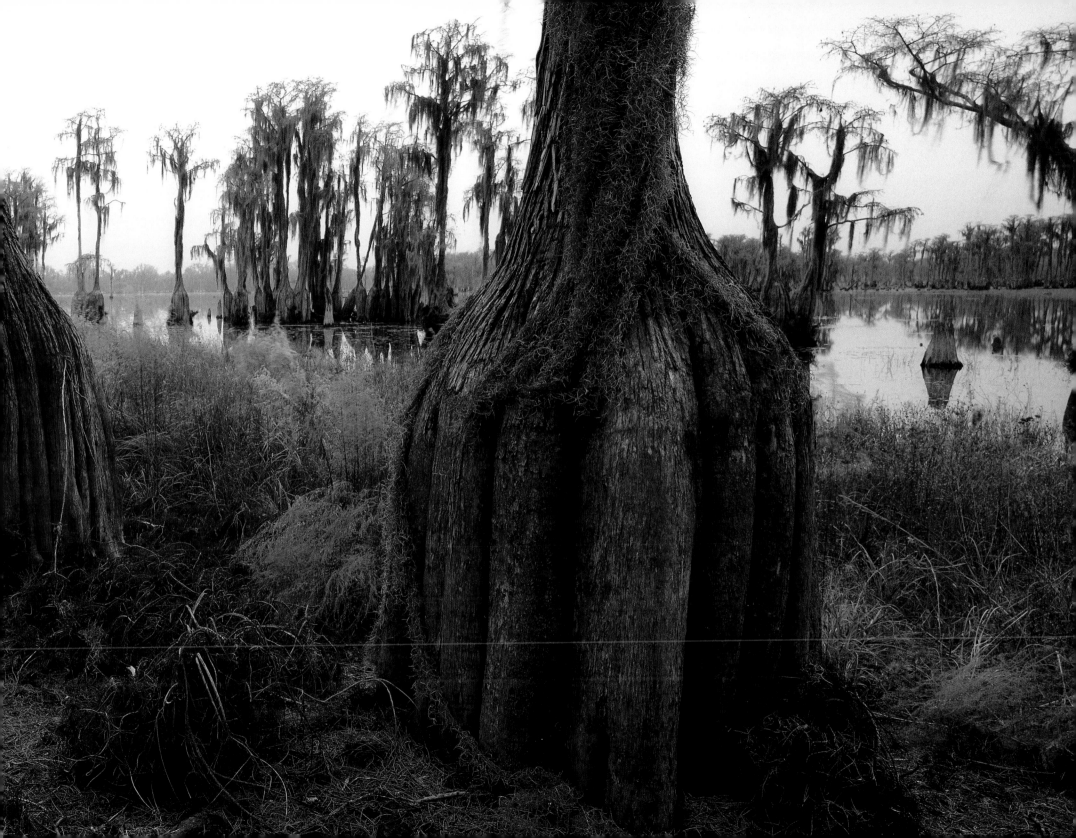

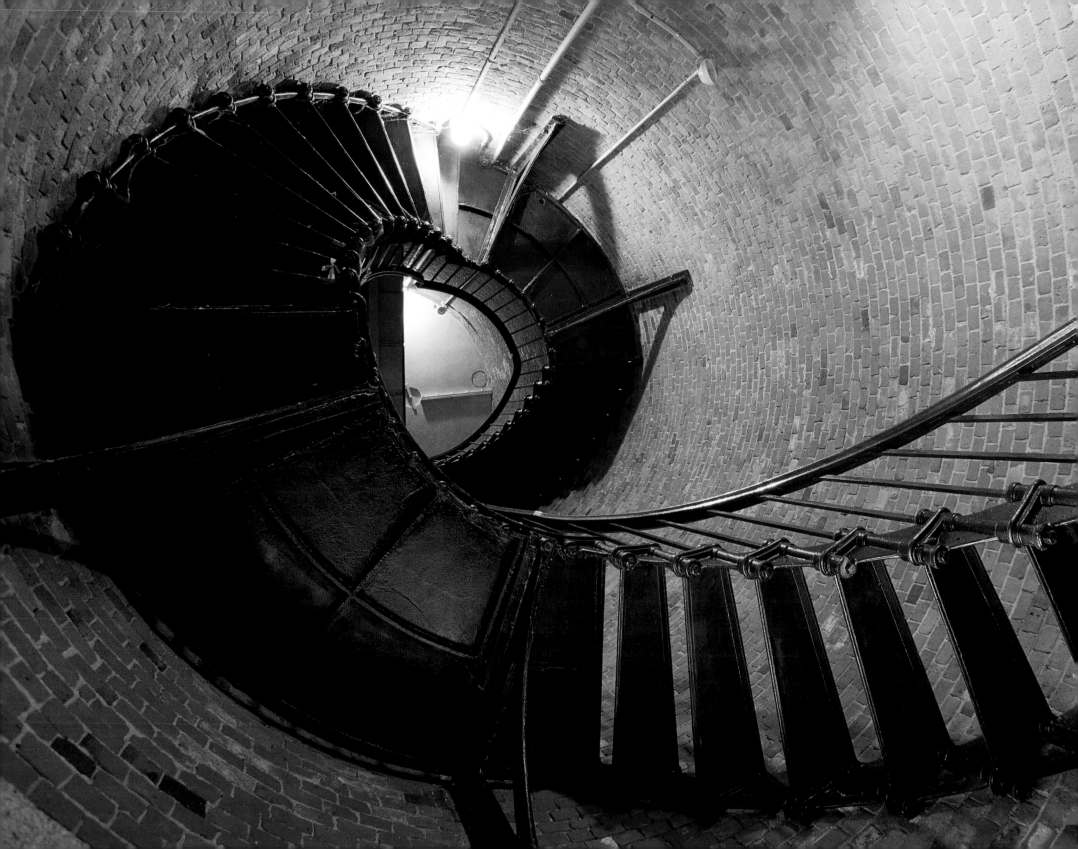

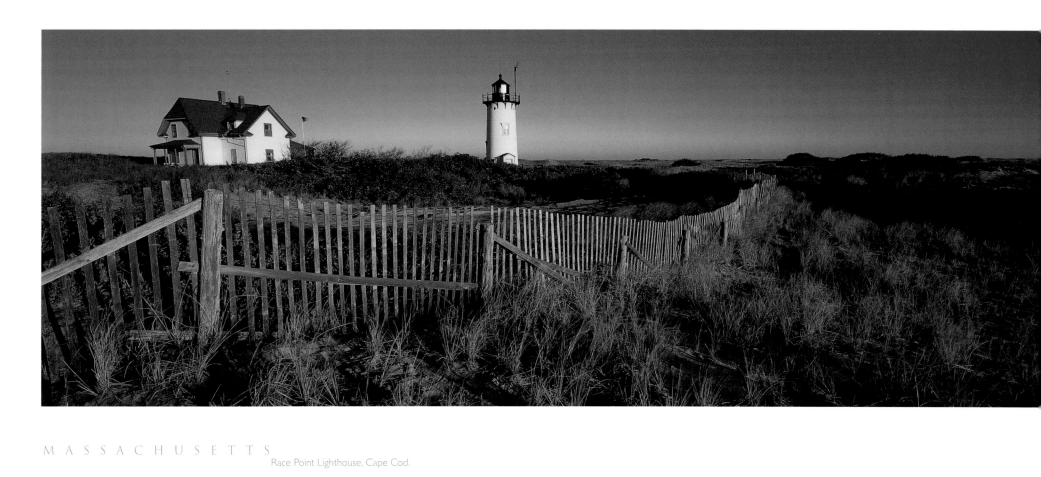

MASSACHUSETTS

Race Point Lighthouse, Cape Cod.

MASSACHUSETTS

Highland Light interior, Cape Cod.

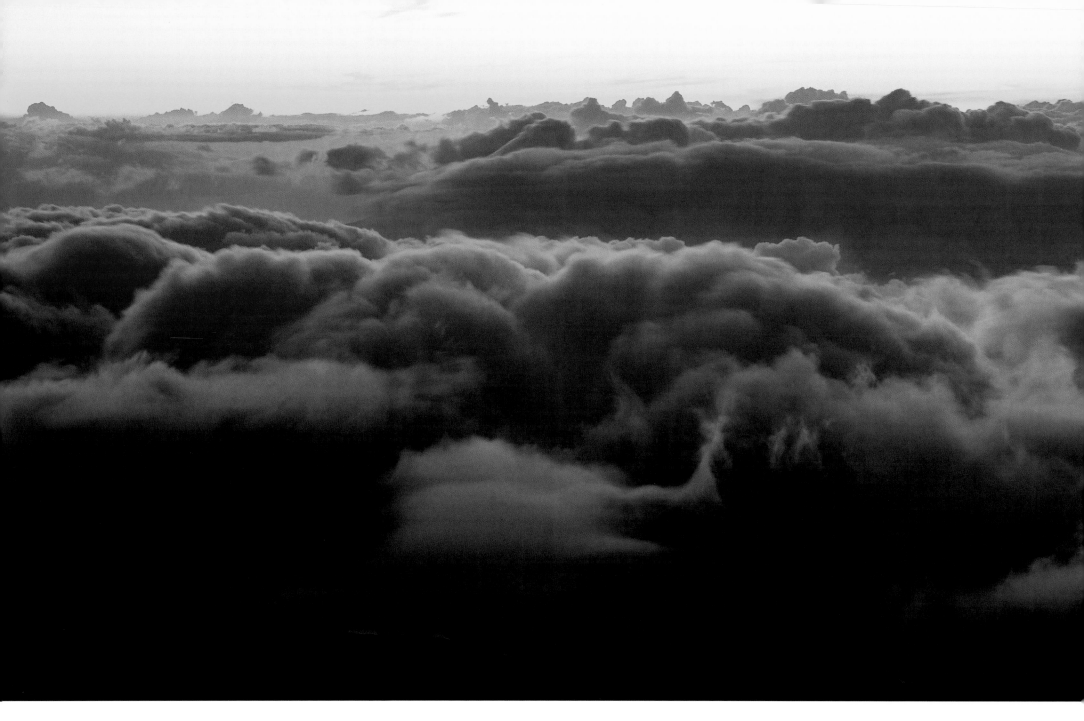

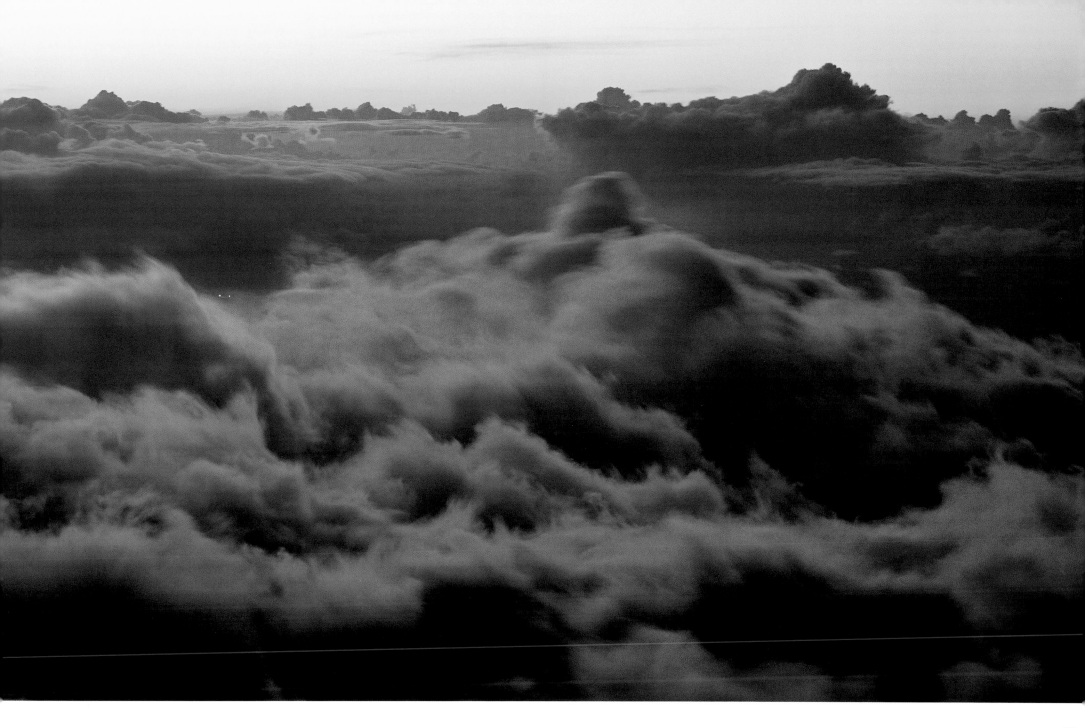

HAWAII

Haleakala National Park - House of the Sun - Maui.

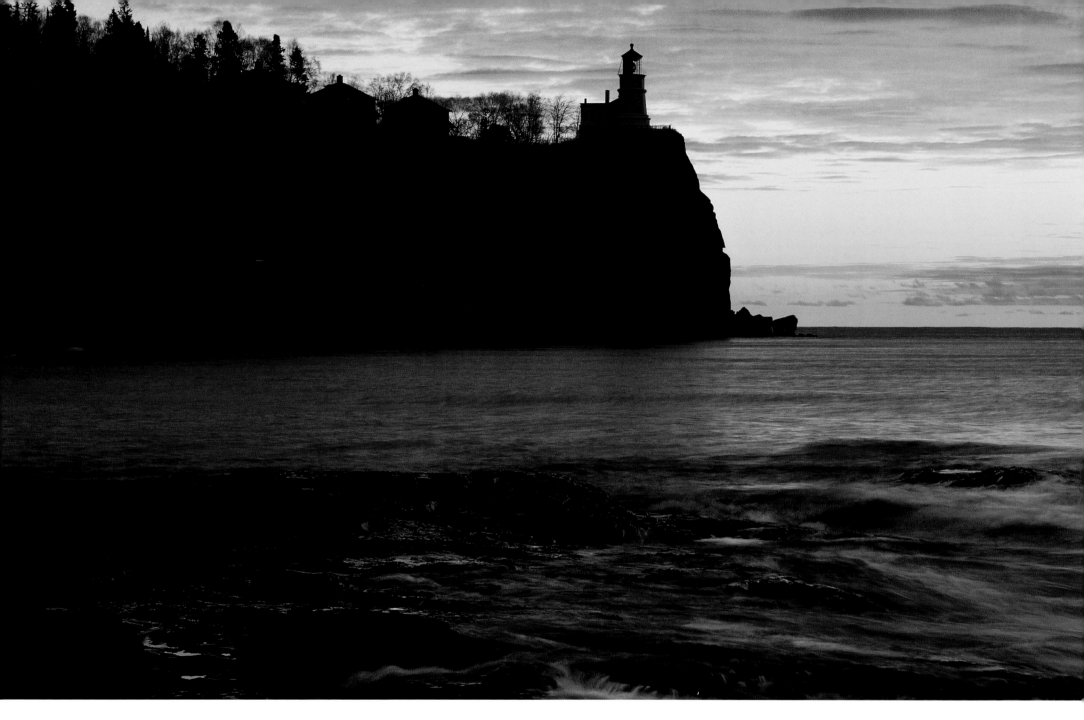

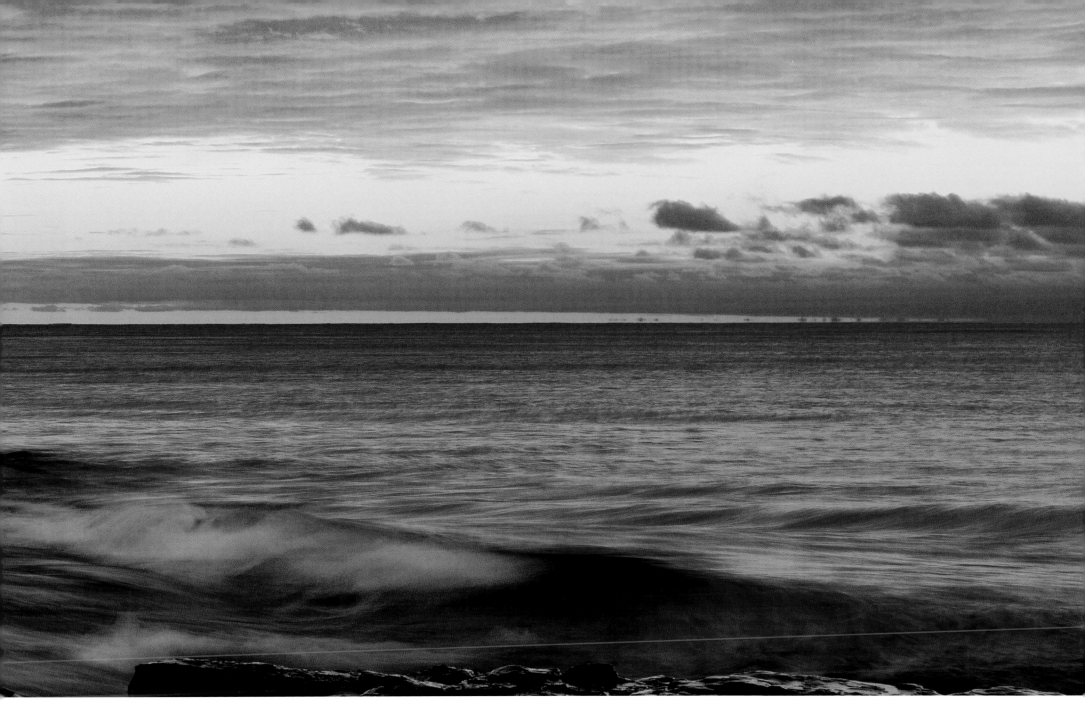

MINNESOTA

Split Rock Lighthouse State Park, Lake Superior.

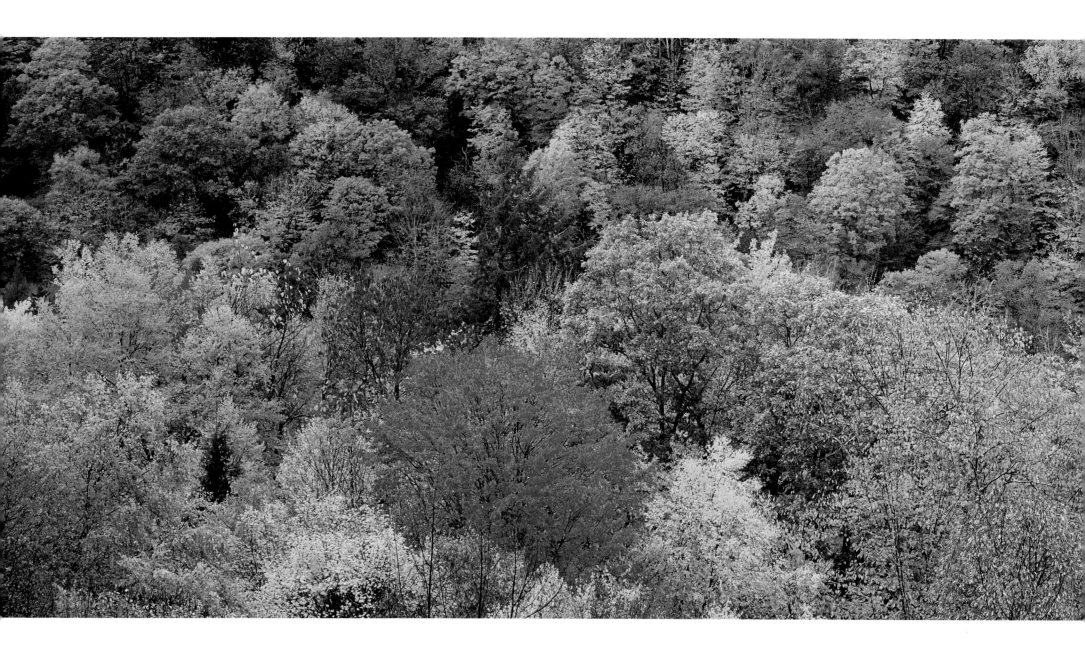

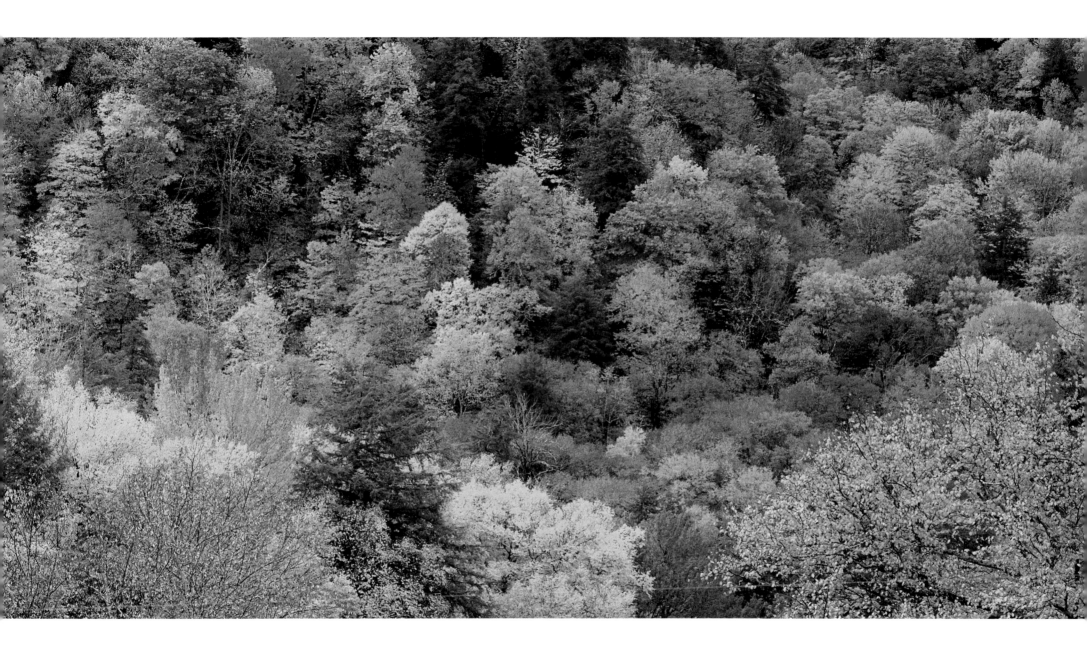

VIRGINIA

Autumn palette, Shenandoah National Park.

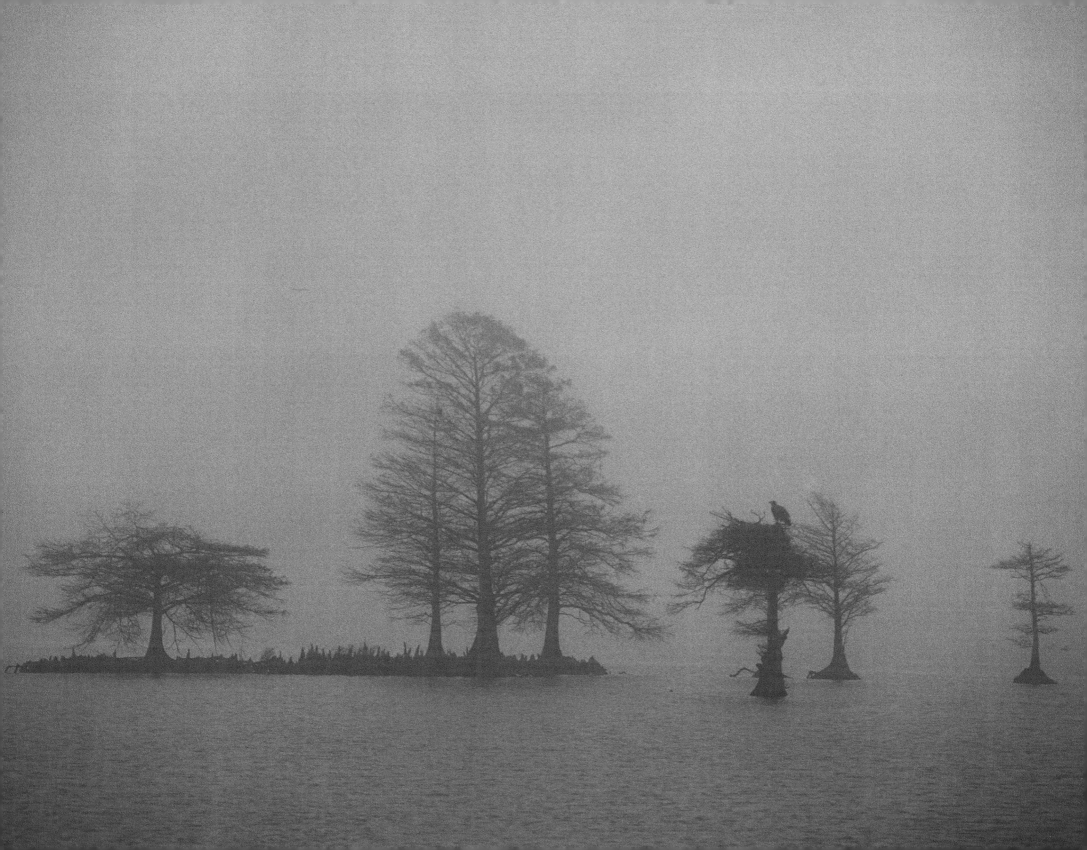

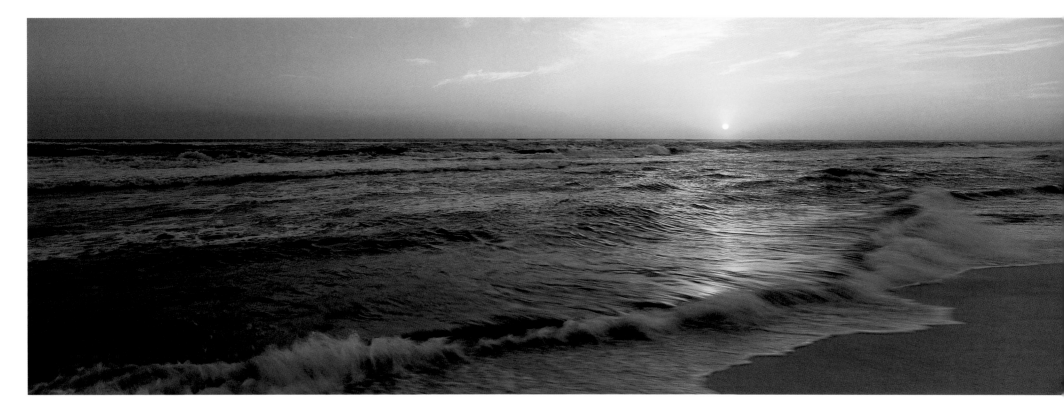

ALABAMA
Gulf Shores.

NORTH CAROLINA
Lake Mattamuskeet.

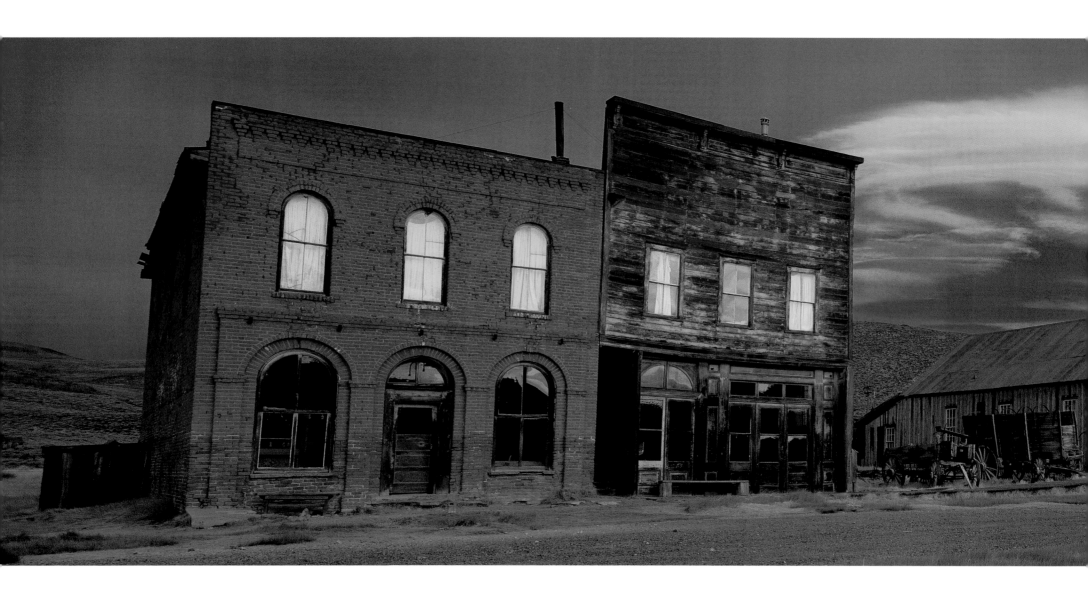

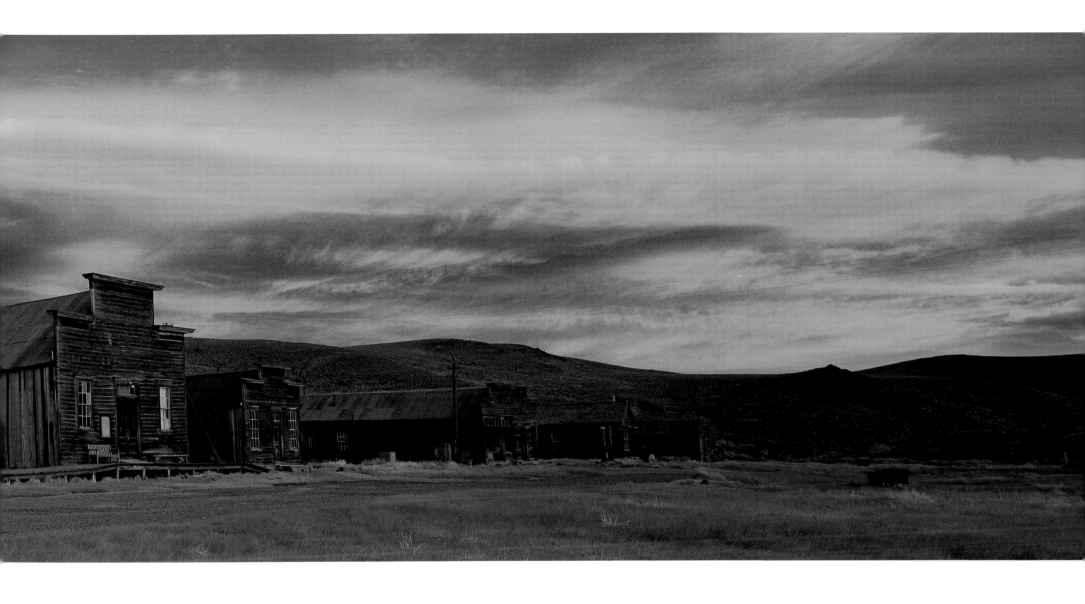

CALIFORNIA

Sierra skies, Bodie ghost town.

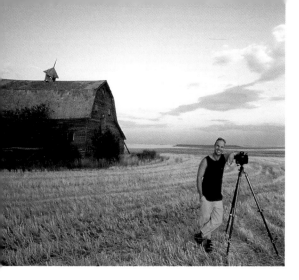

PETER LIK
M. Photog. (Master of Photography - AIPP)

Born in Melbourne Australia in 1959, landscape photographer Peter Lik's unbounded passion and dedication to his craft have seen him achieve a remarkable success. Completely self-taught, his daring and determination have put him at the cutting edge of contemporary landscape photography.

An accredited Master of Photography, Lik's fascination with the lens began at an early age. His boyish curiosity and keen eye for detail set him on a journey of discovery that has endured into adulthood. Growing up within the confines of Melbourne's 'urban jungle', nurtured a respect and reverence for the wide-open spaces of the Australian landscape.

Annual family pilgrimages to the picturesque Dandenong Ranges and the rugged coastline of the Great Ocean Road fuelled his love affair with the land. Often disappearing for hours on end with only his camera for company, early work from these childhood expeditions shows a mature and sensitive approach to composition. From the first image he ever captured - a delicate study of morning dew on a spider web - his natural ability was evident.

Over the next thirty years, Lik honed his craft through a painstaking process of trial and error. His body of work was nothing short of prolific and he experimented fearlessly, pushing the boundaries of traditional photographic techniques. Working his way through a procession of mundane jobs he never lost sight of his dreams, finally setting off on his first exploration of the USA in 1984 in an attempt to cure himself of the wanderlust that had plagued him for years. A chance meeting with

fellow photographer and friend Allen Prier in Alaska, became a defining point in his life. He was introduced to the encompassing field of view of the large format panoramic camera, and was entranced. Some lighthearted words of advice from Prier - 'Go big or go home' – struck a chord. In the end Lik did both. Taking the ultimate leap of faith, he sold his van to purchase the camera and returned to Australia with nothing but a fierce determination to pursue a career in photography on his own terms.

The underlying secret to Lik's success is his enduring respect for the power of nature. He has a genuine connection with the land, and a commitment to preserving the 'spirit of place' in his images. His work displays a

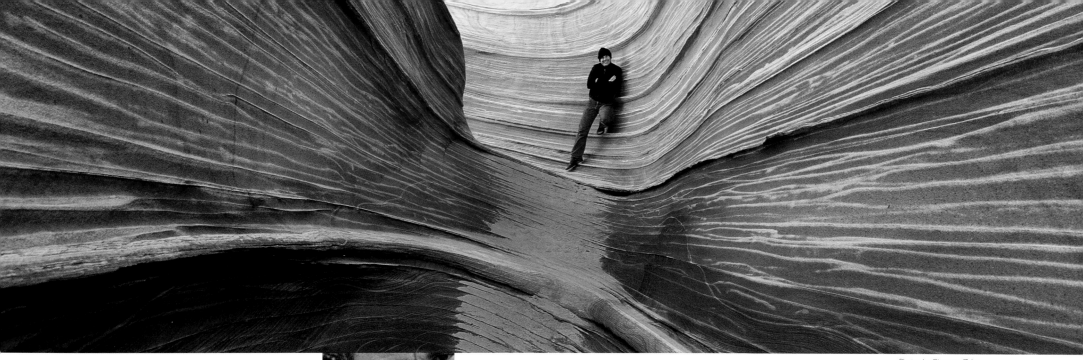

Photos by Giovanna Zalar

"*The real voyage of discovery is not in discovering new lands, but in seeing with new eyes*"

– *Marcel Proust*

resonance more often seen on canvas than in the photographic medium, and his seductive images invite one to not merely observe a scene, but to be transported entirely.

Lik himself is the ultimate observer, and his works are a labor of love. Often waiting at remote and inhospitable locations for hours for the right light and conditions, he will return time and time again before being satisfied. He sees beauty in even the most mundane scene, and his gift is in creating images that encourage the viewer to search for it too. Believing the existence of the photographer is justified only by the quality of the work he produces, Lik's never ending quest for the indefinable 'perfect' image, and his voracious appetite for adventure propels him on.

Lik's raw and honest approach to photography has earned him a legion of fans throughout the world. His artistic achievements have gained him the respect of his peers, and the AIPP (Australian Institute of Professional Photography) has awarded him with their highest accolades. Although a formidable and driven businessman, he remains more comfortable behind the lens of his camera than a desk, and spends much of his time travelling.

Spirit of America is the culmination of a five-year odyssey spent exploring the USA.

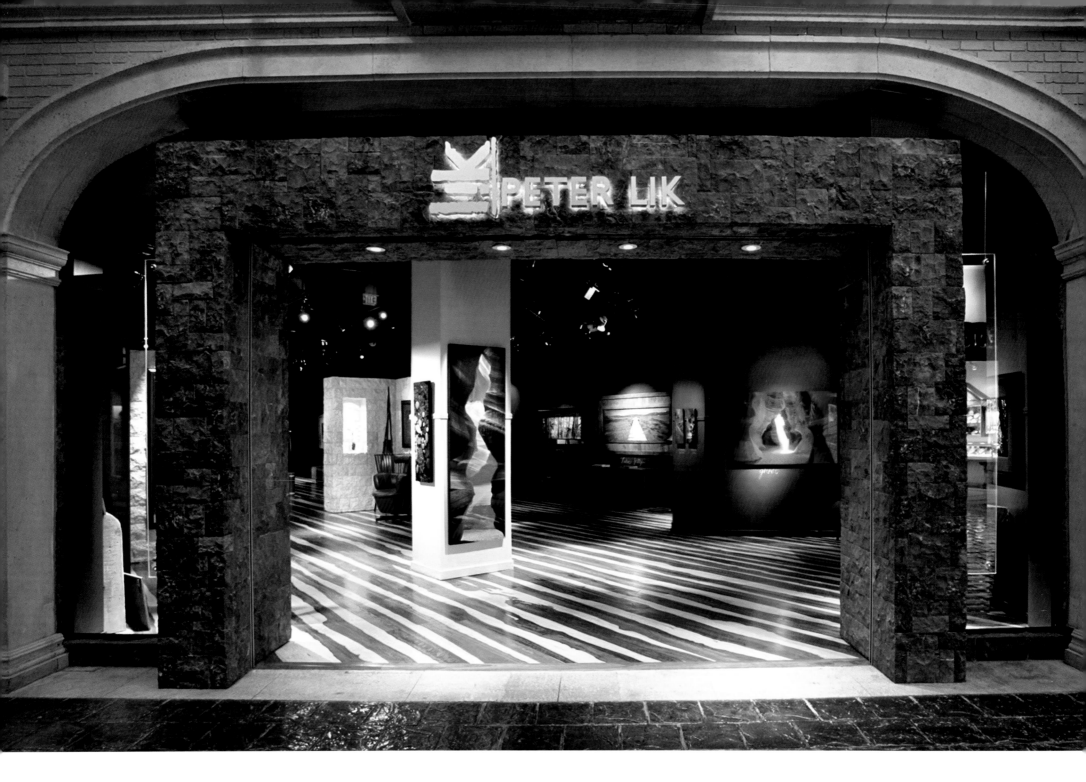

PETER LIK GALLERIES

In 1999 Peter Lik realized a lifelong dream to open his own photographic gallery. Since then demand for his work has resulted in the establishment of eight more signature showcases throughout Australia and the USA.

Featuring his extensive collection of limited edition landscape photographs, the award-winning galleries are a tribute to Lik's attention to detail and dedication to his craft. A delicate balance blending environment and art is achieved by incorporating elements of nature within the décor. Warm timber floors and custom designed furniture create a unique ambience throughout. The open and welcoming atmosphere is enhanced by the inclusion of comfortable lounges and reading areas where the visitor is encouraged to sit and soak up the experience.

Each gallery offers a full framing service specialising in both traditional styles and more unusual mediums such as recycled timber and hand beaten metal. A team of experienced Art Consultants are on hand to guide the visitor through their journey, or they can simply relax and enjoy the gallery at their leisure.

Lik's original design concept was to create a contemporary space that enhances the natural beauty of his imagery, and the galleries continue to evolve under his direction. Attracting a diverse mix of visitors and collectors, the galleries are a fitting environment in which to experience an extraordinary photographic collection.

INDEX OF LOCATIONS

HAWAIIAN ISLANDS

Kauai, Oahu, Molokai, Maui, Lanai, Kahoolawe, Hawaii, Pacific Ocean

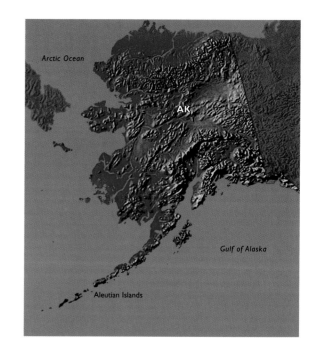

Arctic Ocean, AK, Gulf of Alaska, Aleutian Islands

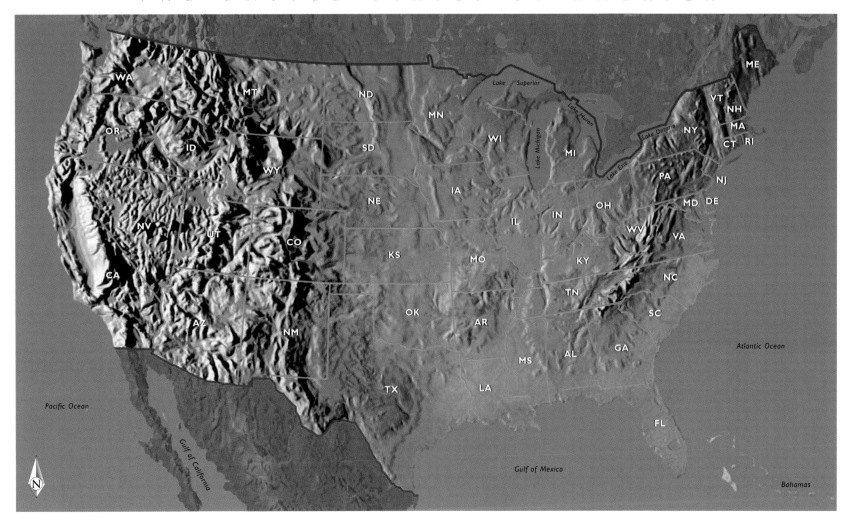

SPIRIT OF AMERICA
by Peter Lik

DESIGN
Cameron LeBherz

TEXT
Julietta Henderson

PHOTO ASSISTANTS
Giovanna [JoJo] Zalar

Gene [Pin] Moule

PHOTO EDITORS
Peter Lik

Julietta Henderson

Cameron LeBherz

Giovanna [JoJo] Zalar

Steve [Merv] Moorhouse

*To my Mum, Dad, Di, Kev and my much loved
and long awaited niece Jasmine.*

ISBN 187658515-3

Printed in China at Everbest Printing Co Ltd

PETER LIK PUBLISHING

HEAD OFFICE USA
4250 Wagon Trail. Las Vegas 89118 Nevada USA

HEAD OFFICE AUSTRALIA
39 Moffat Street. PO Box 2529 Cairns Queensland 4870 Australia

PETER LIK GALLERIES

USA
MAUI 712 Front Street, Maui, Hawaii HI 96761 Tel 808 661 6623
WAIKIKI Space L118 & L121, Waikiki Beach Walk, Lewers Street, Honolulu. HI 96815
VENETIAN #2071 Grand Canal Shoppes, 3355 Las Vegas Blvd. Las Vegas, Nevada 89109 Tel 702 309 8777
CAESARS PALACE T-10 Forum Shops, 3500 Las Vegas Blvd. Las Vegas, Nevada 89109 Tel 702 836 3310
MANDALAY PLACE #126 Mandalay Place, 3930 Las Vegas Blvd. Las Vegas, Nevada 89109 Tel 702 309 9888

AUSTRALIA
SYDNEY Level 2 QVB, 455 George Street, Sydney NSW 2000 Tel 61 2 92690182
NOOSA Shop 2, Seahaven, 9 Hastings Street, Noosa Heads, QLD 4567 Tel 61 7 5474 8233
PORT DOUGLAS 19 Macrossan Street, Port Douglas, QLD 4871 Tel 61 7 4099 6050
CAIRNS 4 Shields Street, Cairns, QLD 4870 Australia Tel 61 7 4031 8177

Mother nature sets the scene,
I simply capture it.